THE BIRTH OF BOURBON

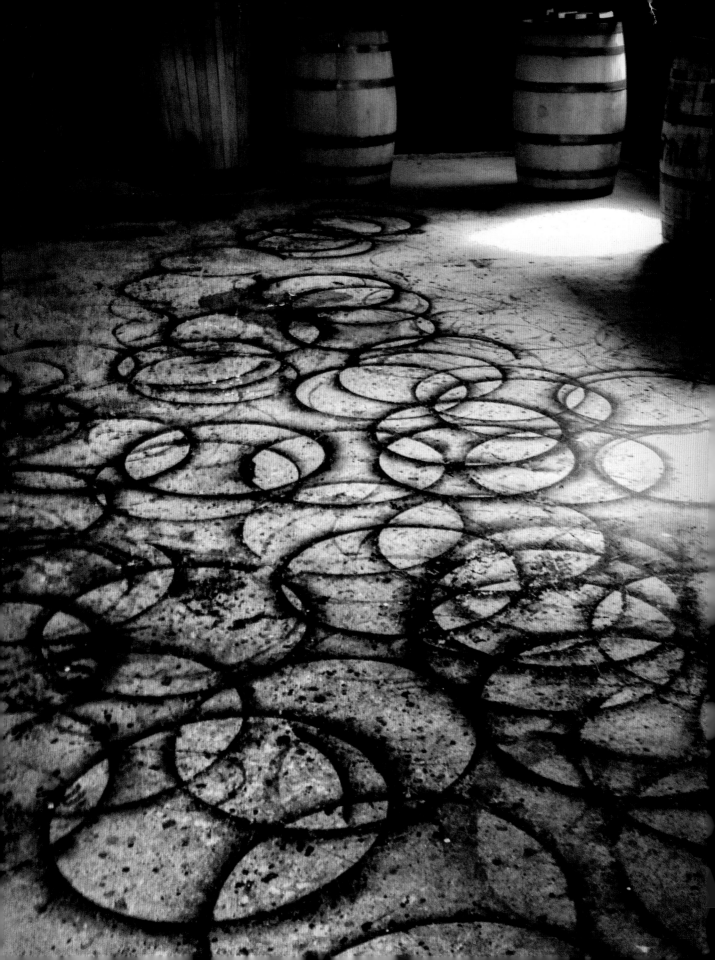

THE BIRTH OF BOURBON

A PHOTOGRAPHIC TOUR OF EARLY DISTILLERIES

PHOTOGRAPHS BY CAROL PEACHEE FOREWORD BY JIM GRAY

UNIVERSITY PRESS OF KENTUCKY

Published by the University Press of Kentucky

Scholarly publisher for the Commonwealth,
serving Bellarmine University, Berea College, Centre
College of Kentucky, Eastern Kentucky University,
The Filson Historical Society, Georgetown College,
Kentucky Historical Society, Kentucky State University,
Morehead State University, Murray State University,
Northern Kentucky University, Transylvania University,
University of Kentucky, University of Louisville,
and Western Kentucky University.
All rights reserved.

Editorial and Sales Offices: The University Press of Kentucky
663 South Limestone Street, Lexington, Kentucky 40508-4008
www.kentuckypress.com

Library of Congress Cataloging-in-Publication Data

Peachee, Carol.
 The birth of bourbon : a photographic tour of early distilleries
/ photographs by Carol Peachee ; foreword by Jim Gray.
 pages cm
 ISBN 978-0-8131-6554-7 (hardcover : alk. paper) —
ISBN 978-0-8131-6585-1 (pdf) — ISBN 978-0-8131-6584-4 (epub)
1. Bourbon whiskey—History—Sources. 2. Distilleries—
Kentucky—History—Sources. 3. Abandoned buildings—
Kentucky—Pictorial works. 4. Industrial archaeology—Kentucky.
5. Photography, Industrial. I. Title.
 TP605.P43 2015
 663'.52—dc23

∞ This book is printed on acid-free paper meeting
the requirements of the American National Standard
for Permanence in Paper for Printed Library Materials.

Due to variations in the technical specifications of different
electronic reading devices, some elements of this ebook may not
appear as they do in the print edition. Readers are encouraged to
experiment with user settings for optimum results.

Member of the Association of American University Presses

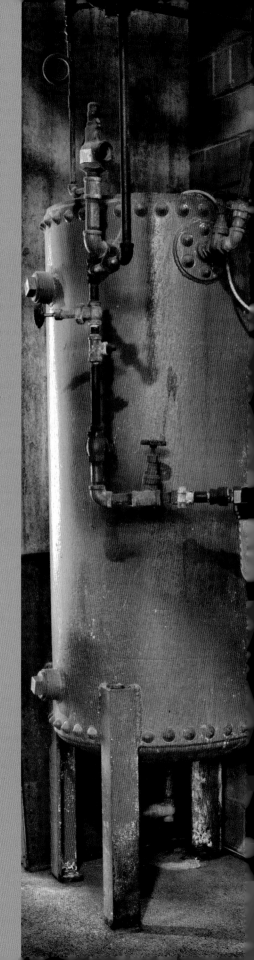

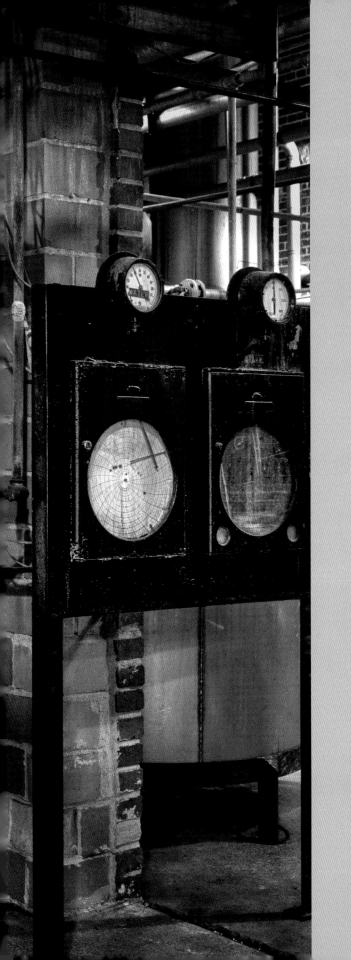

FOR MONICA

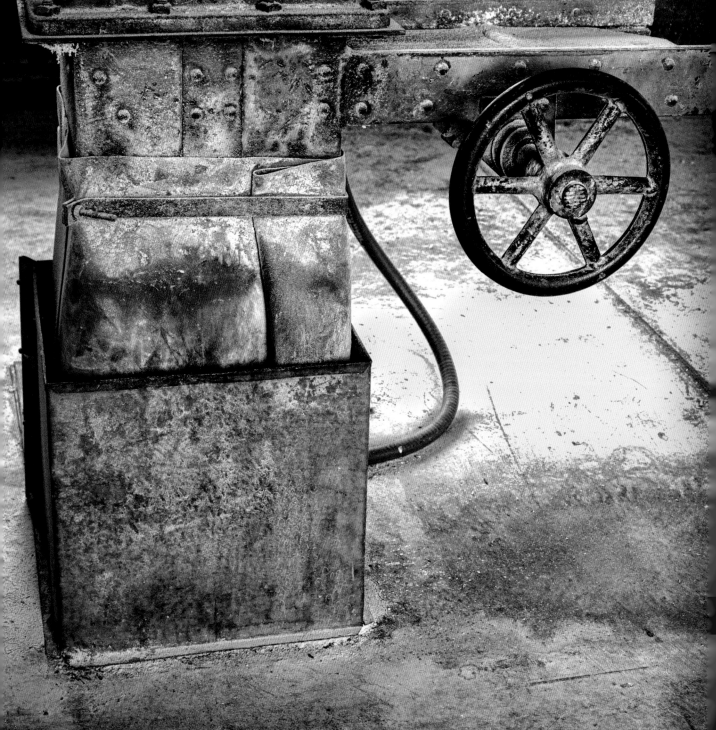

CONTENTS

FOREWORD

Where do we find art? Anywhere. Everywhere.

Take a look at Carol Peachee's art . . . photographs of the long-abandoned and retired distilleries from Lexington's Distillery District and throughout the Bluegrass State.

As early as 1810, there were some 140 distilleries operating in central Kentucky, and approximately 2,000 in all Kentucky. By 1987 the bourbon market had decreased dramatically, and many distillery plants were abandoned, while other distilleries severely cut back production. Now spirits are once again being distilled in the Bluegrass, and several thousand tourists have visited the area at the west end of Lexington's downtown.

Thanks to the vision of creative entrepreneurs, after decades of people passing by these buildings without giving them a thought, several years ago Lexington realized there's once again a lot of potential in the Distillery District and in the state's forgotten distilleries. Exciting initiatives are under way to develop the area, using the historical buildings for shops, restaurants, housing, entertainment, breweries, craft distilleries, and more.

C. S. Lewis, the author of *The Chronicles of Narnia*, wrote of books that had "baptized" his imagination. Carol's photographs baptize the imagination for what the Distillery District and the Bluegrass region can yet become. They are a distillation of the region's history and its potential.

Where do we find art? In these pages.

JIM GRAY
Mayor of Lexington, Kentucky

INTRODUCTION

A Visual Archaeology of Kentucky Bourbon Distilleries

Photography is a practice that reveals. A certain moment, one that is gone as soon as the shutter captures it, becomes static in time. What is no longer there, absence, is present. As well, a distant presence is revealed in the viewer's current moment. In the case of a photograph of a historical subject, the photograph reveals something of the past in a moment that itself will be history. For example, several of the structures shown in these pages no longer exist, some have been salvaged for materials, and some have continued deteriorating. Others are in various stages of reclamation or repurposing. Photographed again today, they would look different, which would make some of the images, barely four years old, a relic in their own right.

A photograph contains not only the presence of place but also the presence of the photographer—a point of view, artistic choices, the moment of light, the technology available at the time. Depending on these factors, photographs can reveal what is not noticed by the naked eye. A certain slant of light might create a contrast of edges illuminating a texture or pattern unseen under normal circumstances. Or a telephoto lens might provide a view of a detail beyond a normal viewer's physical access. As a result, each photograph is a portrait of many layers, a still life of both the content photographed and the photographer. Yet as literal as the photograph might be, inference is needed to decipher the image.

Archaeology is a common metaphor in the discussions of photography, probably because archaeology and photography share concerns about revelation, inference, presence, and absence. The archaeologist looks for traces of what is no longer, evidence of a once-vibrant existence that is inferred from traces of what can be found or revealed in the now. The presence of this artifact or that structure brings the past into the present, but only by inference—what might already be known—or by imagination. "The archaeological imagination refuses to acknowledge, quite, the loss of anything," the art historian Kitty Hauser notes, much as the photograph does.[1] Entwined, archaeology

and photography are really presenting memoir from a variety of angles, and through many layers, revealed and implied. Together they also try to comprehend, salvage, preserve, and hold on to what is in danger of being lost.

Sitting on the edge of Manchester Street are the historical ruins of the James E. Pepper Distillery. I had never noticed them before, but as I wandered the streets looking for good documentary material, I came upon the abandoned buildings that the Distillery District in Lexington, Kentucky, is named for. In the winter weather, the exterior of the plant looked unremarkable at first glance. Still, I peeked inside the mostly boarded-up lower windows. Everywhere was color, pattern, form, texture, light, space, absence, and presence.

I started photographing the distillery that winter, returning each weekend to spend at least one full day in the cold spaces of the rooms. When I unlocked the outside padlock and stepped into the chilled interiors, it was as if I were stepping into an earthbound *Titanic*. Here once were heat, noise, human activity, a thriving business, and Kentucky's signature industry—bourbon whiskey. Now time and nature floated through the space, transforming the building into a museum and machinery into art. In fact, I came to see the whole distillery as both a museum holding individual works of art, connected works of art, and a work of art itself as a whole. This work of art was still in progress; what had once been here was inferred by what was present.

Around the abandoned distillery was a palpable absence. It was cathedral-like in its cool, open spaces. That year we had a very cold and snowy winter, and the physical sensations of photographing inside a deteriorating yet beautiful human-built space echoed other experiences of deterioration and absence I had witnessed. I found memoir and meaning in the transformation of the materials from functional metals into artistic elements. As I searched for images, the vast cold space slowed my mind and focused it into the moment. My work here became a meditation on impermanence, labor, time, absence, presence, and loss.

Anthropology divides the study of buildings into two fields. Ruins are delegated to archaeology and structures currently in use to ethnology. But, in fact, an occupied building bears marks of the same processes that produce archaeological remains. There are all sorts of occupations and reoccupations. Throughout this project, there was evidence in every one of the historical distillery sites of generations of structures. My photographs became testimony to what had existed before, giving afterlife to the evolution of the structures as well as the moment the image was taken. The first time I photographed the Pepper Distillery, it was unoccupied. The 1935 post-Prohibition distillery stood outside Lexington. It was an upgrade of an earlier, late 1800s plant, used, upgraded, used, and upgraded again. The last incarnation, now standing in ruins, was in operation until it was totally abandoned in the 1980s. It is now to be repurposed and occupied again in 2014 (purchased

for artists' studios and commercial venues). I first photographed the boiler room in 2010 with all the brightly colored, highly textured hoppers and ovens, and then again as it was dismantled in 2013, witnessing the excavation of the pipework that was beneath the beautiful teal green brick ovens. Another layer of beauty and function was revealed. But then, the green brick was stacked outside for repurposing in some other construction, and the interior space was cleaned for reoccupation. There is not quite loss, not quite preservation, always impermanence; the images allow future viewers to infer what it was like during many pasts.

My project in the Pepper Distillery started my obsession with industrial archaeology, and then with the bourbon distillery in particular. The bourbon industry is experiencing a renaissance in the twenty-first century after a crash in the 1980s. As international interest in Kentucky bourbon and bourbon distilleries has increased, there has been a movement to reoccupy yet again, to update old structures and machinery with modern technologies to produce more bourbon more efficiently. I wanted to investigate the industrial and architectural heritage and identity of the bourbon distillery as it begins to shift once again. And I wanted to document the old structures and machines to preserve what remained of early distillery industrial sites in that moment.

Prohibition resulted in the massive shutting down, and tearing down, of hundreds of bourbon distilleries. The earliest Kentucky distilleries, those built in the 1700s and early 1800s, have left us mostly old stone and brick warehouses and stone foundations for our inferences. It is the post-Prohibition distillery whose archaeological remains are most intact. My getting access to photograph them resulted from a sort of underground bourbon trail. I was lucky enough to display my photographs of the Pepper Distillery in a show sponsored by the Blue Grass Trust for Historic Preservation. I was approached by numerous people who suggested this or that bit of ruins, structure, or abandoned distillery. Professionals and experts in the distillery industry unselfishly shared knowledge of existing sites and suggestions for whom to approach for permission to photograph. In the end, I chose whole, intact distilleries that had been abandoned or currently occupied operating distilleries on the National Register of Historic Places (NRHP) or designated National Historic Landmarks (NHL) that had integrated old distilleries. I couldn't help photographing foundations of the pre-Prohibition distilleries also; some are included, scattered throughout the book, literally and metaphorically. What I discovered is that there are probably hundreds of old distillery warehouse and foundation remains, enough to justify an enduring survey, and more than can be represented here.

Some of the distilleries I wanted to photograph were torn down before I got to them, such as Buffalo Springs Distillery. Once a whole town had grown up around this plant. Now remnants can be found in the stone arch crossing a

drainage ditch in front of a grocery store parking lot, or a small stone building containing Department of Transportation signs. A walk through the woods behind the grocery store reveals old warehouse columns and foundations. There was an almost Greco-Roman feeling to the warehouse columns standing alone down in the overgrown depression that must have been an underground floor. Dowling Distillery warehouse in Burgin, Kentucky, was being torn down as I photographed, exposing the beauty of the wooden barrel storage system, known as the patented rick system, within. Other distilleries have been altered to house other industries; they now barely reveal the structure's earlier function. Athertonville grew up around the Atherton Distillery in LaRue County, a few miles from the Abraham Lincoln Boyhood Home at Knob Creek National Park. Before that, the distillery site was the location of the Old Boone Distillery. It was said that Abraham Lincoln's father worked in the distillery, which eventually went through several structural evolutions up through the 1980s. The oldest part burned in the last century, and a cooperage company operates there now. Down the road the old cistern room and a small warehouse still stand, privately owned and used for storage, and one can see the wooden walkways that edged the cistern tank's circumference. In Scott County, visible from Interstate 64, is one of the oldest brick bourbon warehouses in Kentucky, next to a stone foundation that outlines the earlier distillery. The beautiful warehouse is used as a stable now. And about five miles from the current Four Roses Distillery, overgrown in the woods and down by the creek, are the foundation ruins of the Old Joe Distillery, the oldest distillery in Anderson County. In all these cases, I photographed what I thought seemed to reveal the distilleries' earlier lives. Some of those images are included here.

Each distillery complex had its own unique presence even as it shared similar typologies of machinery, construction material, and floor plans. The distillery ruins in particular invite an imaginary conversation about existential issues of life well lived, function, death, transformation, memoir, abandonment, and art. Whereas the J. E. Pepper Distillery had the presence of space, time, and stillness, the Old Crow Distillery in Millville, Kentucky, presented more turbulent activity: deterioration, crumbling, and reclamation by nature. Texture abounded to the point of being overwhelming. Inference was needed for comprehension of the wild array of components, trash, and mechanical fragments. The light that made its way into the interior had to be mean and sharp to penetrate the dark dankness. As I photographed inside Old Crow, I experienced a sense of devastation throughout. The archaeology of the place was readily apparent. The various distilleries that had been involved in the evolution of the site from the 1800s were identifiable in the stillroom by the changes from hand-cut stone to brick to the tiles of the 1980s. In the boiler room the passage of time could be marked by different types of stokers and piping. Amazing warehouses that

used the early wooden rick system were still mostly standing, and the more modern cement-pillared warehouses were still occupied next door by another distillery. The front of the still house showed off a beautiful, round, yellow glass medallion—a testament to the tendency of distilleries in the late 1800s and early 1900s to embellish plants with architectural beauty. And, finally, there was a beautiful hand-hewn stone well house, its three chambers covered by a roof of barrel tiles and wooden lattice. Within this distillery were both horror and evidence of grandeur. I wanted my images to display both. A visit to the site about eight months later revealed that changes continued as the process of demolition moved the distillery further into archaeological remains. The photographs may show the archaeological evidence of distillery production life, but they now also present the Old Crow Distillery's afterlife in progress. Within months of my last visit, the distillery ruins were sold to entrepreneurs planning a craft distillery in the bottling house portion. I have not heard of plans for the remainder of the site, which is named after one of the most famous bourbon distillers. And so afterlife takes another turn.

The Old Taylor Distillery, just down the road from Old Crow, is an example of a distillery that was in a state of ruin, first purchased with plans to salvage materials and destroy the remains, and then miraculously purchased again, in 2014, with plans to restore it to its past glory. I photographed the site in ruins during both eras, in different seasons. The main distillery building is a flamboyant stone castle built on the Green River, located between Old Oscar Pepper Distillery/Labrot and Graham Distillery and the Old Crow Distillery. In its time it was quite an architectural showcase. The design was meant to impress, to communicate success, and to convey grand status. When I first visited in 2013, the character of this distillery complex ruin was one of absence, even yearning. As I photographed it, I felt a sense of mourning and at the same time a sort of stunned amazement at the magnificence of the place. A beautiful and grand spring, surrounded by a colonnade, sunken gardens with a natural limestone spring, pergolas, embellished windowworks and stoneworks, and even a fermenting room once used as a greenhouse, with small-paned French windows throughout its interior—all these charming elements adorned this distillery. It was a showcase for its legendary owner, E. H. Taylor, who entertained senators, bankers, and businessmen on its grounds. Even during the earlier process of being salvaged for its stone and wood, the presence of the place still retained its elegance, even if it was peeling and aged. My favorite place on the grounds is the colonnaded spring and reflecting pool. The double rows of columns that lead down to the pool, which has a metal garden ring suspended above it, and the stone benches around the pool give the effect of a Max Parrish painting. Standing in front of this onetime social gathering place is to understand the political and societal significance that bourbon played in Kentucky. Built before Prohibition, this area of the complex was meant to impress and woo politicians

toward Taylor's policies and to persuade bankers to support his ambitions. What strikes me is that art here is part of the social, economic, and political structure. Everywhere is art. How to capture the grandeur that is still evident, I wondered. The crumbling ovens are surrounded by arched windows, the geometry of the fermenting room is enhanced by its French windows, the Doric columns of the grain scales sit imposingly; the details like the springhouses, the corbels on the roofs of the buildings, the crenellation of the water tower, and, of course, the castle design of the plant's exterior all imply the designer expected the architecture to be there for posterity. Here form is integrated with function, though often form existed only for the purpose of pleasure. Yes, once there were production activities, busy machinery, workers traveling the wire catwalks, heat, noise, and all the functions of distilling. But above all, beauty embellished function. This distillery stirred the imagination.

T. W. Samuels Distillery, abandoned, repurposed, reabandoned, but tended carefully throughout time, was a place of beautiful absence and a gentle movement within. Even as nature reclaimed the boiler room through open sky and humans reclaimed the machinery of the stillroom through its dismantling, the plant has retained an almost stage-set quality, which allows historical and architectural vision to be projected onto it. The layout of this distillery was different from those of other complexes, as it was designed along the railroad line for maximized efficiency. Designed after Prohibition by Leslie Samuels and his son Bill, an engineer, the structure was built to function as a machine itself. More utilitarian and efficient and without the architectural embellishments of Taylor's distillery, T. W. Samuels Distillery was clean-lined inside and out. The exterior afforded opportunities for geometric abstraction in the photographs, inviting playfulness. There were two interior areas that were unique for understanding the archaeology of the bourbon distillery. The first area was the engine room, which still contained steam engines and machinery from very early post-Prohibition times. The colors and designs of the huge, belt-driven engines go beyond functional to embody an aesthetic that no longer exists in manufacturing, evidenced by the curve of a belt-drive cover that is reminiscent of art deco. The second area was the bottling operation, which remains relatively intact owing to the repurposing of the plant at one time for bottling the distillery's springwater. Again, the aesthetic of movement, design, and embellishment enhances the functionality of the area, here without aggrandizing and in the service of efficient performance. This distillery plant, much like the J. E. Pepper plant, evoked art throughout, by means of individual and compositional pieces.

The historical areas of currently operating NHL/NRHP distilleries that I photographed stirred a sense of the past moving forward, living history rather than time stopped. An evolved presence rather than absence prevailed. Much as

archaeologists rely on present structures to understand those of the past, these distilleries informed my vision of the abandoned or repurposed distilleries. In these distilleries occupation and reoccupation continued.

Within the George T. Stagg Distillery is the earlier O.F.C. Distillery, and both were within the post-Prohibition Blanton Distillery, which was then absorbed into the currently occupied distillery complex, Buffalo Trace, in Frankfort, Kentucky. The George T. Stagg Distillery is part of the recently awarded NHL designation to Buffalo Trace for the completeness of the historical complex and the evidence of continued distillery evolution. Here, because of ongoing occupation, is an intact, well-maintained representation of machinery and procedures from the 1930s and 1940s. Past and present cross paths, deciphering remains and pointing toward modernity. With unfettered access to the historical distillery and to workers who had operated the old works and then the new technology, I explored and excavated with my camera. Because Stagg exists inside a currently operating distillery, the vibrancy, heat, and activity only imagined in the ruins of other complexes came alive. As I photographed Stagg Distillery, many of the mysteries of my visits to Pepper, Samuels, and Old Crow distilleries were clarified. There were also areas of the distillery where a quiet history prevailed. Old hoppers, grinders, ovens with decorative brickwork, grain chutes, and no-longer-used dials stand sentinel over the newer operations. Here seemed a multigenerational operation that valued its aging and aged through preservation. A living history of machinery and structure revealed what had only been inferred in distillery ruins and is no longer on-site in other operating distilleries.

Old Oscar Pepper Distillery was reoccupied by Labrot and Graham Distillery, which is now itself reoccupied by Woodford Reserve Distillery. This too is NHL-designated. The historical areas are its architecture and external structures rather than machinery and internal processes. A simple distillery, set up with fermenting vats, three copper stills, and one mash tub, evokes the simplicity of pre-Prohibition small-scale distilling, although it is all contemporary operations. The need to infer has been removed, replaced with a preservation reenactment that allows visitors to experience rather than imagine. The stone warehouses and the long barrel runs from the past are still in use. The old dry house, cistern houses, and weigh houses are preserved and open to the public, repurposed for present-day distillery use. Still, out in the woods are the stone steps, covered with plants, leading to the old log house of Oscar Pepper, and the original spring spills forth on the other side of the creek. If one looks with the archaeologist's eye, one can see the springhouse that gave the stream its name, Grassy Spring, keeping its green moss and vegetation year-round. Preserved here is not so much an afterlife, but an interpretation that keeps the original natural site active and alive with purpose.

The Old Joe Distillery of the 1700s, now a stone foundation ruin overgrown by woodland, was moved down the road to become the Old Prentice Distillery, later reoccupied by Four Roses Distillery. Recently, some warehouses have been reoccupied by Wild Turkey Distillery. The internal space of the central building is unchanged; its fermenting room is divided from the distilling area, but all old internal operations have been replaced. It is the external structure of the central building, a unique Spanish-style design, that qualified the distillery for National Historic Register designation. Around the property are the original post-Prohibition building sites of the springhouse, bottling house, cistern house, government building, and office house, no longer in use or accessible. Near the distillery's perimeter are the building shells of an earlier distillery, Bonds Mill Distillery, run by waterwheel during its day. That distillery was never part of Old Prentice or Four Roses, but it used the same water source. Inside the Old Prentice Distillery, it is the geometry of the scaffolding that beckons the artist's eye. The ceiling scaffolding repeats ceiling patterns I have seen at the T. W. Samuels plant. It was the fermenting room, however, that triggered the archaeological imagination. Although new, the tubs are crafted of redwood and cypress, as the original tubs would have been. As I walked around the floor among the huge tubs, I felt the sense of pattern that would always have been in this room.

The same Samuels family that built T. W. Samuels purchased the old Burks' Spring Distillery in the late 1940s and began operating Maker's Mark Distillery with a special sensitivity to the history of the Burks' site. Preservation of as much original 1880s design and structure as possible is evidenced in every part of the distillery. Even the copper stills are modeled in size and shape after the original copper still of the 1800s. The family houses of both the Burkses and the Samuelses are close to the distillery and accessible rather than remote, which is not the case at so many other sites. This proximity reveals a sense of Kentucky distilling as a family business. Although continuing an earlier emphasis on designing the distillery with an engineer's perspective on function, the present-day Samuels family has brought back artistic embellishment. A visitor center constructed by Bill Samuels Jr. blends an innovative art deco interior within an original 1800s warehouse, preserving both pre- and post-Prohibition styles. Rob Samuels commissioned an amazing glass installation by the internationally recognized artist Dale Chihuly, a thirty-six-foot-long ceiling between stacked rows of barrels of aging whiskey, between the visitor's center and a tasting room. Photographing in the original Burks' Spring Distillery, full of wooden patinas (wooden grain bins, beautiful light on wooden floors, and the old worn cypress fermenting tubs), felt much like being in a pre-Prohibition distillery. The well-worn wooden ladders exposed the steps of two hundred years of workers climbing up and down the grain bins, the whitewashed stone walls revealed the opening of the original waterwheel millstone, and the original still had

just been removed from the barn for cleaning, its absence present in the stills reproduced from its shape. The atmosphere in the old Burks' Spring Distillery felt frontierlike, felt familial, and felt intimate.

To fully understand the complex spaces of an industrial site, the archaeologist must understand all its components, such as the technological processes, materials, innovations over time, connections to related industries, landscape, history, and the social life of the people who worked in these spaces. The industrial space is a repository for societal memories; what is left behind is memoir. The distilling industry of Kentucky has been a major economic force for the state since its beginnings. The bourbon industry in particular is a Kentucky trademark, and it is strongly tied to Kentucky's identity. With all that has been written about the history of the industry, the distillers, the labels, the owners, the politics, and the economics, the distillery complexes themselves have received attention mostly for things other than their architecture and operations. As I expanded my photographic documentation of the industrial distillery plants' histories in Kentucky, I came to know and understand this identity and its historical components through the visual details. As I stood in a distillery ruin, looking at huge concrete blocks in a beautiful pattern, my understanding of current distilling allowed me to infer what had once stood there. But it was conversations with folks who lived near, or who had once visited sites no longer in existence, with people working in the industry as historians, administrators, and line workers, that brought this book into being. Everyone I had the opportunity to talk with about this project was generous with time, information, and enthusiasm. I was guided through currently operating sites by people whose ancestors and families had owned and worked in distilleries, those whose careers had been spent in distilling, people with amazing anecdotes, and all with a deep love of the distilling industry. The distillery plant, I realized, is the dwelling space of the amber liquid and the amazing people and culture of Kentucky bourbon. May the images in this book stir an interest in this little-documented aspect of Kentucky's bourbon distilling history.

Cheers!

Carol Peachee, 2015

NOTE

1. Kitty Hauser, quoted in Frederick N. Bohrer, *Photography and Archaeology* (London: Reaktion Books, 2011), 8.

THE BIRTH OF BOURBON

It is true that photography is a witness,

but a witness of something that is no more.

—ROLAND BARTHES

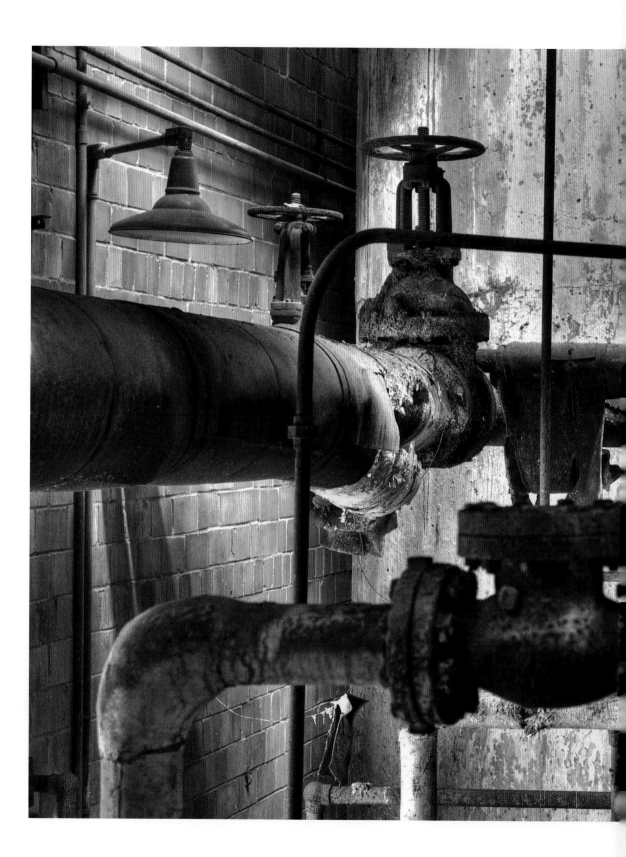

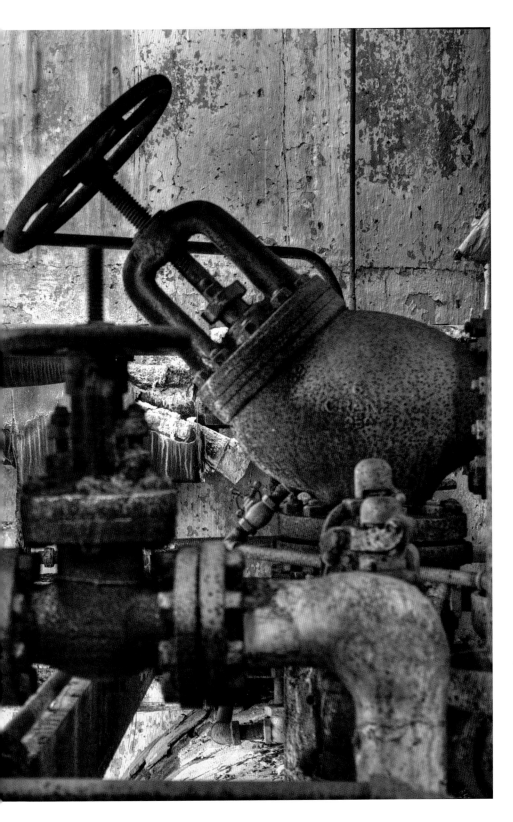

Knobs and pipes,
J. E. Pepper Distillery,
Lexington. Throughout all
the distilleries I photographed
there were hundreds of knobs,
pipes, valves, and sockets.
Although these elements
seem trivial, they control the
production flow within the
distilleries.

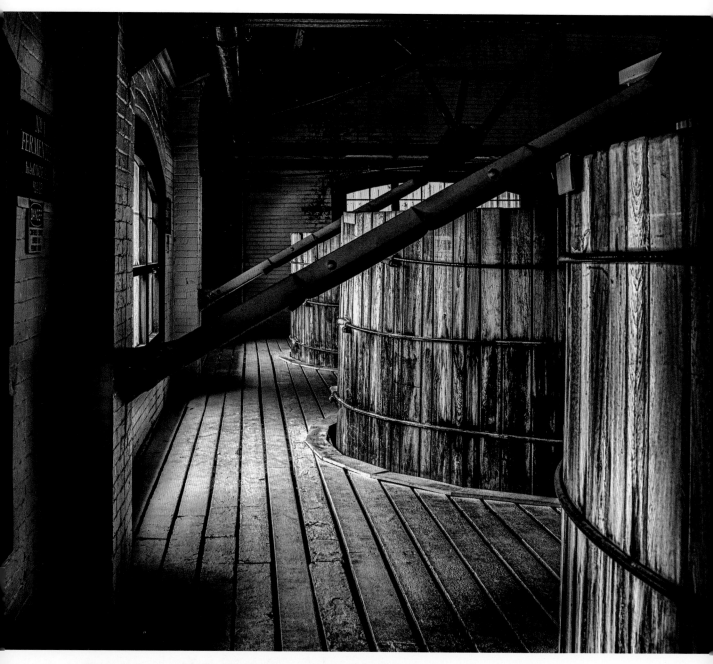

Fermenting room, Old Prentice Distillery, Anderson County.
Inside the Old Prentice Distillery there were basically two rooms:
the fermenting room and the stillroom. Later, bottling and offices were
located in other buildings. The fermenting room in the NRHP area
of Old Prentice still uses cypress tubs.

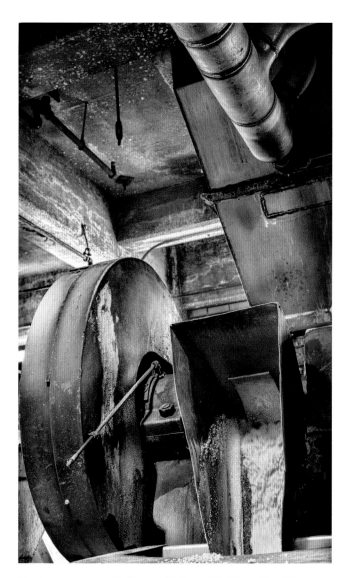

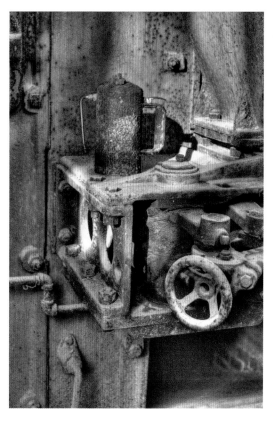

Oilcan on stoker, J. E. Pepper Distillery, Lexington. As I photographed the distilleries, I would run across relics that seemed more personal, sitting there as though they had just been left.

Dry house press mill, George T. Stagg Distillery, Frankfort. The spent grain from the bourbon stilling is converted to food for cattle and livestock in both modern and historical distilleries. This 1930s press is one of five original presses left in the country, three of which are still in use in the conversion process at Buffalo Trace.

Fermenting tubs, Burks' Spring Distillery, Loretto. After grains are cleaned, weighed, and mixed according to the particular recipe, or mash bill, they are ground and cooked. The mash is then cooled and added, along with yeast, to fermenting tubs to create a fermented grain beer. These fermenting tubs of cypress and related woods were the types used in early distilling. Later distilleries replaced the wooden tanks with metal tanks that were easier to clean.

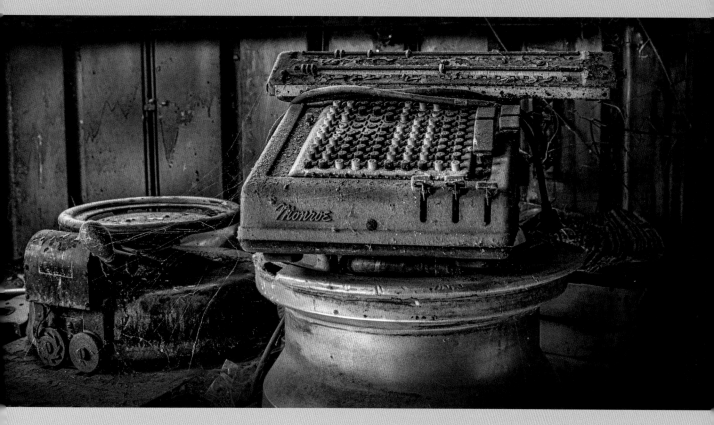

Adding machine, T. W. Samuels Distillery, Deatsville. This old adding machine would have been essential in the office area.

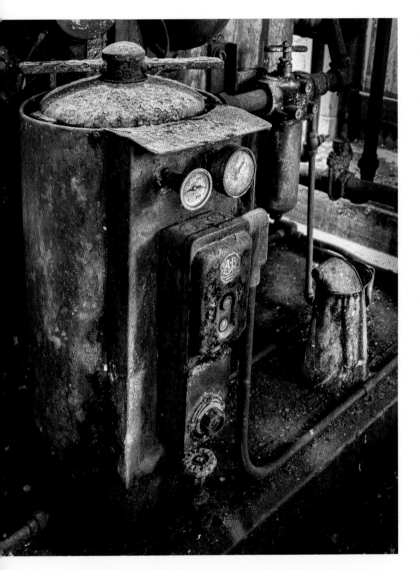

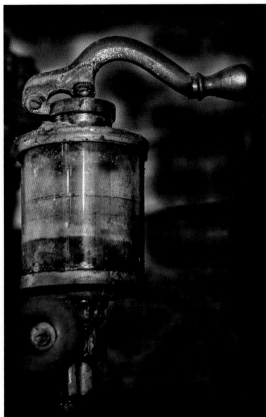

Brass crank, T. W. Samuels Distillery, Deatsville. The Samuels distillery used steam along with other types of energy to power the plant. Located at the top of several of the steam engines in the machine room, these containers seemed to still hold oil or lubricant.

Engine room machine, T. W. Samuels Distillery, Deatsville. A variety of types of engines and machinery were used to run the distillery, many that also ran other industrial complexes of the early 1900s. In this image one of those engines has been left with a pitcher beside it, inviting us to infer that, like an old radiator, the engine might have needed water.

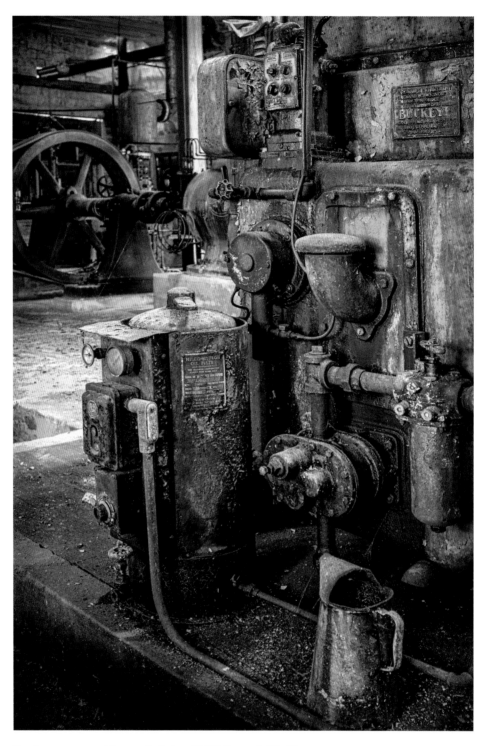

Engine room machine and pitcher, T. W. Samuels Distillery, Deatsville. The Samuels Distillery, like the Pepper Distillery, had relics like this old pitcher lying around that give us insight into the types of smaller auxiliary equipment that was used.

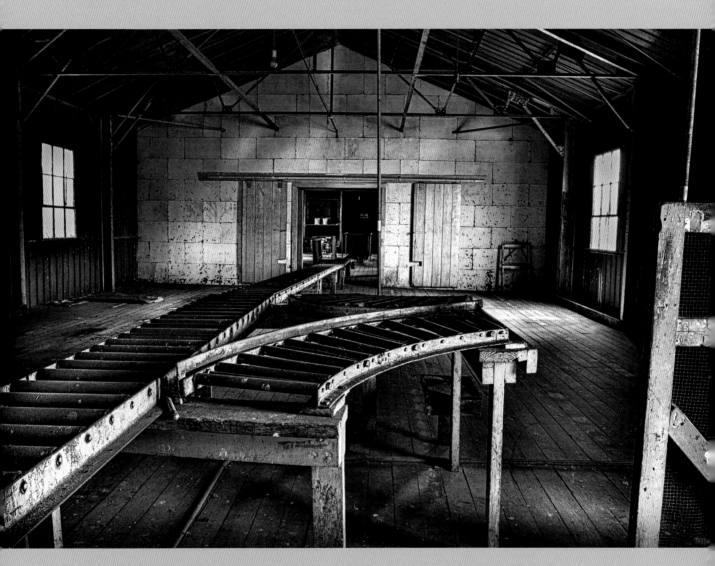

Bottling room line, T. W. Samuels Distillery, Deatsville. The bottling process is one of the last steps to be completed before the bourbon is shipped out for consumption. Although no longer connected, these parts of the bottling house conveyer stand ready to resume.

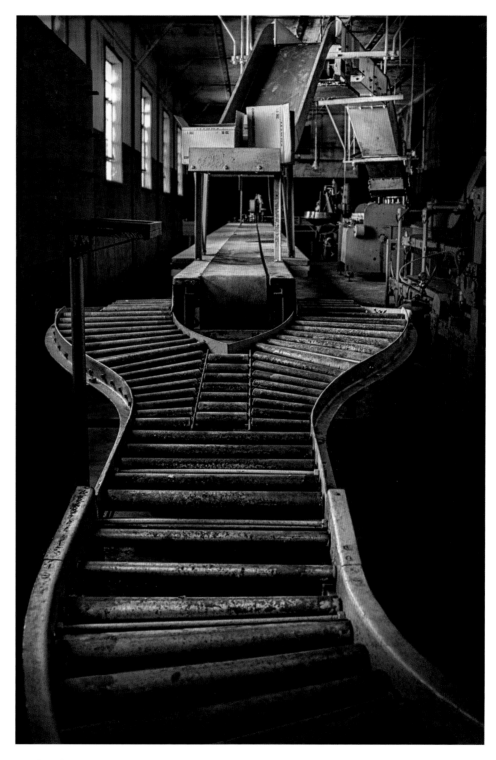

Bottling line split, T. W. Samuels Distillery, Deatsville. The split lines might convey
boxes on one side and bottles on the other, which then come together efficiently.

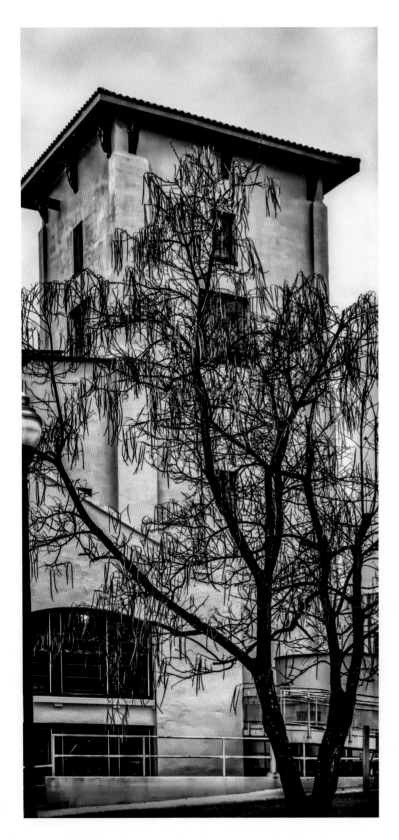

Old Prentice Tower, Old Prentice Distillery, Anderson County. Old Prentice is the best example of Spanish Mission architecture in Kentucky. It was designed by the Frankfort-based architect Leo Oberwarth.

OPPOSITE: Springhouse, Burks' Spring Distillery, Loretto. Fresh, high-quality water is a key ingredient for making bourbon, and Kentucky's limestone-filtered springwater is ideal. The original spring for the distillery and a gristmill was covered by this building, built circa 1800.

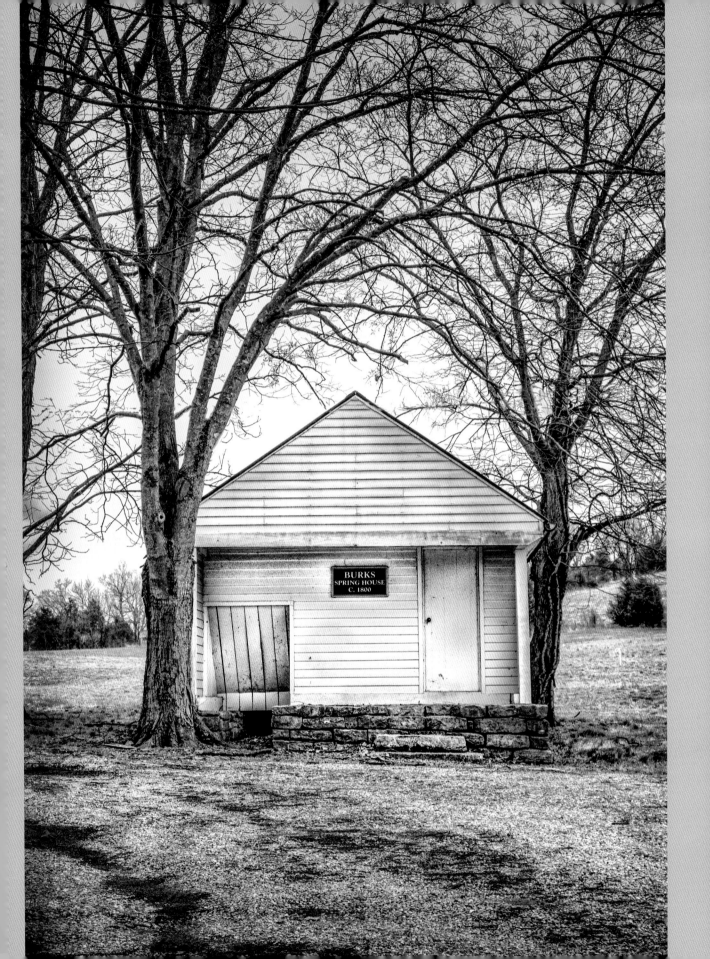

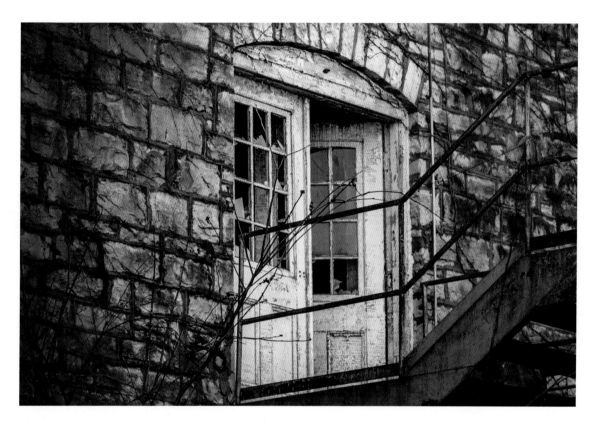

Side door, Old Taylor Distillery, Woodford
County. These steps lead from the fermenting
room of the castellated distillery to the yeast lab
and offices in the brick turretlike building next
to the still and engine house.

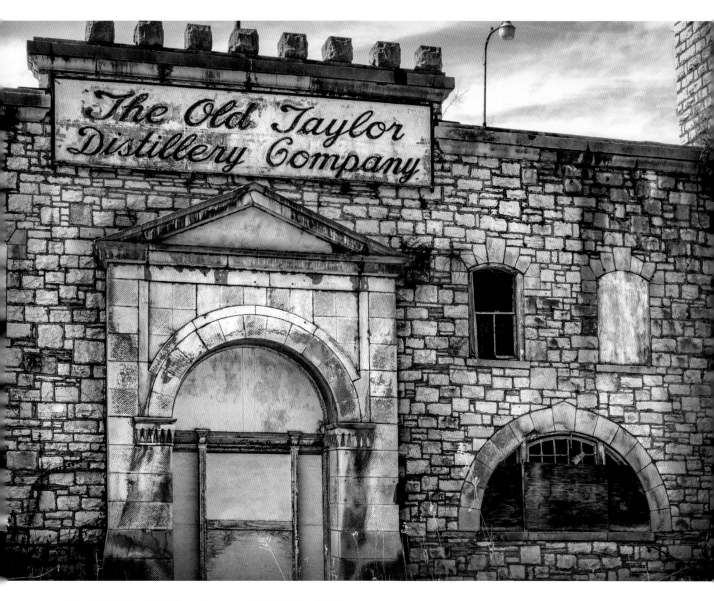

"The Old Taylor Distillery Company," Old Taylor Distillery, Woodford County. The front of the Taylor distillery shows the arched stone windows and crenellation that give it the appearance of a castle. Colonel E. H. Taylor's trademark was architectural embellishments meant to convey confidence and success.

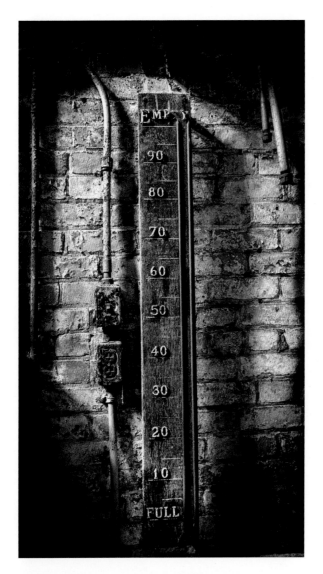

Empty/full gauge, Old Taylor Distillery,
Woodford County. This is a close-up of an old scale
that measured the fullness of now absent
adjoining tanks in the still house.

OPPOSITE: Oven bricks against an oven room window, Old Taylor
Distillery, Woodford County. This brick building adjoining the
distillery held the massive ovens that powered the plant. Here an
early evening sun lights up the crumbling oven walls, contributing
to a romanticism that the architect of the late-nineteenth-century
arched windows might have approved of.

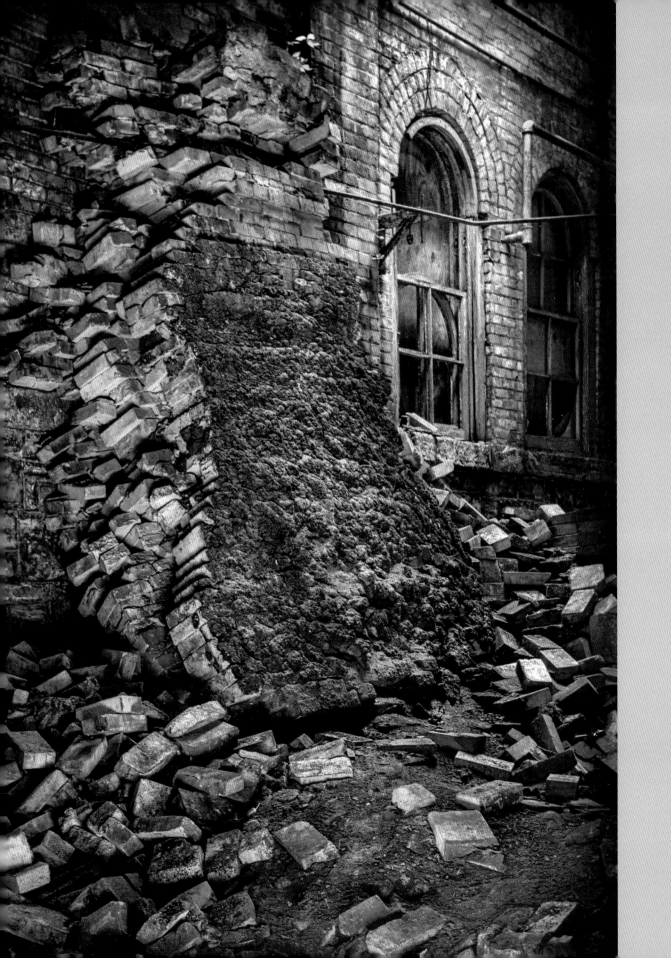

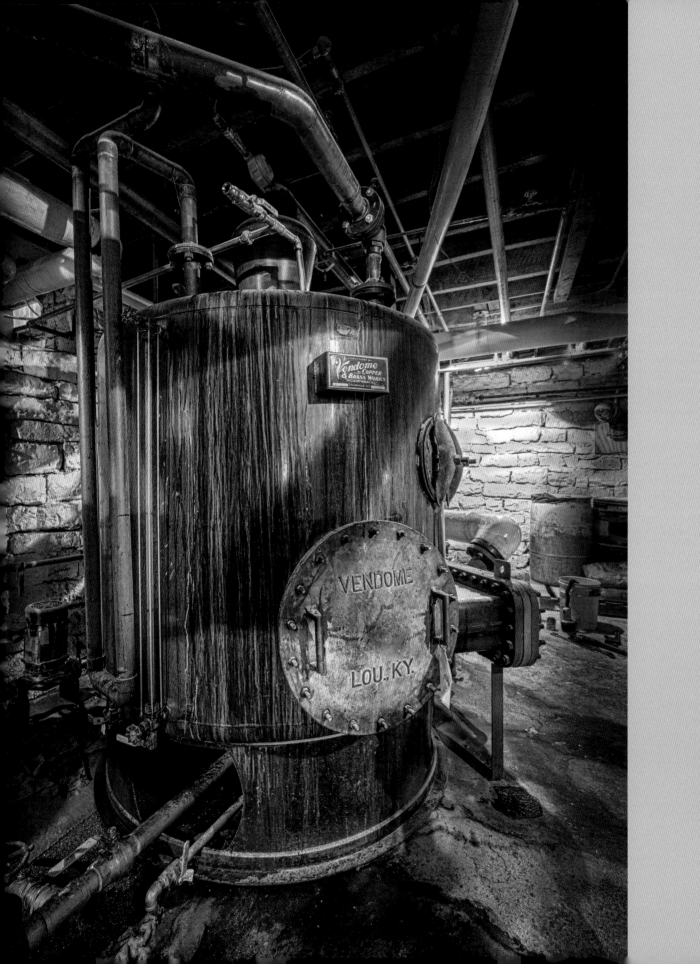

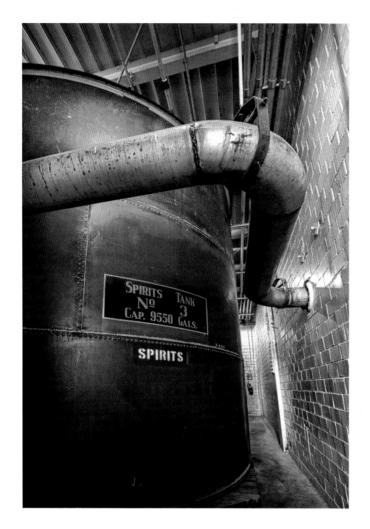

Spirits tank, George T. Stagg Distillery,
Frankfort. An original copper tank from
the Stagg Distillery continues to reside
in the present-day still house.

OPPOSITE: Still I, Burks' Spring Distillery, Loretto. Still design
has evolved from simple pots to the massive tanks and columns
seen in today's distilling processes. In some instances both the
pot and the column stills are used. Two stills in the basement
of the still house, the original foundation of Burks' Mill of
1805, are replicas of stills used by the Samuels family in its early
distilling days.

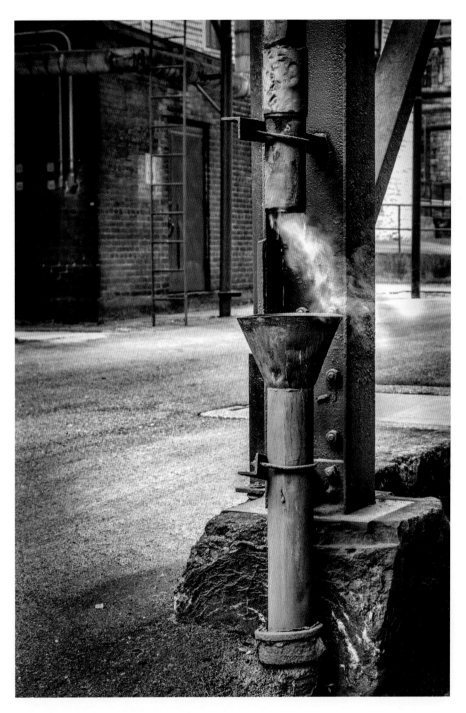

Steam funnel, George T. Stagg Distillery, Frankfort.
The steam from the boiler room went through this pipe to
alleviate pressure. Steam was funneled underground during
production, but it was allowed to ventilate above ground
during downtimes.

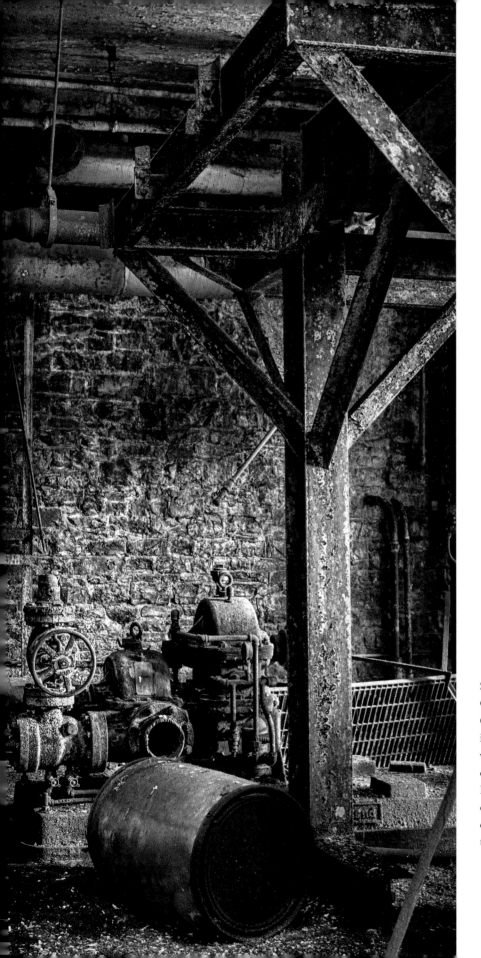

Stillroom pillar and engine, Old Crow Distillery, Woodford County. There are old stone walls in the background as well as the wooden pillars from the 1835 distillery here in the still house. Most distillery ruins show the evolution of building materials, as existing buildings were added on to and repurposed over time.

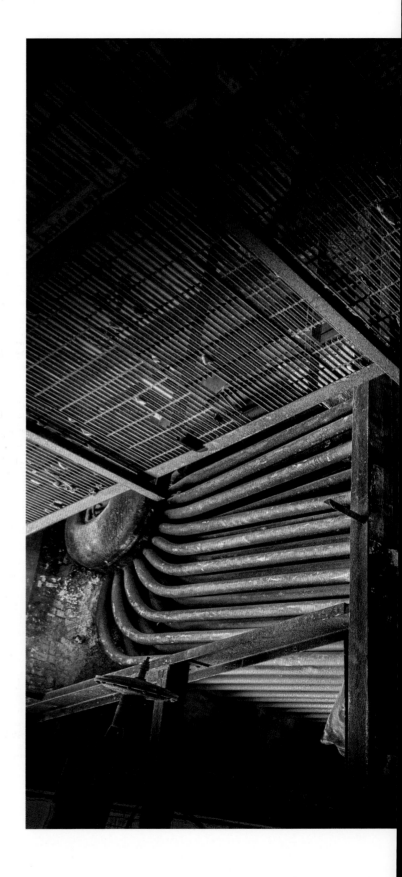

Exposed boiler oven pipes,
J. E. Pepper Distillery, Lexington.
The piping of the boiler ovens that
powered the plant was revealed in
2013, when the bricks around the
ovens were removed during demolition.

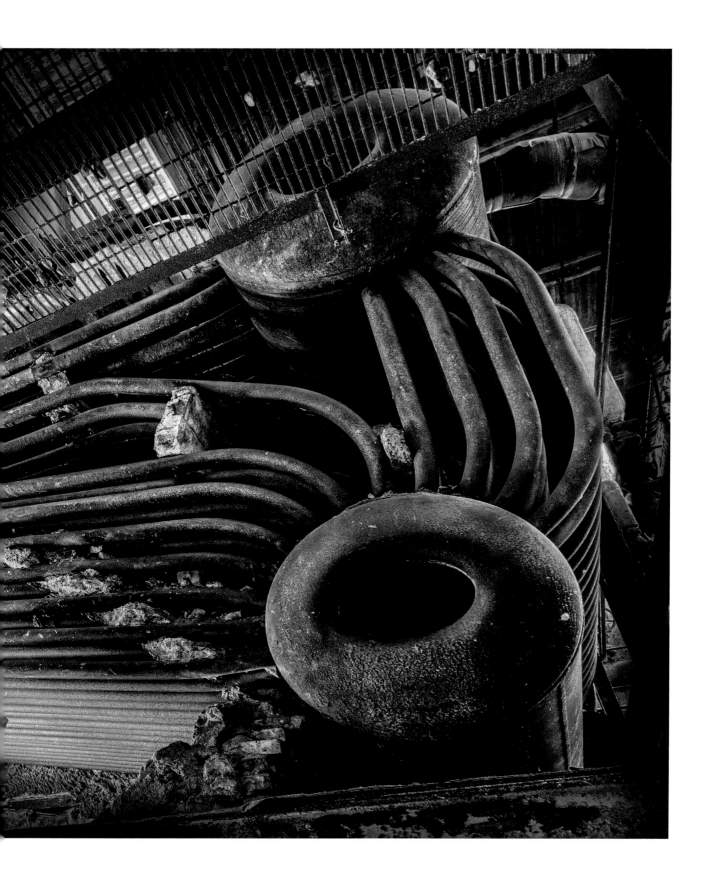

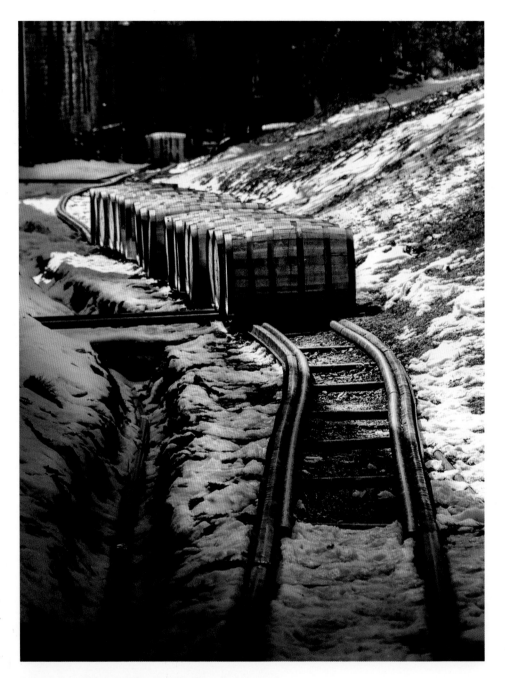

Barrel run, Old Oscar Pepper Distillery/Labrot and
Graham Distillery, Woodford County. The historical
post-Prohibition elevated barrel runs snake throughout
this distillery. Though barrel runs are common in all old
distilleries, the Old Oscar Pepper runs are famous for
their use of gravity and physics to move the heavy barrels,
and they are still in use today.

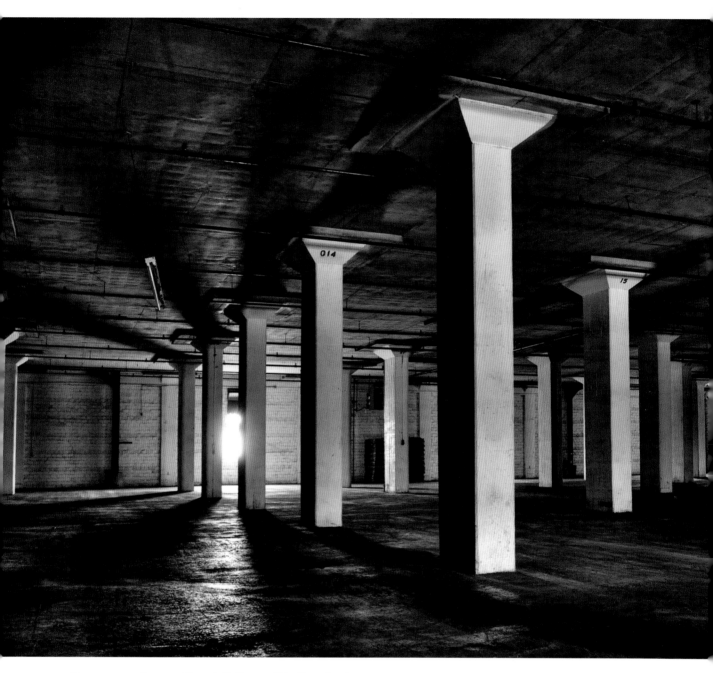

Concrete warehouse pillars, J. E. Pepper Distillery, Lexington.
The warehouse at Pepper did not use the wooden rick system
for storing bourbon barrels that had been popular before
Prohibition, but instead used concrete flooring and pillars.
Racks would have been stacked between pillars. Concrete was
more fireproof than wood, and the pillars were an efficient
way of supporting floors above.

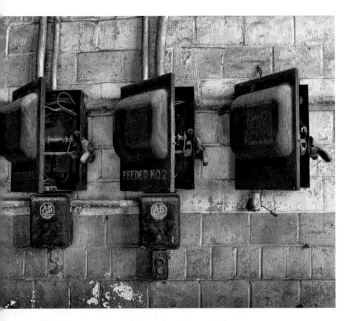

Three feeder meters, J. E. Pepper Distillery, Lexington. Meters of all types measured everything from electric flow to bourbon flow, which made them a significant element in controlling the flow of the distilling process. These meters controlled grain feeders.

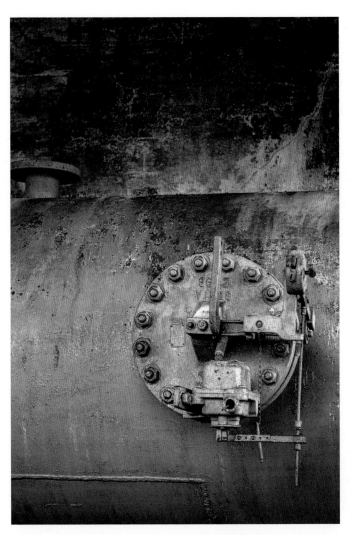

Dry room tank valve, George T. Stagg Distillery, Frankfort. During World War II, production of drinking alcohol was slowed and converted to manufacture of alcohol that was used to make rubber, gaskets, and whiskey for soldiers. The old mash and spent grains were then dried out and converted to livestock feed.

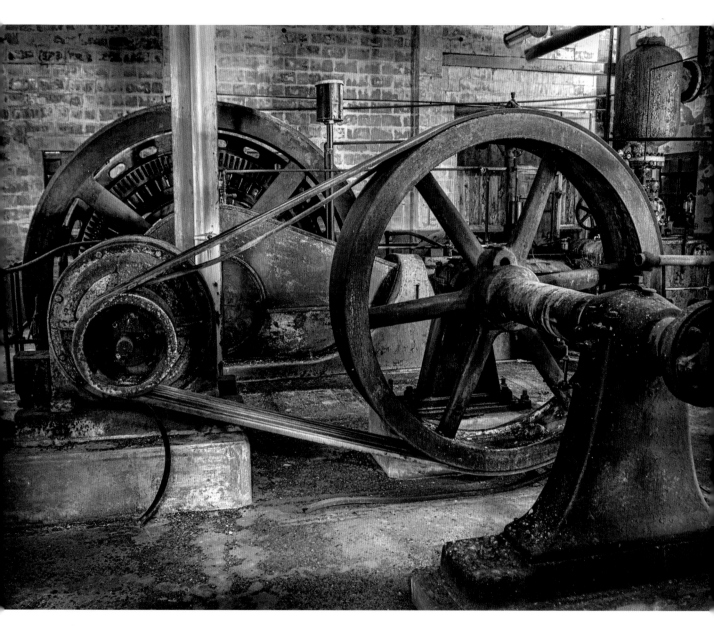

Steam engine wheels, T. W. Samuels Distillery, Deatsville. It is rare
to find any remains of steam-driven power engines still in place.
The Samuels Distillery was the only distillery where I saw belt-driven
steam engines complete with wheel, belts, and accessories.

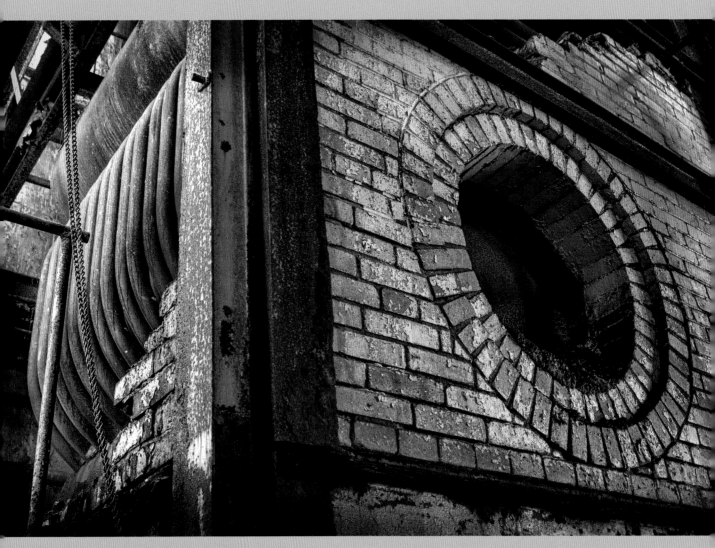

Green oven, J. E. Pepper Distillery, Lexington.
Beautiful brick surrounds the boiler ovens at Pepper,
unusual for post-Prohibition industrial design.

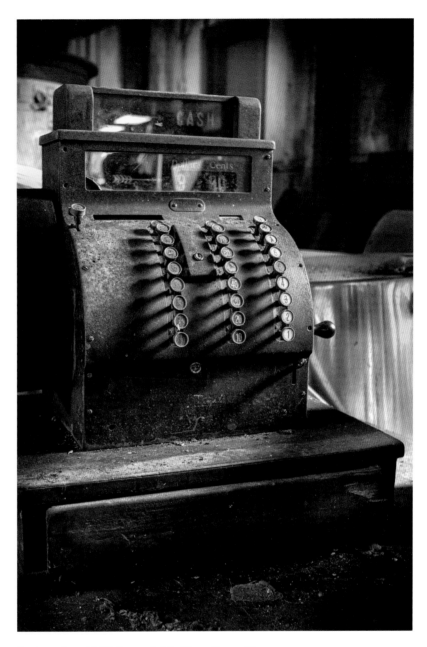

Cash register, T. W. Samuels Distillery, Deatsville.
An artifact from the business of early-twentieth-century
bourbon sales still sits in storage at Samuels.

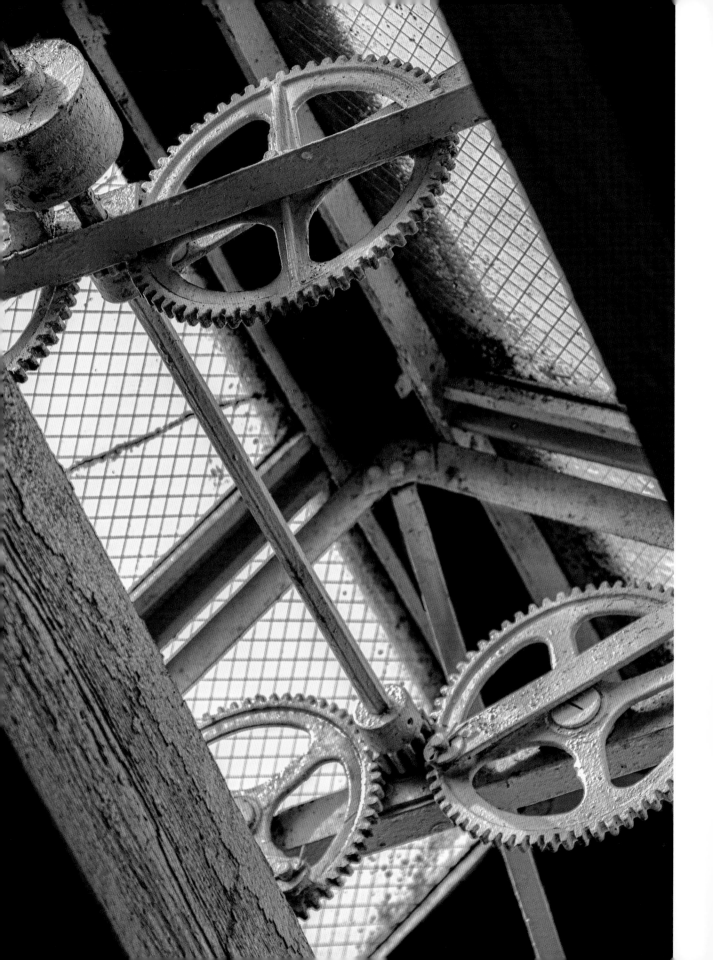

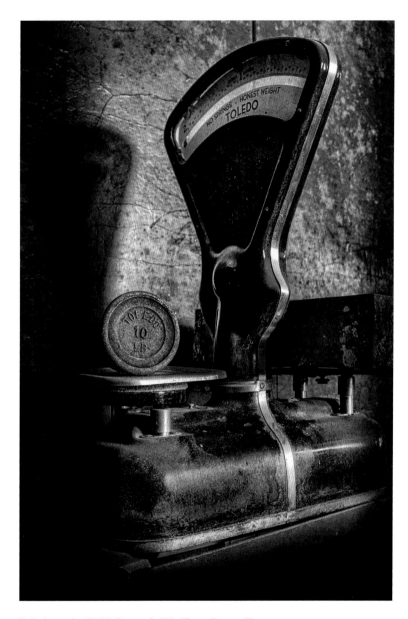

Toledo scale, T. W. Samuels Distillery, Deatsville.
A variety of scales were left behind in the abandoned
ruins. This one is in good condition.

OPPOSITE: Fermenting house window gears,
Old Oscar Pepper Distillery/Labrot and Graham
Distillery, Woodford County. Installed during a
post-Prohibition updating, these gears controlled
temperature by adjusting ventilation in the
fermenting house ceiling.

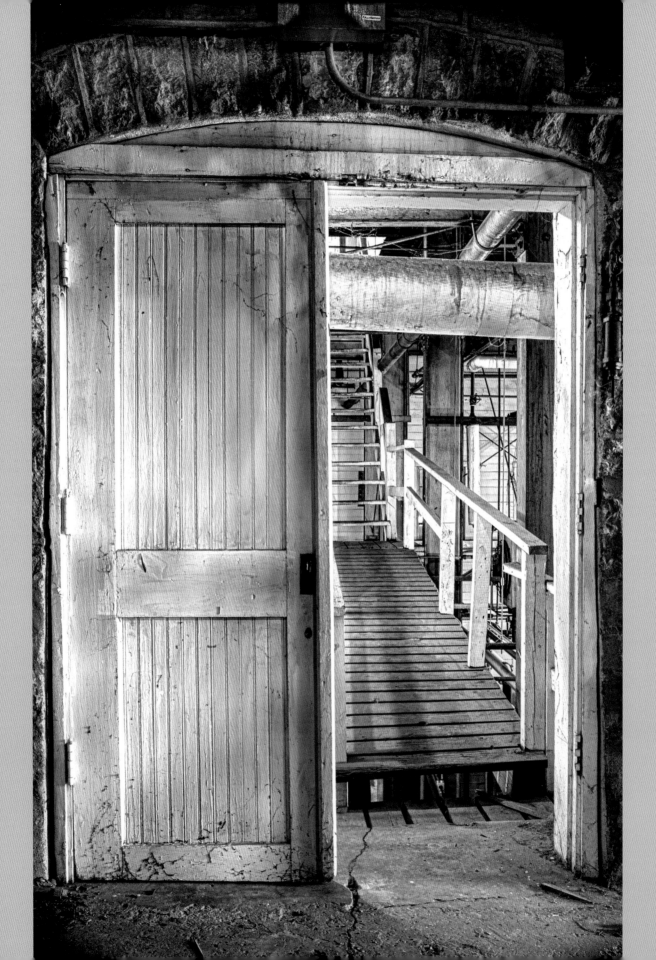

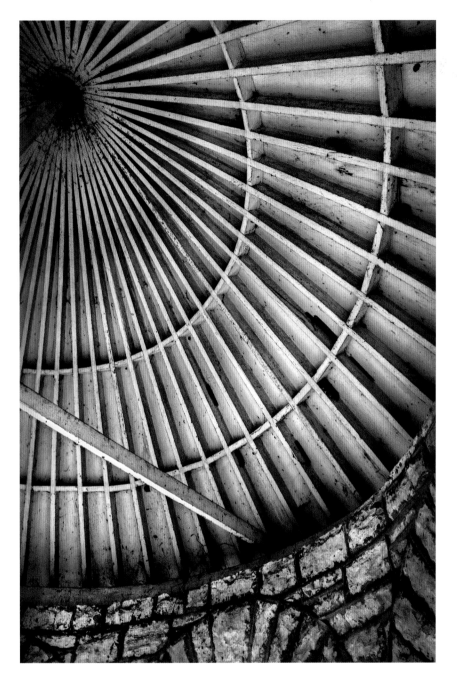

Pump house ceiling, Old Taylor Distillery, Woodford County. The ceiling
of the pump house is meticulously handcrafted in a style similar to that of the
colonnaded springhouse pergola, its conical shape sitting atop limestone.

OPPOSITE: White door and walkway, George T. Stagg Distillery, Frankfort.
The hand-cut stonework walls and the wooden walkways still exist in the
original part of the O.F.C. Distillery, now called the Dickel Building,
later absorbed by George T. Stagg Distillery.

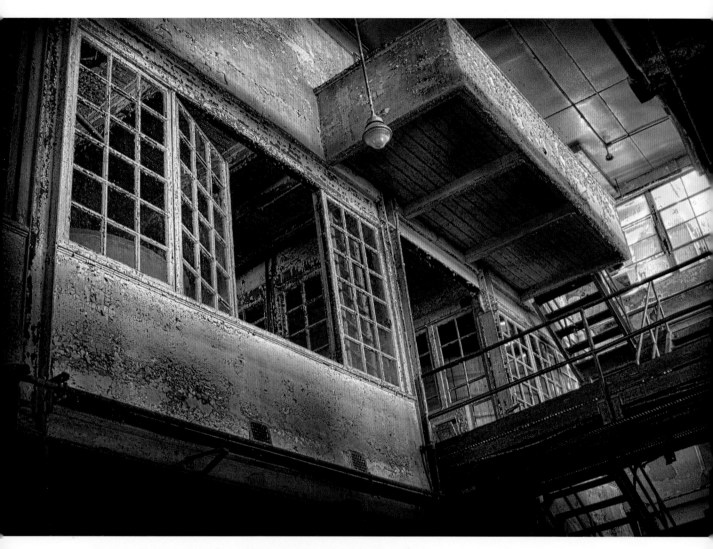

Fermenting room French windows, Old Taylor Distillery, Woodford County. Looking up from the level of the fermenting vats, one can see the windowed rooms from which visitors observed the bins, engines, and fermenting processes in Taylor's time.

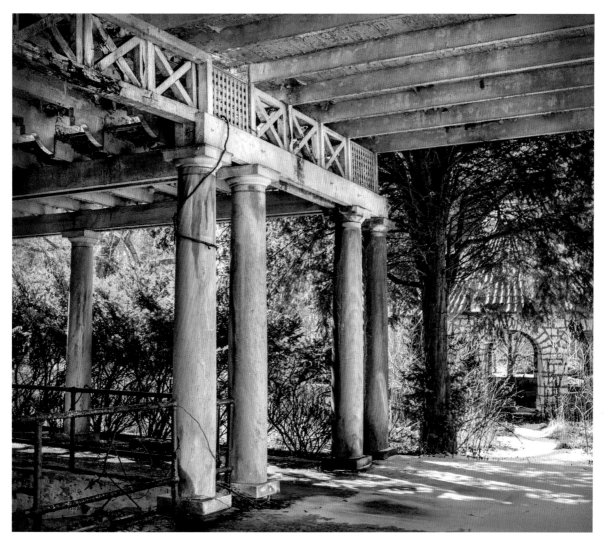

Promenade and pump house, Old Taylor Distillery,
Woodford County. The entrance to the spring colonnade
is adjacent to the pump house pergola, which draws water
from Glenn's Creek to power the distillery.

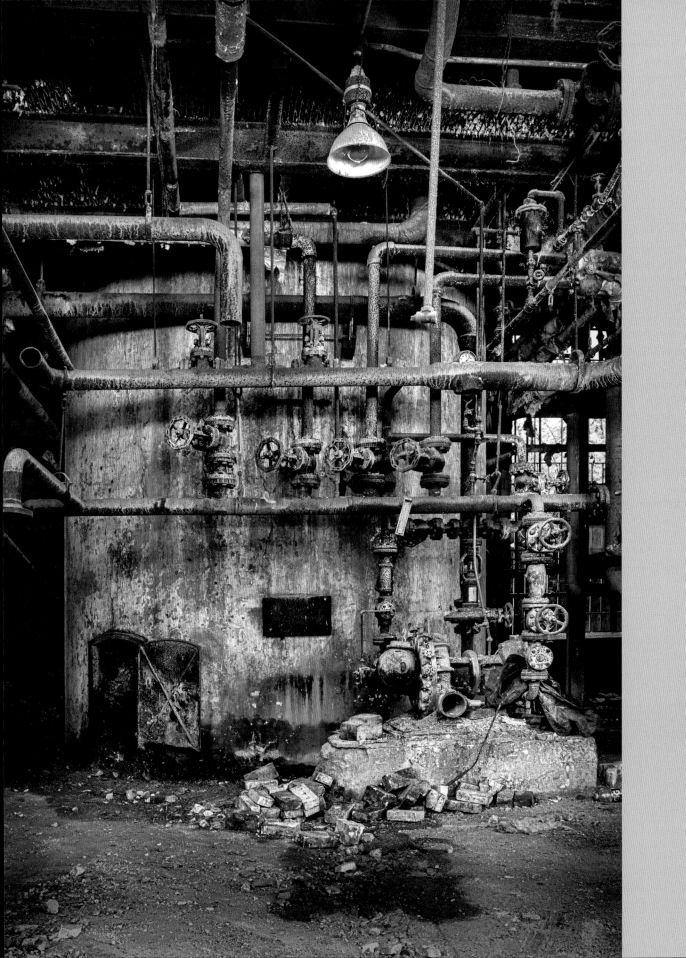

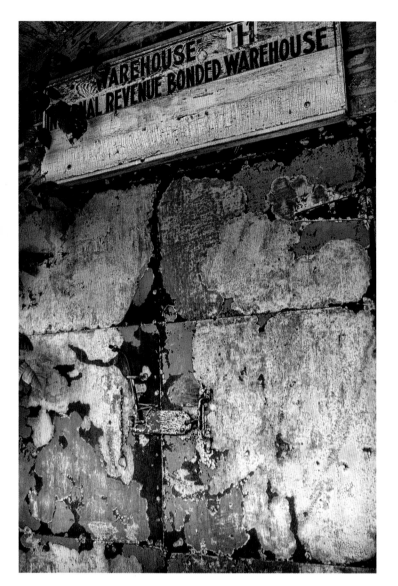

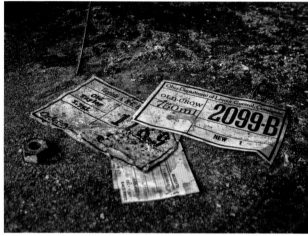

Bottle labels, Old Taylor Distillery, Woodford County. These loose labels are just some of the labels that lie around in the government building, where federal agents oversaw shipping of bottled-in-bond bourbon. The post-repeal laws that required the whiskey to be bottled in bond with federal stamps had been promoted by Taylor himself at the end of the nineteenth century.

Warehouse H and Internal Revenue building, Atherton Distillery, Athertonville. Down the road from the main distillery are several buildings once a part of the distillery complex and now in the hands of separate owners. Warehouse H joins the old cistern room in a single structure, currently used for storage.

OPPOSITE: Oven smokestack and pipes, J. E. Pepper Distillery, Lexington. The tall smokestack visible on the outside of the works originated here in the boiler room, between two sets of boiler ovens.

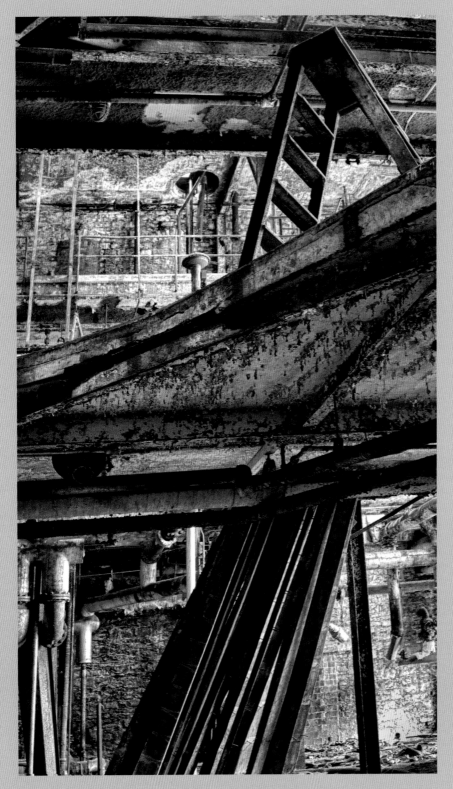

Stillroom stepladder, Old Crow Distillery, Woodford County.
A view through an opening that once surrounded a cylindrical tub
exposes two floors of the stillroom.

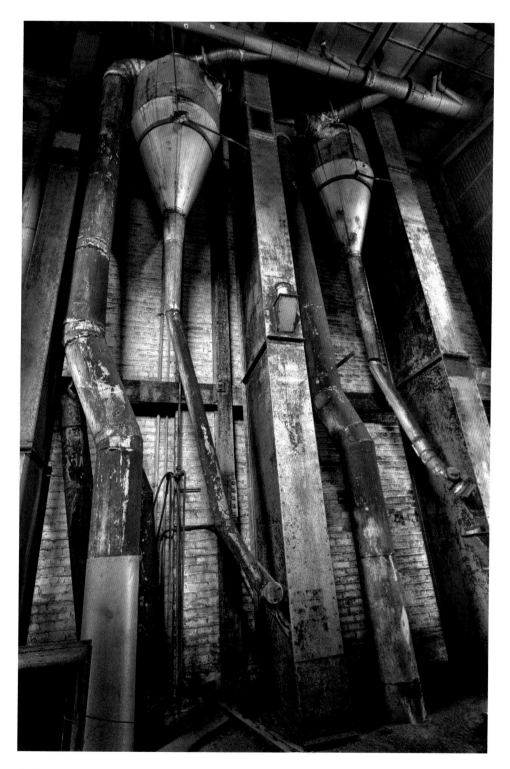

Grain house chutes, Old Crow Distillery, Woodford County.
Bins and chutes in the grain elevator building dangle, disconnected
from the original grain hoppers that once existed below them.

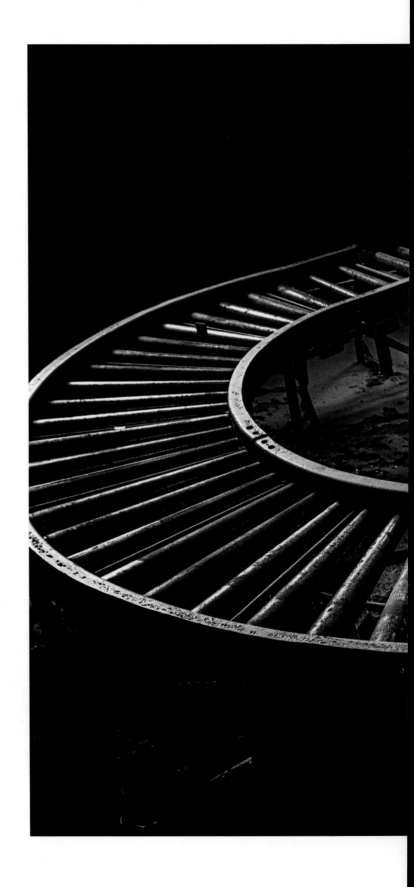

Bottling line loop, T. W. Samuels Distillery, Deatsville. The bottling room conveyer looped at the end of the room and doubled back, which allowed more workers to position themselves along it.

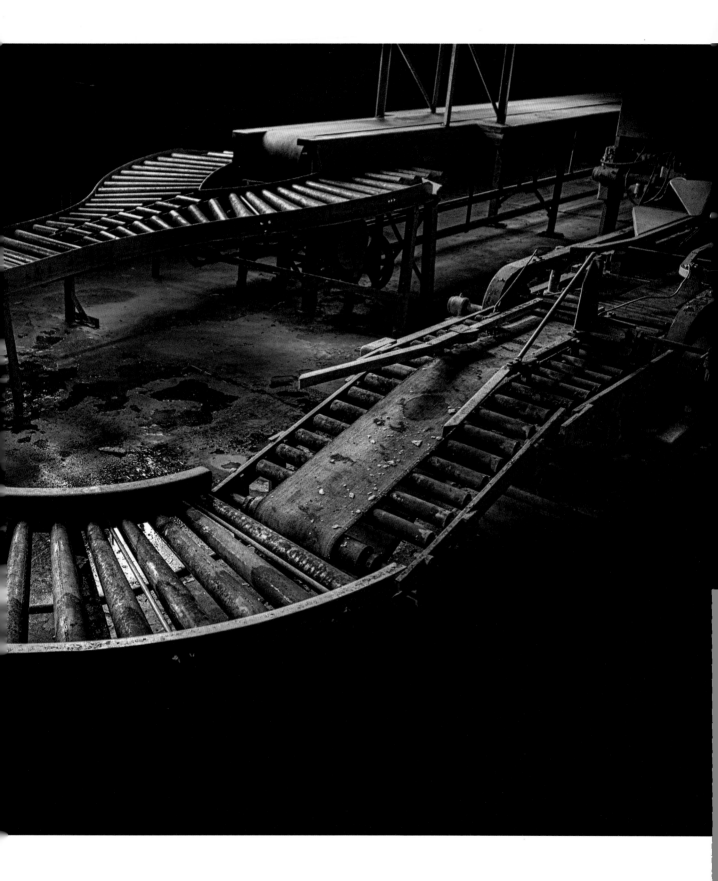

Drop tank dial, Old Taylor Distillery, Woodford County. Mash goes from the cooker into a drop tank where it is held before going into the fermenters. This dial was attached to the drop tanks in the fermenting room.

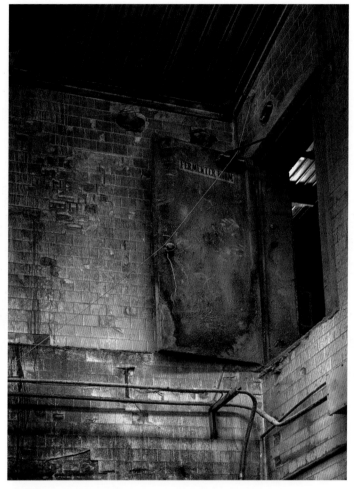

Fermenting room door, Atherton Distillery, Athertonville. The interior of the distillery was stripped of equipment and even its floors when the space was repurposed. This door to the fermenting room would have opened onto walkways circling the fermenting tanks, perhaps like those in the old cistern room, possibly wooden but more probably metal.

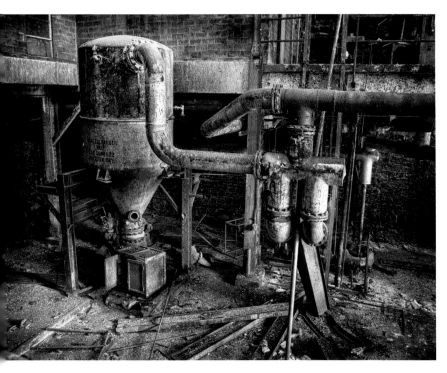

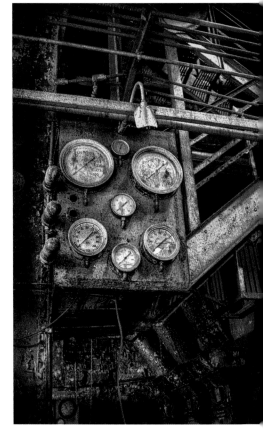

Heat exchanger, Old Crow Distillery, Woodford County. Although the main stillroom is mostly dismantled, this large heat exchanger remains attached to pipes and valves. Mash tubs and beer stills would have been located around the perimeter of the stillroom.

Engine room dials, Old Crow Distillery, Woodford County. These dials in the engine room seem frozen in time, registering information about the pressures and temperatures of the coal engines powering the plant.

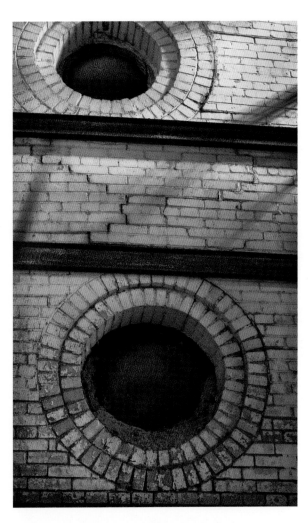

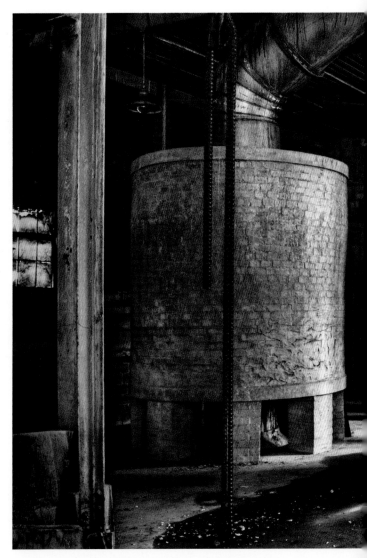

Two green brick ovens, J. E. Pepper Distillery, Lexington. Wrapped around huge steam pipes, these green bricks formed the ovens in the boiler room. These two enormous ovens, along with the tall brick chimney, occupied this room.

Two pink kilns, J. E. Pepper Distillery, Lexington. These brick kilns were upstairs in the dry room, and their function can only be inferred; they were perhaps used instead of mill presses to extract moisture from spent grain before converting it to feed.

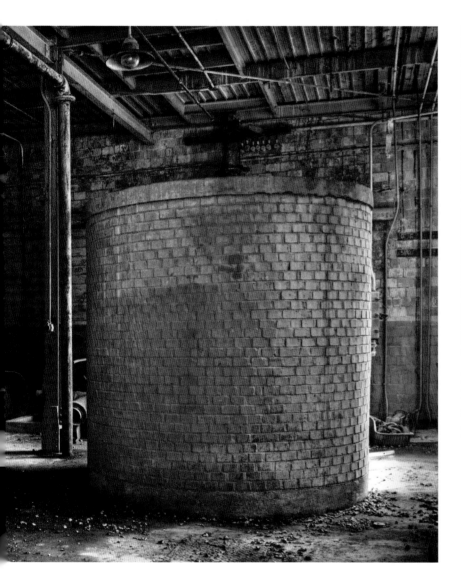

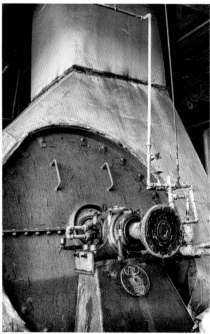

PD oven, George T. Stagg Distillery, Frankfort. No longer used, this oven in the power house remains for preservation reasons.

 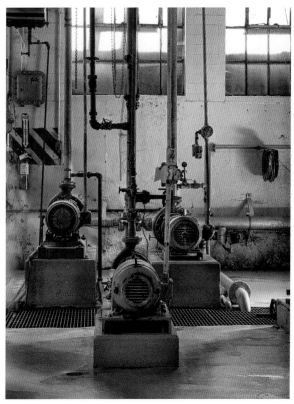

Grain house eggs, Burks' Spring Distillery, Loretto. On the upper level of the still house, near grain bins, this impromptu nest appeared.

Three still house pumps, George T. Stagg Distillery, Frankfort. These pumps were installed during the pre-Prohibition update and are still in use today.

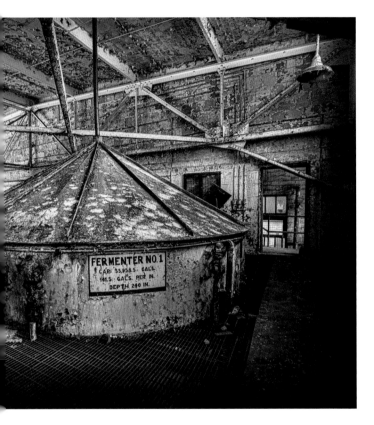

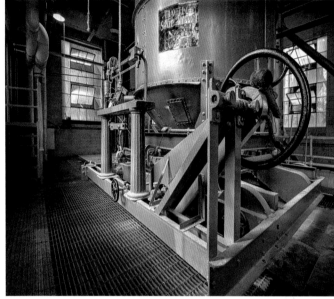

Traveling scale, George T. Stagg Distillery, Frankfort. Milled grain is delivered from the floor above into this scale to be weighed and used according to the mash bill, or recipe, in production. This scale consists of a hopper, wheel, and scales. Note the Doric columns supporting the scale. These same columns can be seen on old scales at the J. E. Pepper and Old Crow distilleries.

Fermenter no. 1, Old Crow Distillery, Woodford County. The metal gridwork seen in the ceiling of the fermenting room was state of the art for early-nineteenth-century industrial architecture.

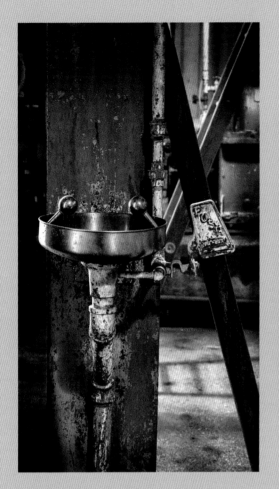

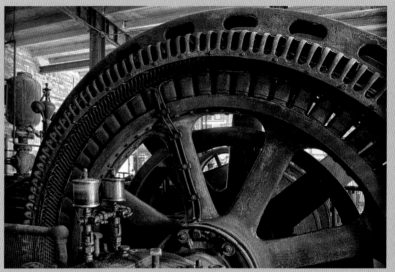

Steam engine wheel, T. W. Samuels Distillery, Deatsville. This huge wheel powered a belt-driven steam engine that provided energy to the rest of the distillery.

Eyeball wash, George T. Stagg Distillery, Frankfort. Chemical splashes could be dangerous for workers. This post-Prohibition eyewash takes on the comic, if not clever, international sign language explaining its purpose.

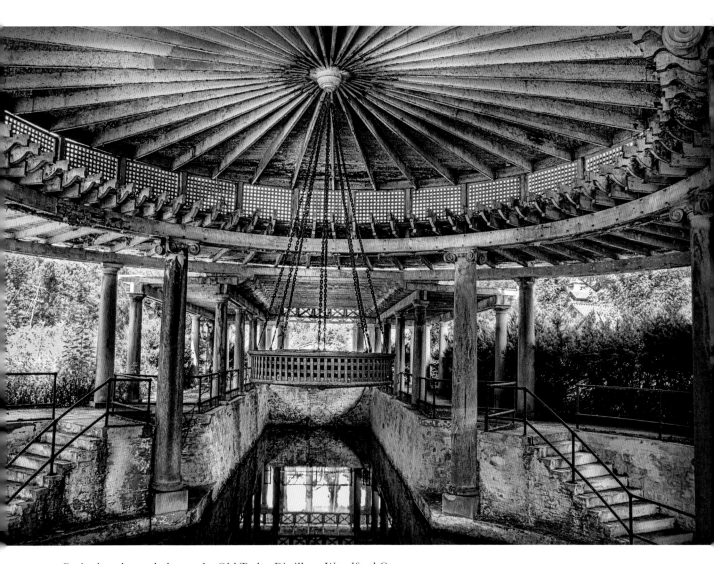

Peristyle colonnaded pergola, Old Taylor Distillery, Woodford County.
From within the art nouveau–style pergola, with its colonnaded promenade
feature, one looks toward the distillery.

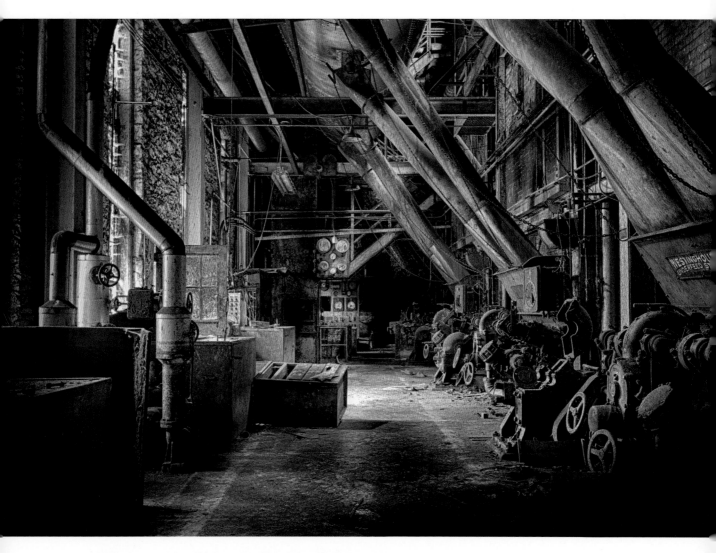

Boiler house aisle, Old Crow Distillery, Woodford County.
The boiler house of Old Crow included three 1930s boiler ovens
with stokers as well as two more recently constructed ovens.

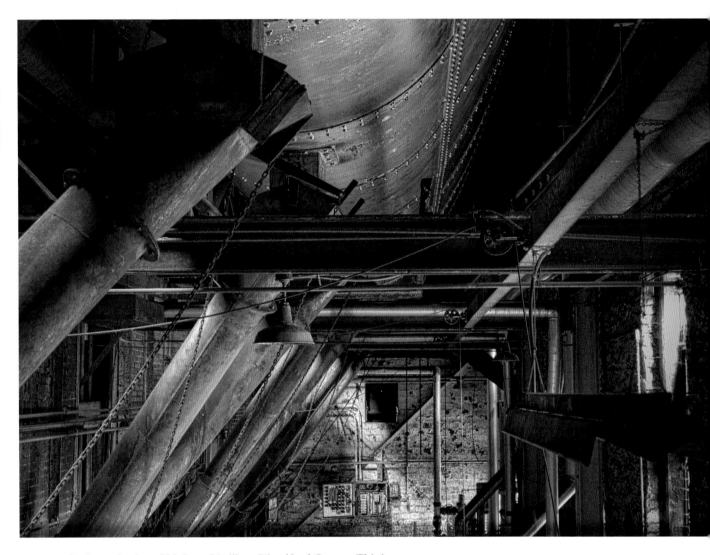

Coal supply pipe, Old Crow Distillery, Woodford County. This large
pipe traversed the entire center aisle of the boiler house, delivering coal
used in the boiler ovens there.

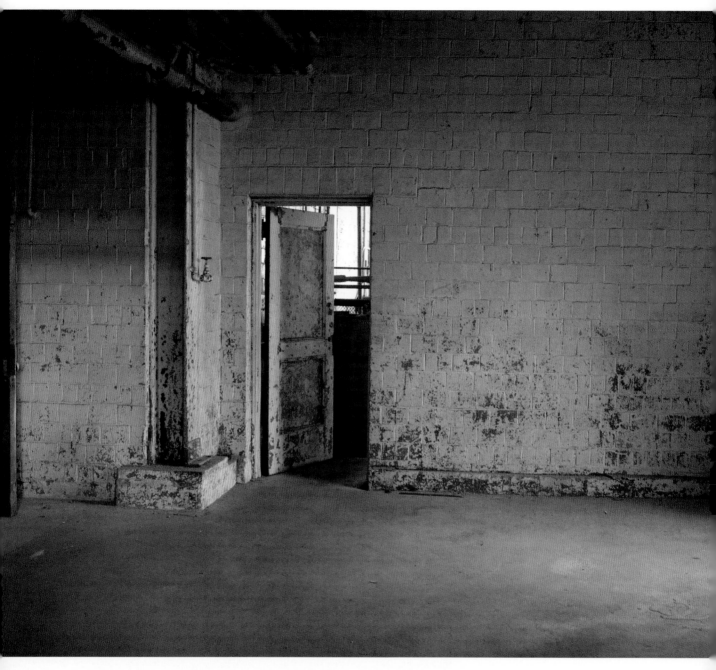

Pink space, J. E. Pepper Distillery, Lexington. This room has been stripped
of all machinery and its former contents salvaged. The door leads to the
room with feeder meters adjoining the boiler room in the powerhouse.

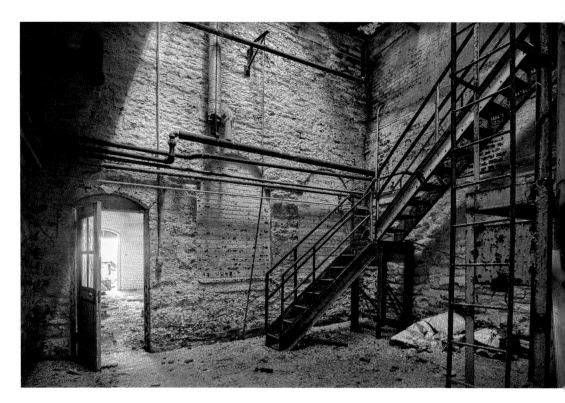

Catwalk stairs, Old Taylor Distillery, Woodford County. Pre- and post-Prohibition architecture details are evident in this view. The catwalk stairs and piping are post-repeal, and the lower walls, arched recesses in the walls, and arched door date from the late nineteenth century. This room is an antechamber to the tall-column still in the next room.

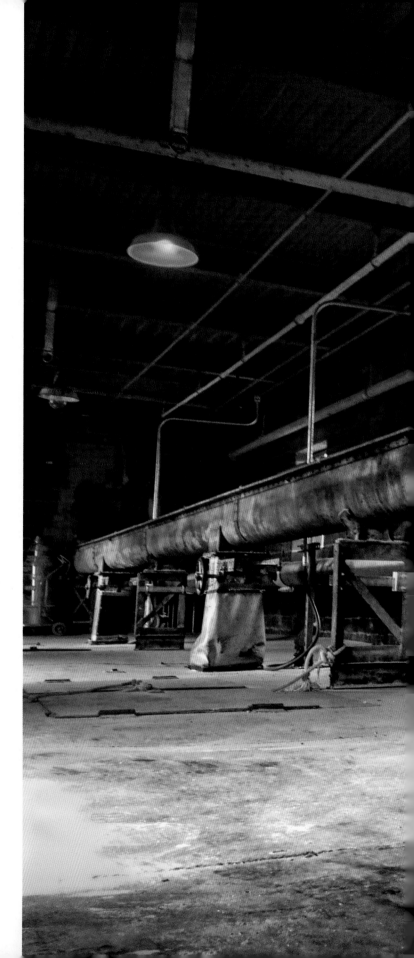

Meal house trough, George T. Stagg Distillery, Frankfort. Rye and malt grains are cooked and processed separately at different temperatures and then married with the corn to create mash. The grains travel from this trough through the chutes into the traveling scales below to be weighed before the mash process begins.

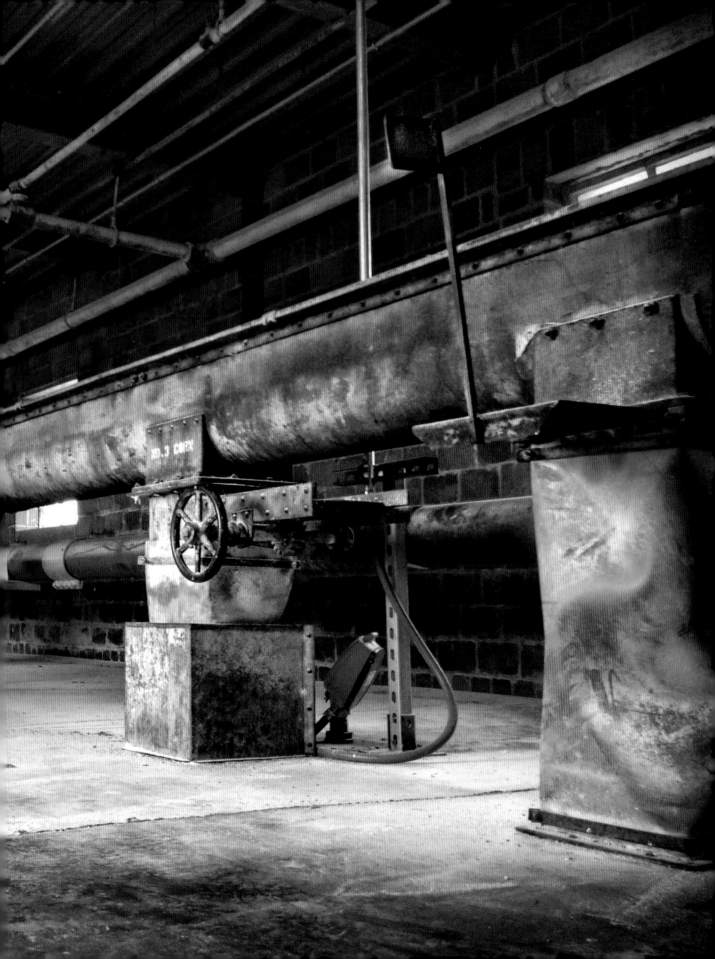

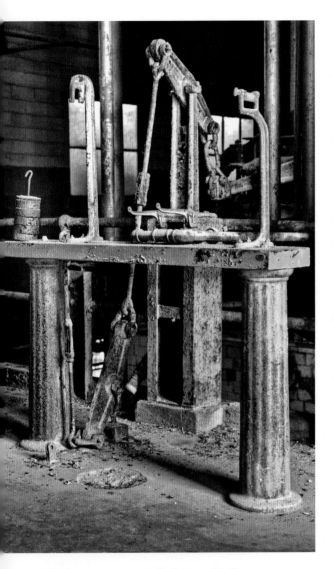

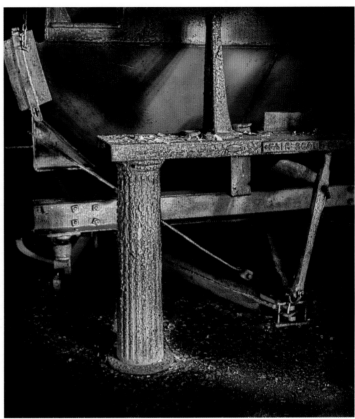

Scales column, Old Taylor Distillery, Woodford County. Doric columns were attached to a traveling grain hopper and were typical of the post-Prohibition Fairbanks Premier Scale Company's embellishments. The scales at Old Taylor Distillery were placed in a glassed room to impress visitors.

Weigh and measure, J. E. Pepper Distillery, Lexington. This is the best example of the scales used with traveling scale hoppers. Similar scales with Doric columns also existed at Old Crow Distillery, Old Taylor Distillery, and George T. Stagg Distillery, all made by Fairbanks Premier Scale Company.

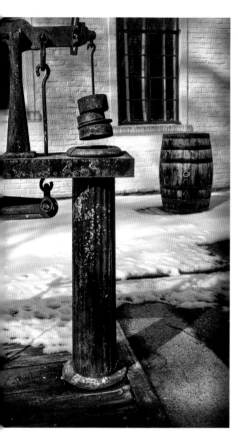

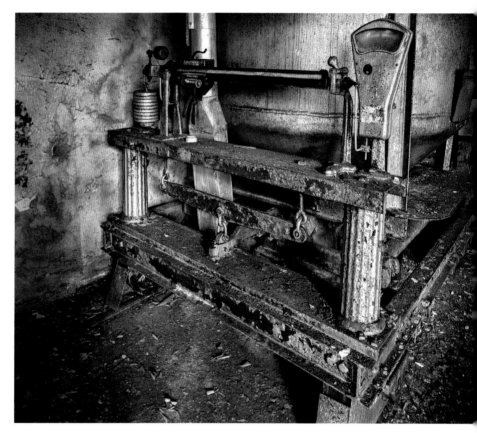

Scale with weights, Old Oscar Pepper Distillery/Labrot and Graham Distillery, Woodford County. Built in 1883, a scale house with a "drive-through shed" and scale pit for wagons to roll onto was detached from the main distillery. This 1934 post-Prohibition scale replaced it, and it is on display outside, on the original scale house site.

Traveling hopper with scales, Old Crow Distillery, Woodford County. The traveling scales for weighing grain at Old Crow were similar to other early industrial grain scales, their features including the Doric columns and disc weights. This scale offered new features such as a metered readout.

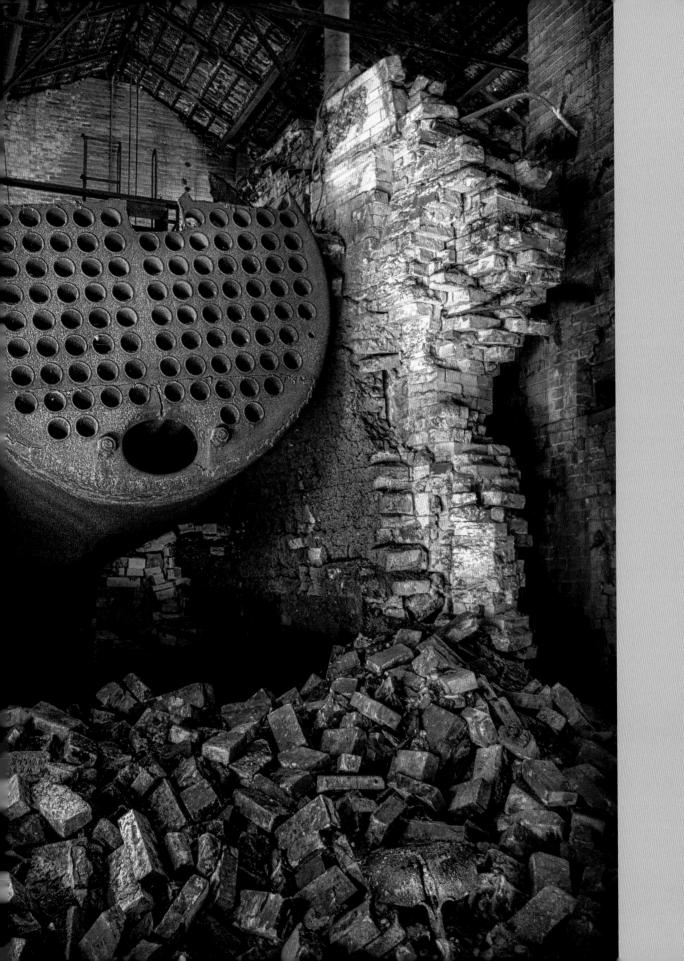

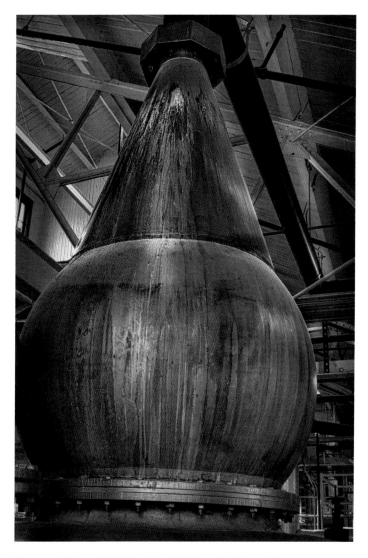

Copper still cap, Old Prentice Distillery, Anderson County.
A new but faithful reproduction of an earlier pot still is in use
in the stillroom.

OPPOSITE: Oven with crumbling wall, Old Taylor Distillery,
Woodford County. The huge post-Prohibition steam ovens here
were in various states of deterioration when photographed. Recent
renovations have removed the unstable elements, leaving two of
the great ovens in place.

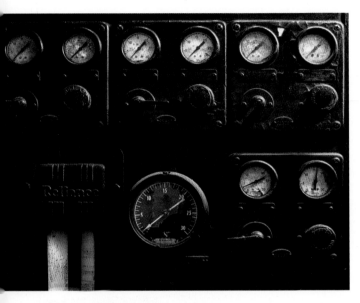

Black dials, George T. Stagg Distillery, Frankfort. Replaced now by digital readouts, these dials from the days of the Stagg and Blanton distilleries are still in good condition.

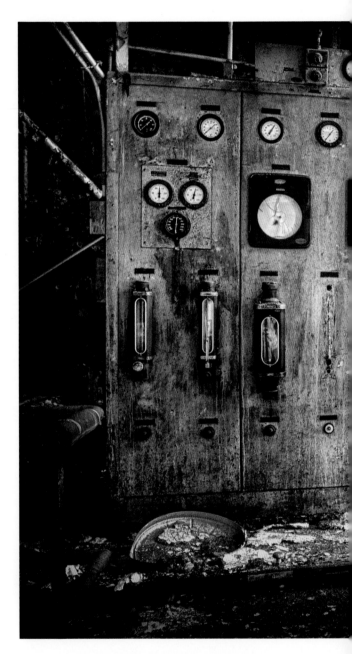

Green dial panel, Old Crow Distillery, Woodford County. Still house dials controlled distilling and beer stills as well as heat exchangers and other machinery.

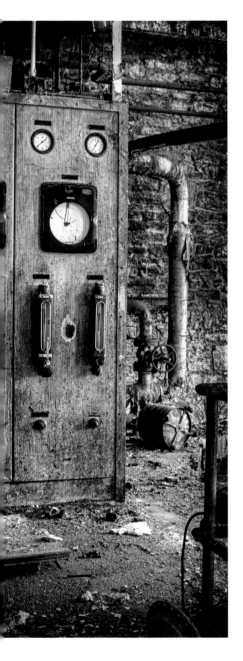

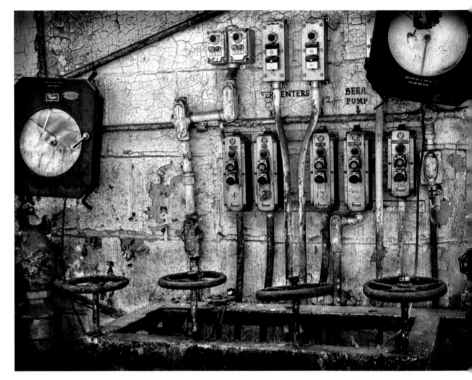

Fermenting room switches, Old Crow Distillery,
Woodford County. The fermenting room wall displays
gauges, switches, meters, and valves used in controlling
the fermenting process.

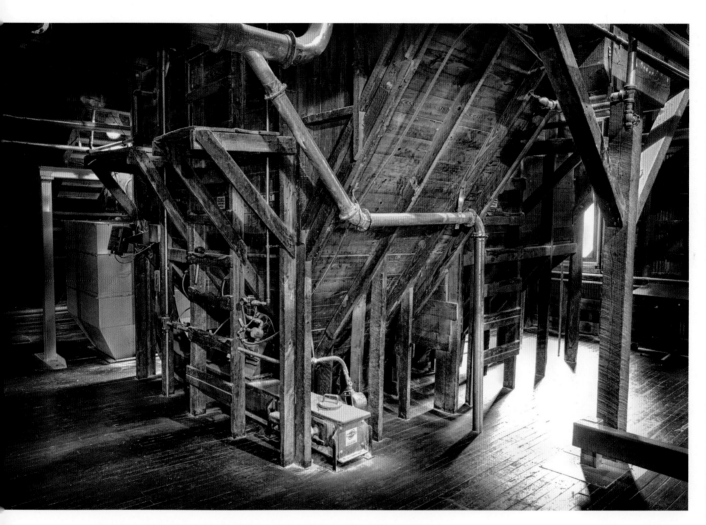

Wheat bin, Burks' Spring Distillery, Loretto. One of the most striking
elements of the NHL area of Burks' Distillery is the preservation and
current use of wooden elements. The old wooden grain bins rest on the
original wooden floors of the late 1800s–early 1900s structure,
creating a warm, golden glow.

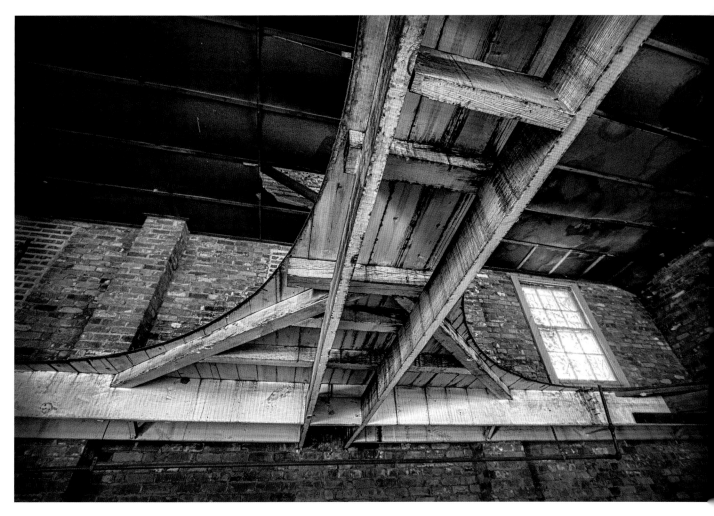

Cistern tank walk, Atherton Distillery, Athertonville. This original wooden walkway encircled two cistern tanks where bourbon was held before bottling. The walkway allowed workers access to the tanks. Wooden floors and walkways are evident in most distilleries that did not switch to metal catwalk systems in the 1930s.

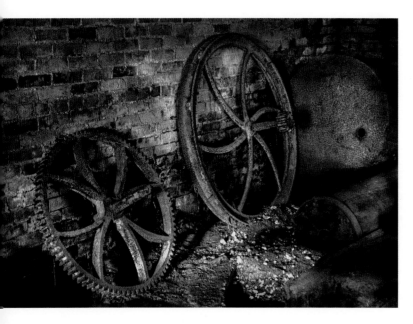

Old mill gears, brick warehouse, Scott County. Early distilleries began on mill sites. Within this early bourbon warehouse are items that were used to grind grains and meal on a stone. It is not known whether they are original to the site's earliest building, but they probably were used at some point in distilling activities.

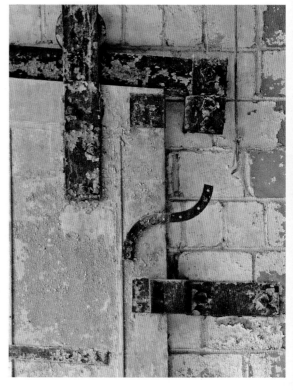

Blue door latch, J. E. Pepper Distillery, Lexington. Years of paint, rust, and weathering have transformed the latch on this fire door to an abstraction. The great variation in color indicates the effect of intense heat. It is obvious throughout all the distilleries just how much heat transformed the visual environment over time.

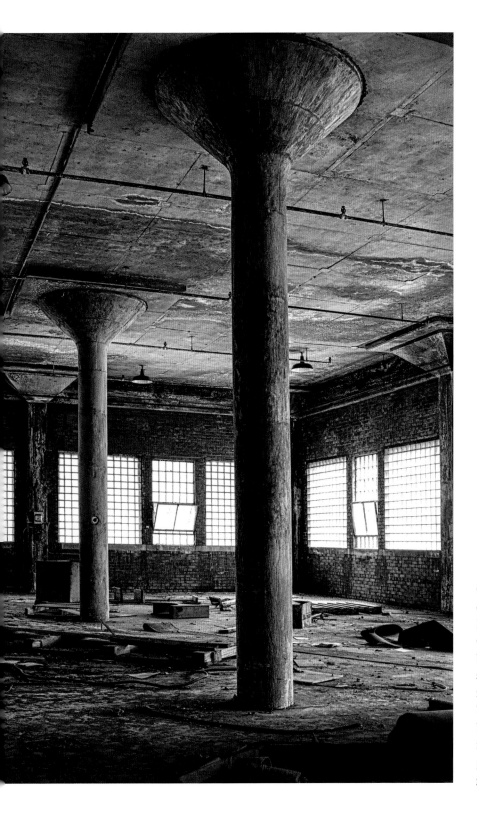

Government building columns, Old Taylor Distillery, Woodford County. These columns both supported the floor above and served as anchors for racks to store barrels or boxes in the government building, where the bottled-in-bond bourbon was prepared for shipping with government labels.

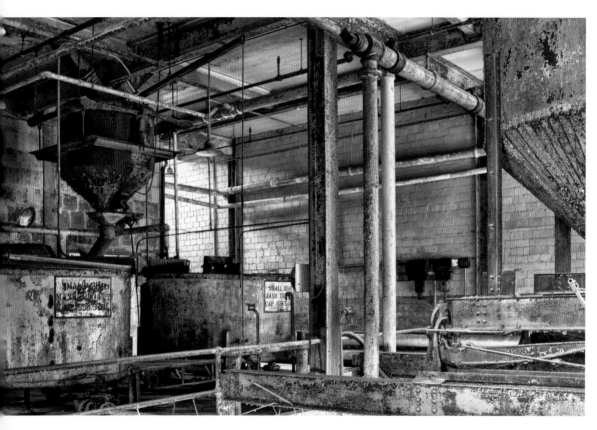

Mash room, J. E. Pepper Distillery, Lexington.
Mash tubs and grain weigh scales were in this
room. There were two sets of scales with Doric
columns attached to bins two stories high,
which indicates huge production amounts.

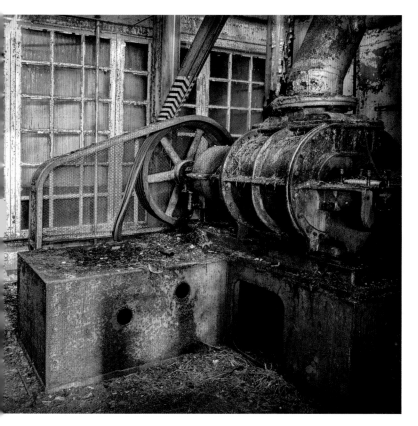

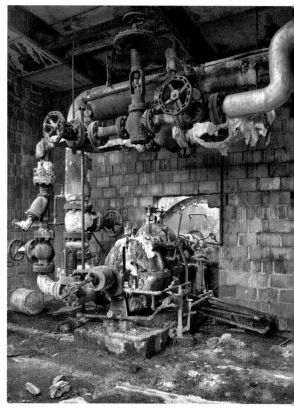

Machine surrounded by French windows, Old Taylor Distillery, Woodford County. Taylor went to great lengths to show off his distillery, including placing his machinery in glass-enclosed rooms, hoping to impress visitors, legislators, and bankers.

Turbine, J. E. Pepper Distillery, Lexington. A photo of this turbine when it was new, in the 1930s, is in the University of Kentucky Special Collections. One of the fascinations for me is the transformation of form to function over time in these industrial works. The 1930s was the beginning of a shift in industrial design that treated the whole industrial plant as a machine, usually designed by engineers for efficiency.

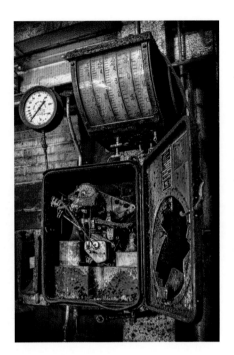

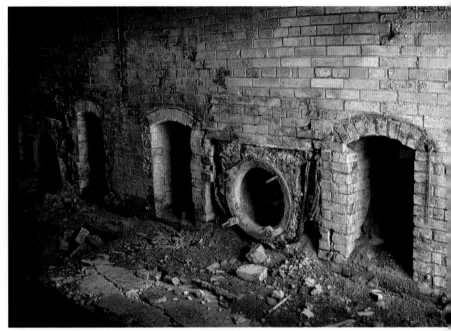

Weigh scale meter, Old Crow
Distillery, Woodford County. Like the
meters at J. E. Pepper, this weigh scale
meter opens to reveal frozen inner
workings that look like a little
man inside.

Oven openings for stokers, Old Taylor Distillery,
Woodford County. The openings that were once attached
to hoppers, stokers, and catwalks for feeding coal into the
boiler oven are visible from this side of the structure.

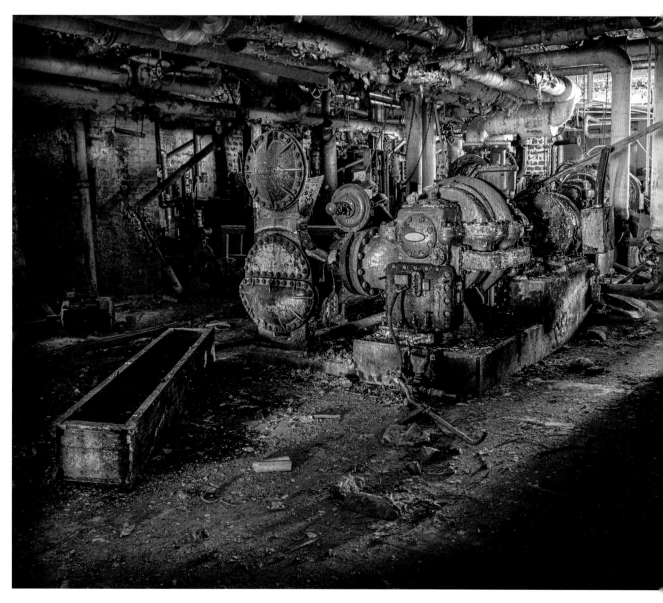

Machine room, Old Crow Distillery, Woodford County.
Deep within the lower levels of the distillery is the machine
room; its engines and turbines provide additional power
to the complex.

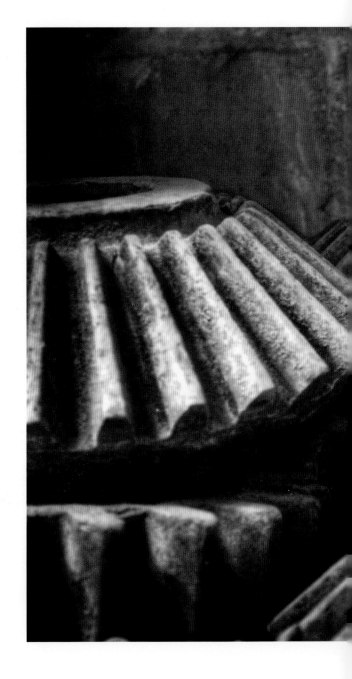

Blue gears, J. E. Pepper Distillery, Lexington.
Every distillery had a hardware and
machinery storage area. These gears were
left in the Pepper hardware room.

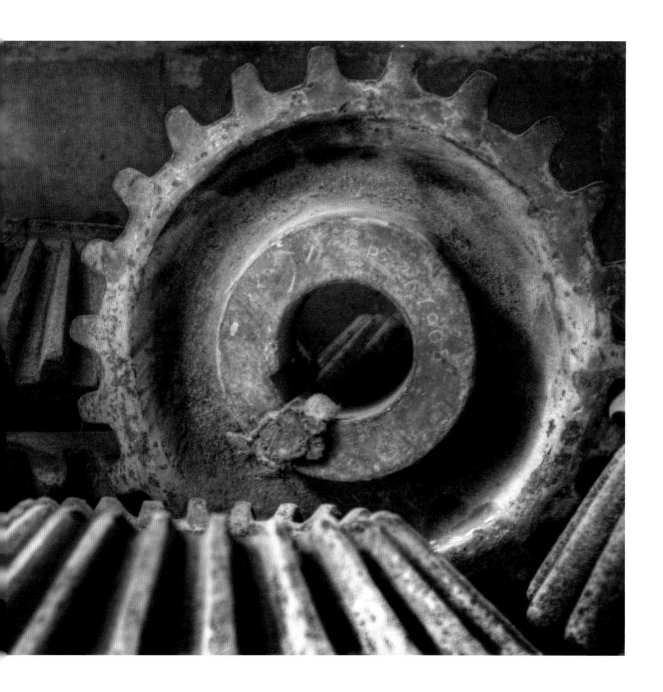

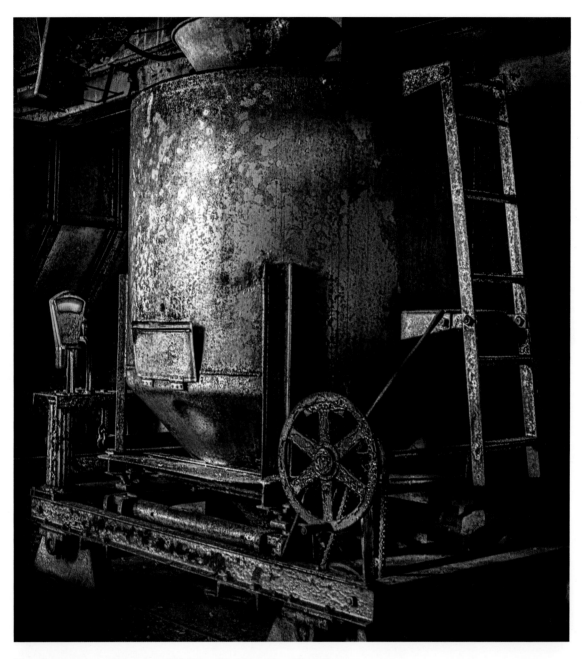

Traveling scales grain hopper, Old Crow Distillery, Woodford County.
This is one of two intact traveling scales that remain at Old Crow.

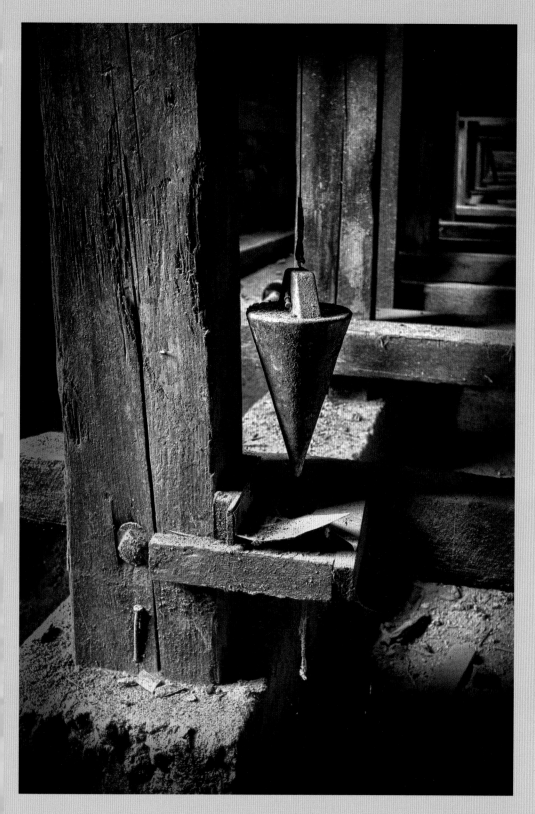

Warehouse plumb bob, George T. Stagg Distillery, Frankfort. Nearly every pre- and post-Prohibition wooden rick barrel warehouse would have hanging plumb bobs at each corner to ensure that the warehouse was level. In the oldest warehouse at George T. Stagg, Warehouse B, this plumb bob indicates all is well.

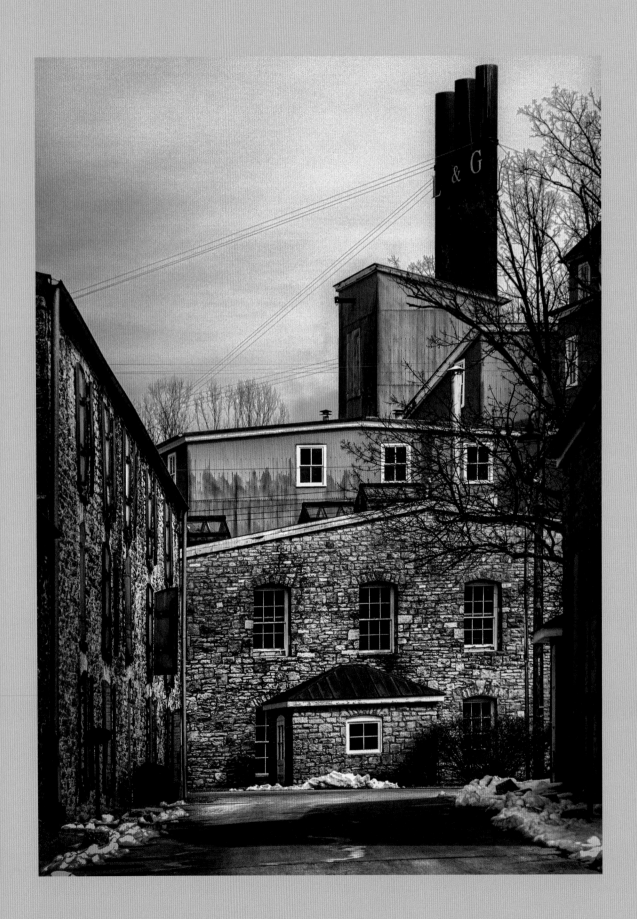

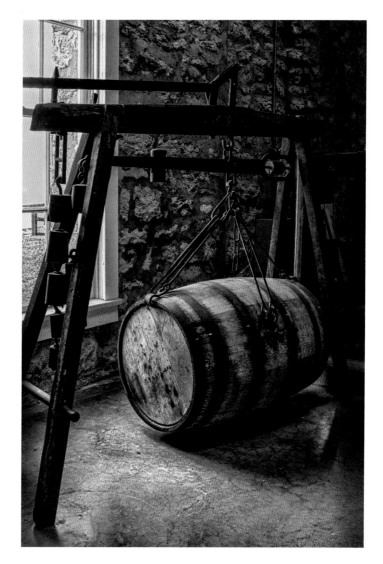

Old barrel scales, Old Oscar Pepper Distillery/Labrot and Graham Distillery, Woodford County. On display inside the currently operating distillery are relics from earlier distilling days. This is an example of scales used during Elijah Pepper's time, predating the outdoor wooden platform scale and the Doric-columned grain weigh scales seen in other images, and possibly made by the Fairbanks Premier Scale Company in its early days.

OPPOSITE: Side view, Old Oscar Pepper Distillery/Labrot and Graham Distillery, Woodford County. This view of the Labrot and Graham additions looks past the old warehouses, slop-drying house, and old cistern room to the newer still house and boiler smokestacks.

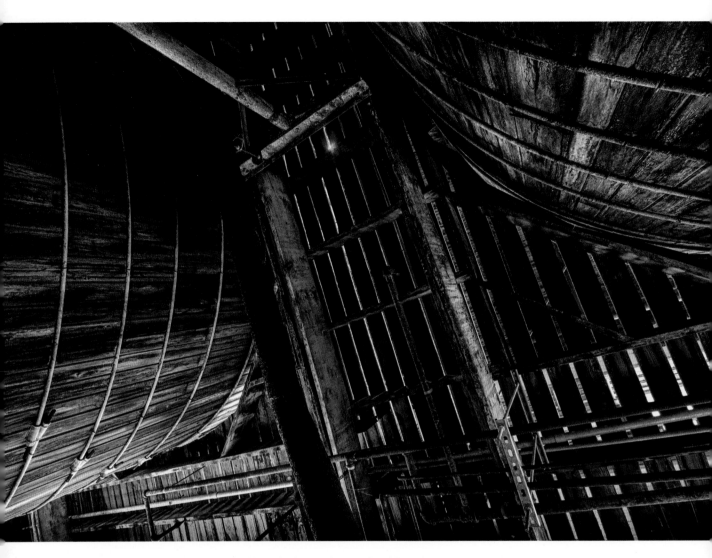

Cypress vats, Old Prentice Distillery, Anderson County. Looking up
from the lower level of the fermenting room, one can see both the cypress
vats and the wooden catwalks.

OPPOSITE: Distillery profile, Old Oscar Pepper Distillery/Labrot and Graham Distillery,
Woodford County. A side view of the distillery shows original elements of the Pepper
site and the two original stone reservoirs. Now open to the air and surrounded by iron
fences, the reservoirs were covered by conical roofs and cupolas in the 1800s. Boiler
stacks added by Labrot and Graham are visible in the background.

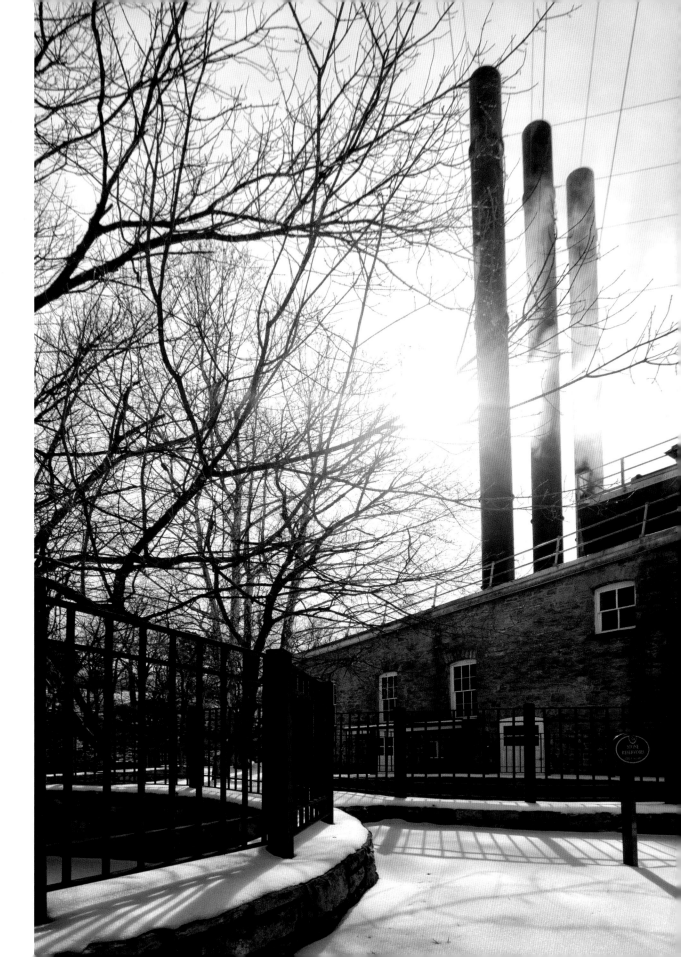

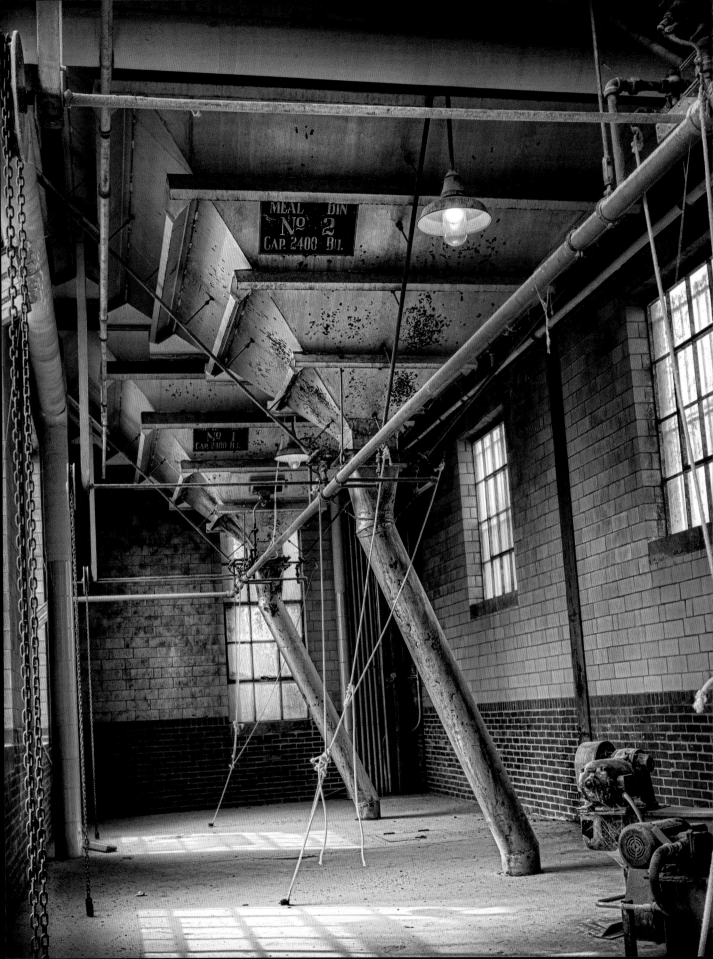

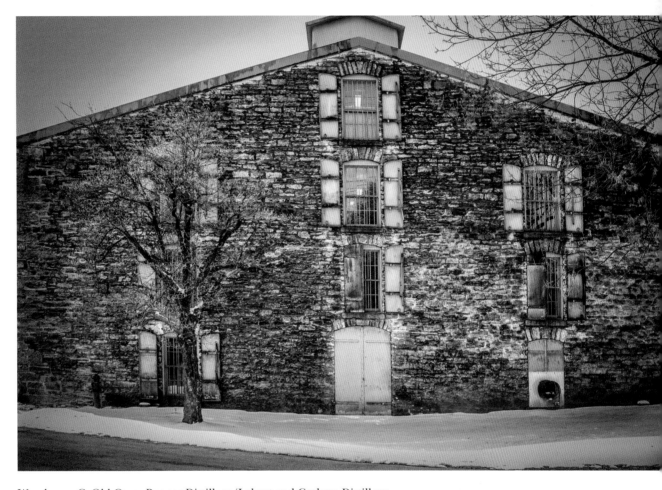

Warehouse C, Old Oscar Pepper Distillery/Labrot and Graham Distillery,
Woodford County. Built by 1896 and attached to Warehouse D by a
covered passage, Warehouse C is still in use, aging five thousand barrels
of bourbon. Warehouses C and D are the only stone warehouses in
Kentucky that store bourbon.

OPPOSITE: Meal bin no. 2, George T. Stagg Distillery, Frankfort. These are
the original post-Prohibition grain bins. The grain empties into a trough
and eventually into the traveling weigh scale on the floor beneath.

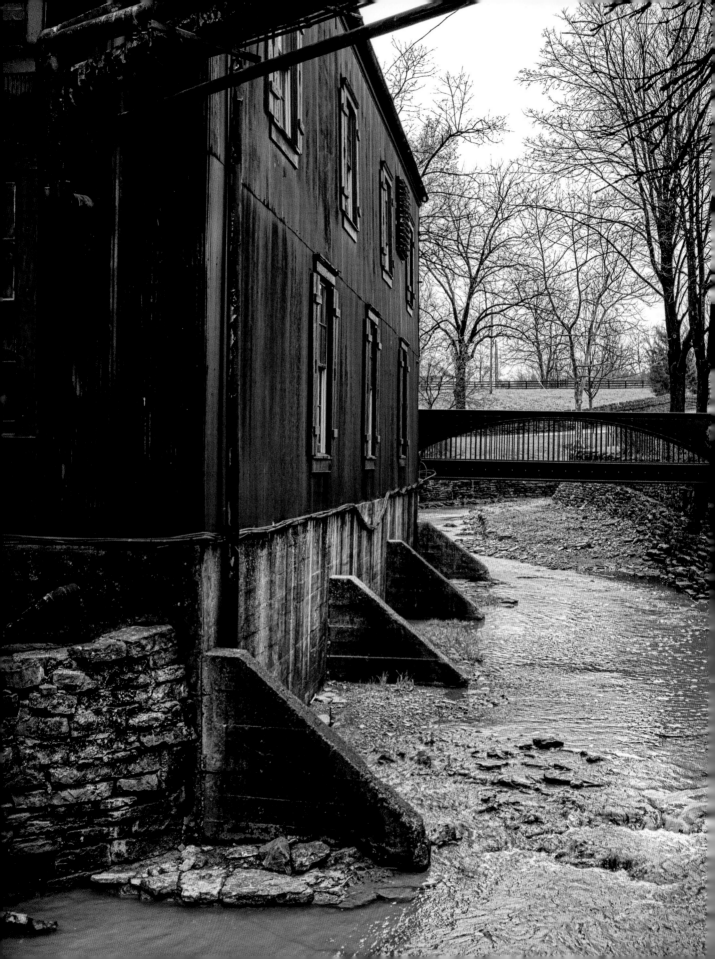

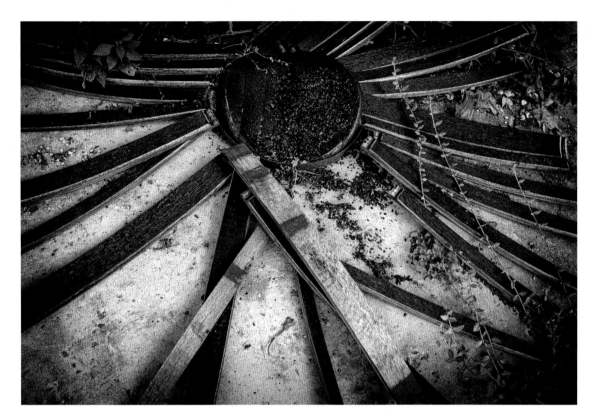

Charred staves, Old Taylor Distillery, Woodford County. Bourbon is
not bourbon if it hasn't been aged in charred barrels. Each barrel is
used only once, since the definition of bourbon requires it to be "aged
in new charred oak barrels." Here a barrel has split apart from age,
revealing staves and charred coals in the bottom.

OPPOSITE: Distillery and stream, Burks' Spring Distillery, Loretto.
A branch of Hardin's Creek wanders by the fermenting room of the
still house. Every historical distillery is located where it is because of the
limestone springs and waters running nearby, and advertising always
bragged about the quality of the water used in distilling.

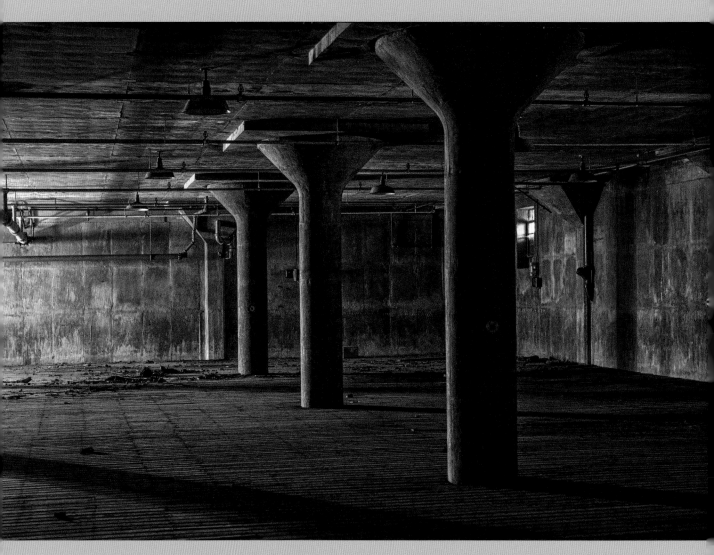

Government house storage pillars, Old Taylor Distillery, Woodford County. In the basement of the government house are warehouse pillars, which suggests that racks with boxed merchandise ready for shipping would have been between the columns. The floor here is wooden rather than the poured cement usually used in the barrel storage warehouses.

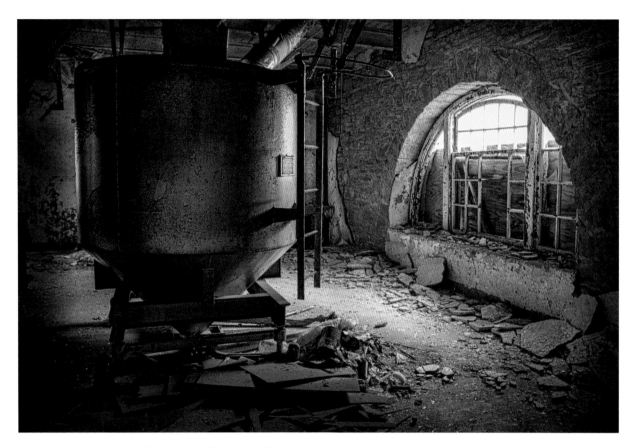

Window and hopper, Old Taylor Distillery, Woodford County. A grain hopper stands abandoned in the front room of the castle-inspired distillery building. This room and an adjacent one, with machinery, were surrounded by small-paned windows so that visitors could observe the fermenting room. It is said that Taylor kept tropical plants in this part of the building to impress guests.

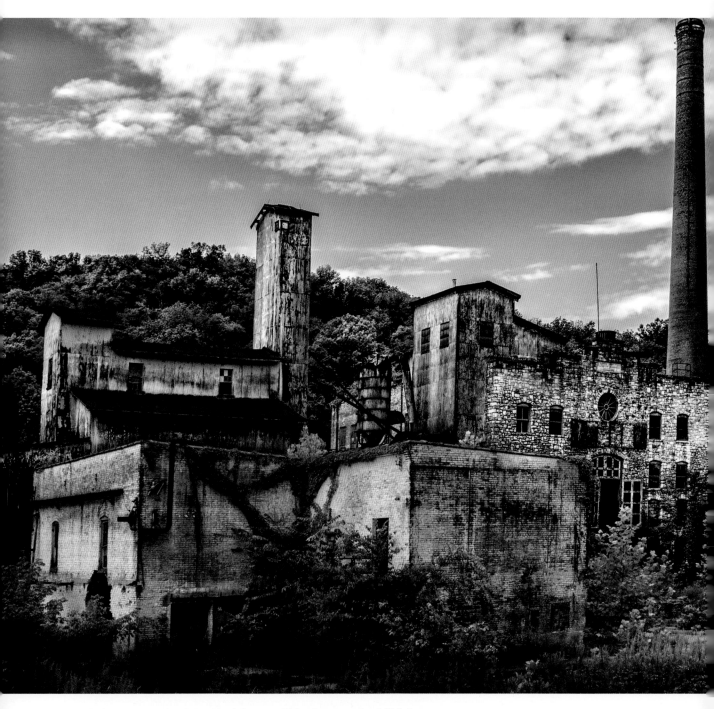

Old Crow complex, Woodford County. This photograph of Old Crow Distillery was taken in 2013. Abandoned in 1987 and salvaged by various companies for stone and wood, the site has been purchased recently for the development of a small craft bourbon distillery.

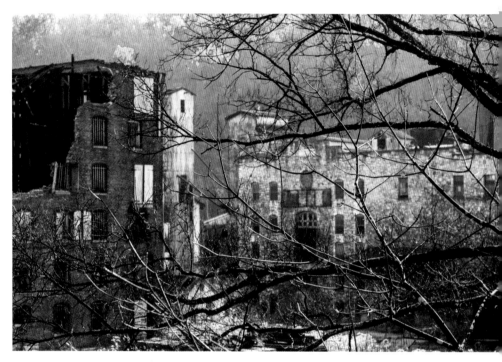

Old Crow Distillery buildings, Woodford County. From the
road in autumn one can see the main distillery in the center,
the grain elevator building to the left, and the remains of
one of the warehouses in the left foreground.

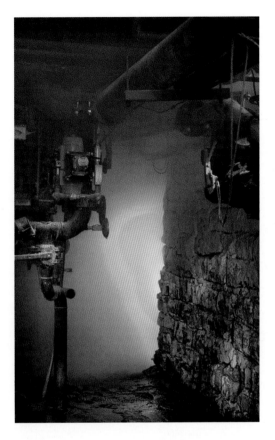

Engine steam, Burks' Spring Distillery, Loretto. Heat, steam, and light emanate from the engine and mash tub area of the still house basement, the original foundation of the Burks' Mill of 1805.

Beer still burners, Old Prentice Distillery, Anderson County. Once the mash has been combined with yeast and fermented for three days, it becomes an alcohol called beer. This is then distilled into an alcohol called low wine. No longer in use, a copper beer still, or continuous still, is on display in the stillroom. Inside the still on the lower level are the burners that provide heat.

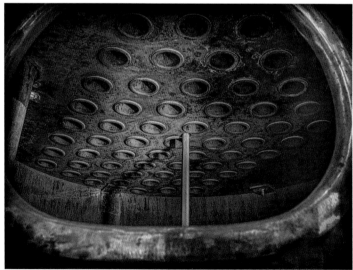

Beer still vents, Old Prentice Distillery, Anderson County. In the copper beer still on display in the stillroom, one can see the vents that allow the flow of liquid within the still.

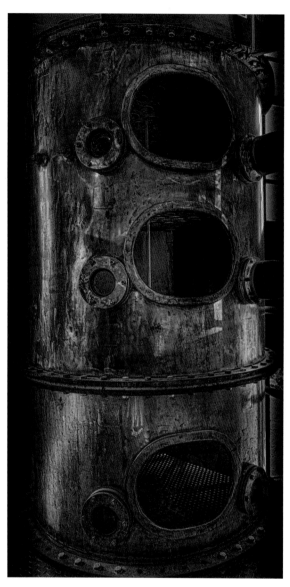

Beer still, Old Prentice Distillery, Anderson County. This old beer still from the Old Prentice Distillery is no longer used; it has been replaced by a pot still and a much larger continuous still.

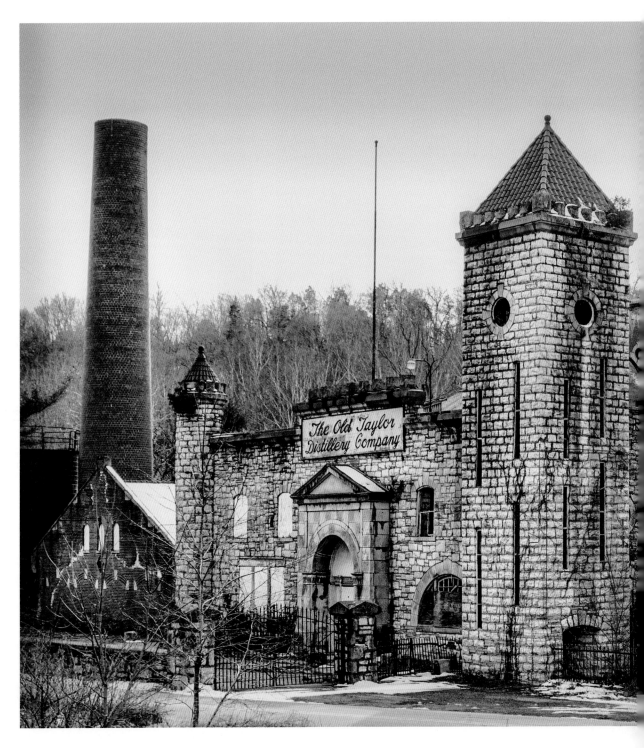

Old Taylor Distillery, Woodford County. A full view of the distillery shows the lengths that Taylor went to to create his distillery castle. The main attraction is of limestone block; the oven house to the left and offices to the right are of brick. A grain house is in the far right corner, and the water tower, with its crenellation, is in the middle background.

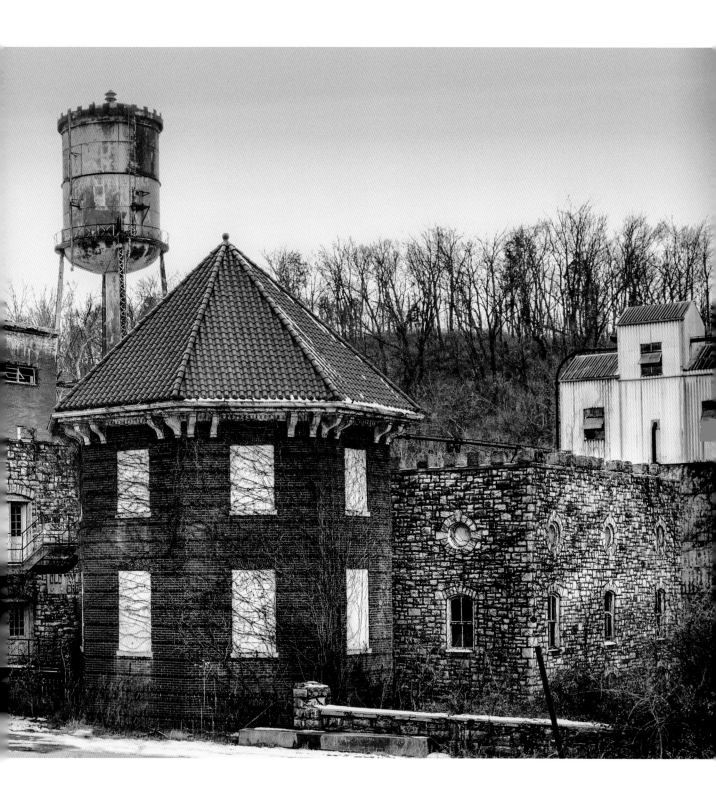

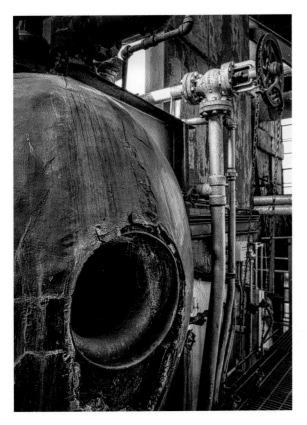

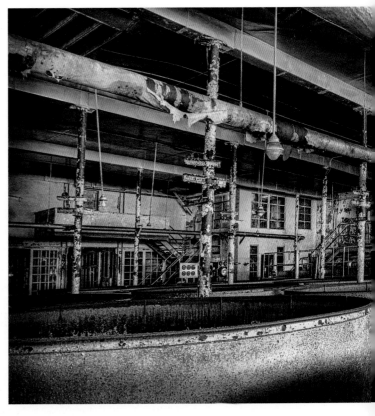

Oven eye, George T. Stagg Distillery, Frankfort. The old section of the boiler house displays the ovens used in a typical 1930s distillery, no longer in use. This oven is surrounded by a type of insulation also no longer used.

Fermenting room, Old Taylor Distillery, Woodford County. This view of the fermenting room is taken on the top floor from between the fermenting tanks, looking toward the front of the distillery.

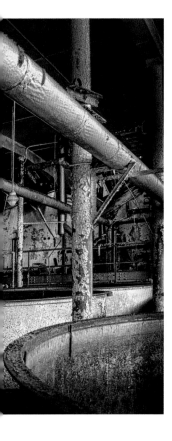

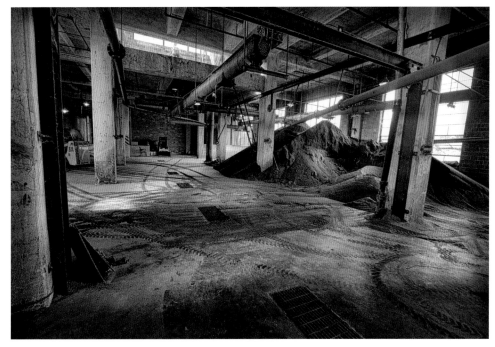

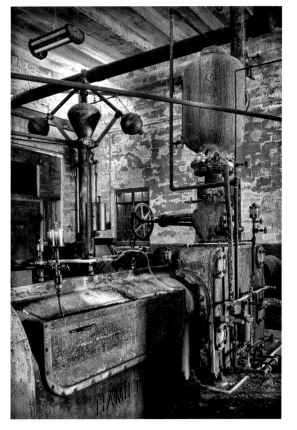

Dry room, George T. Stagg Distillery, Frankfort. Still in use converting spent grain into livestock feed, the George T. Stagg dry house shows concrete floors and pillars. This part of the distillery was added on to the old O.F.C. distillery building during the 1930s expansion done by Schenley Distillers.

Steam engine detail, T. W. Samuels Distillery, Deatsville. This photo shows details of the belt-driven engine in the engine room. A centrifugal force balance, a belt cover, and a tank are all part of the steam engine.

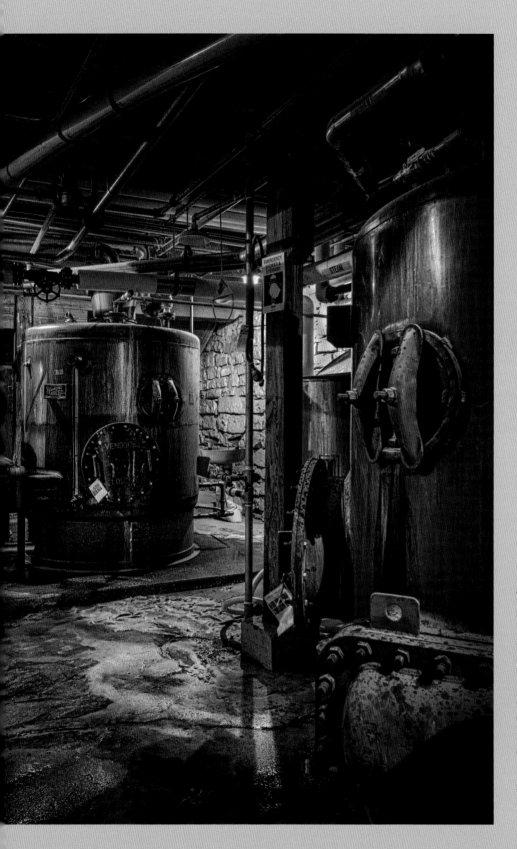

Two stills, Burks' Spring Distillery, Loretto. In the basement of the still house, the original 1805 foundation of Burks' Mill, are two copper stills that replicate the size and design of the stills used by the Samuels family during their early distilling history.

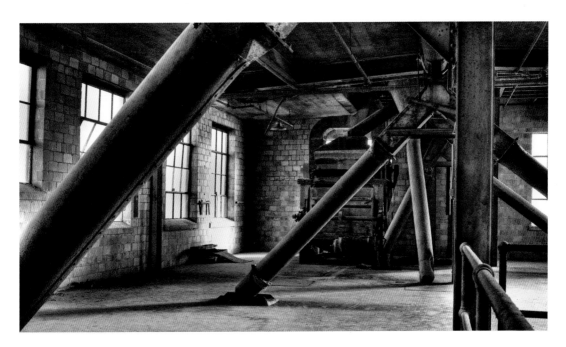

Pipe room, J. E. Pepper Distillery, Lexington. Grain delivered into the machine at the far end of the room is processed and sent through the overhead pipe, down the chutes to hoppers below.

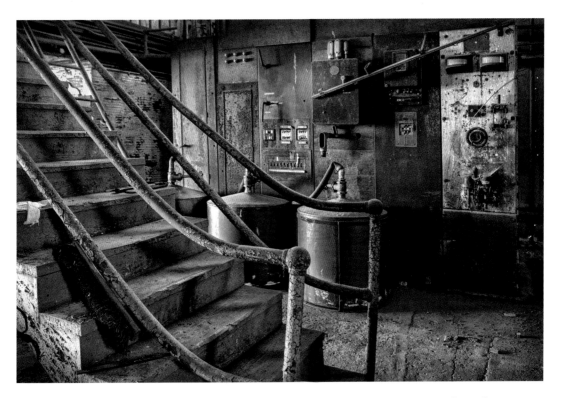

Staircase, T. W. Samuels Distillery, Deatsville. Copper tanks sit next to a defunct control panel behind graceful stair rails that lead to a wooden walkway surrounding the tanks in the still house.

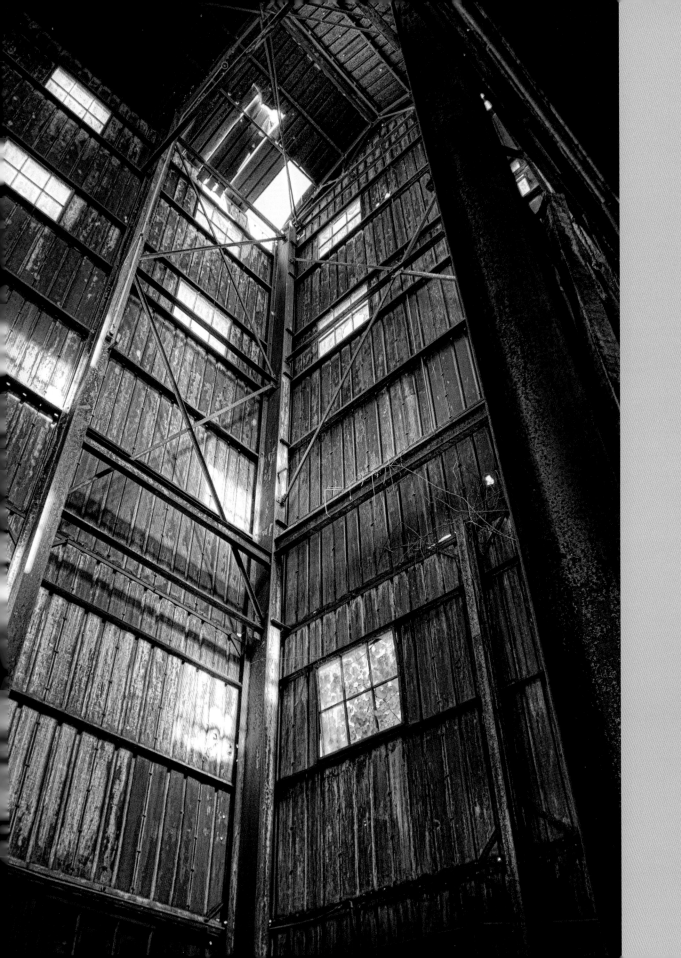

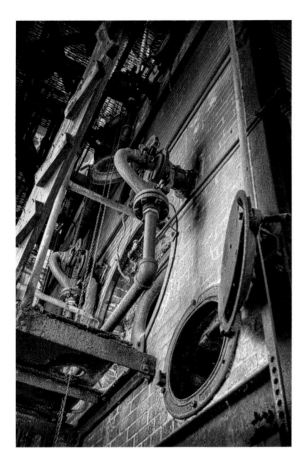

Oven opening, T. W. Samuels Distillery, Deatsville. The oven opening on the second floor of the powerhouse boiler is similar to those found at George T. Stagg and J. E. Pepper, both modern distilleries of the early 1930s. A wooden ladder reaching down to the metal steps next to the oven indicates that both metal and wooden walkways and ladders were in use.

OPPOSITE: Tower, T. W. Samuels Distillery, Deatsville. Inference is required to determine the use of this several-story tower.

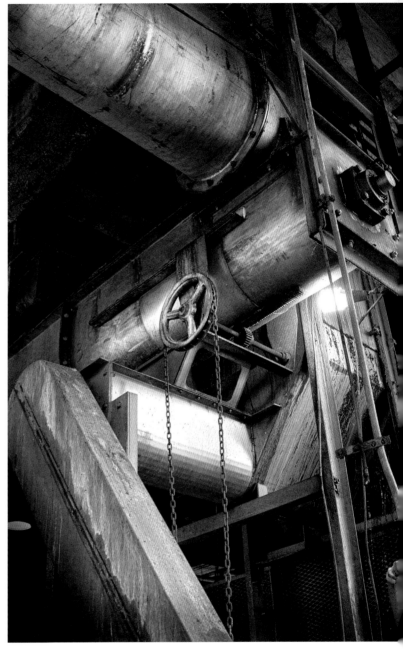

Z pipes, George T. Stagg Distillery, Frankfort. Many of the old works are still in place within the NHL-designated George T. Stagg area of Buffalo Trace Distillery. Some have continued to be in use; others remain as visual explanations of an industry that was at the cutting edge in 1930s, just after Prohibition was repealed.

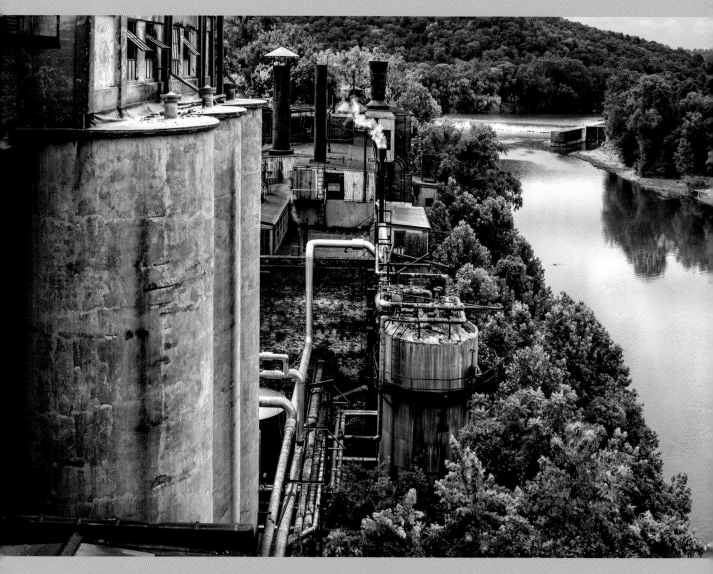

River view, George T. Stagg Distillery, Frankfort. Over time there have been five different distilleries in this location. In this view George T. Stagg expansions extend into the foreground. The front of the Stagg distillery faces the river for easy access to river loading. Downriver one can see the locks built by Commander Richard Taylor (not to be confused with E. H. Taylor) in the distance.

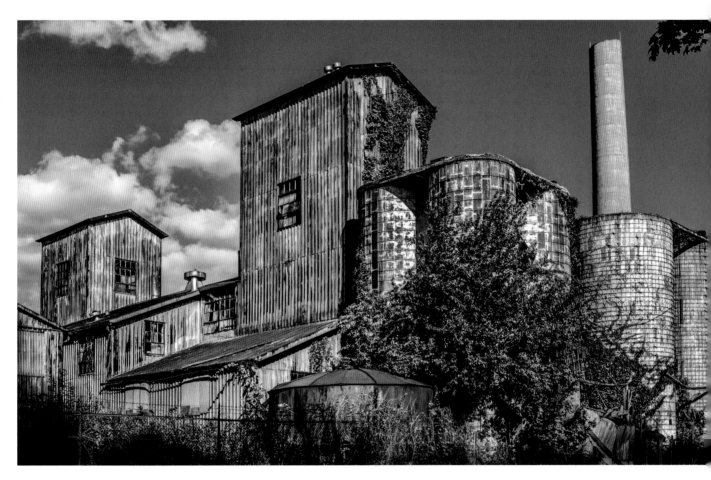

T. W. Samuels Distillery, Deatsville.
Situated along a spur of the Louisville
& Nashville Railroad and at a highway
crossroads, the distillery was designed for
ease of bringing in grain and coal and
shipping out distilled spirits.

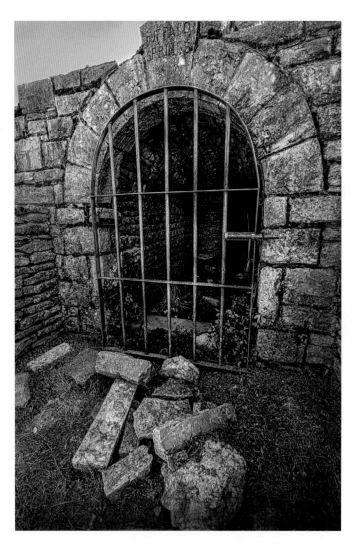

Gate, Buffalo Springs Distillery, Stamping Ground. This gate protects an original spring, over which is a hand-cut stone arch. Note the hand-etched designation, "Buffalo Springs," on the keystone. A new park was constructed on this site after the distillery was torn down; some artifacts and building remnants were left intact.

Door handle embellishment, Old Taylor Distillery, Woodford County. Most of the hardware from earliest times is long gone. This door handle, however, has remained, and it suggests that the embellishment throughout the distillery was not limited to architecture but continued into the details. This is probably pre-Prohibition.

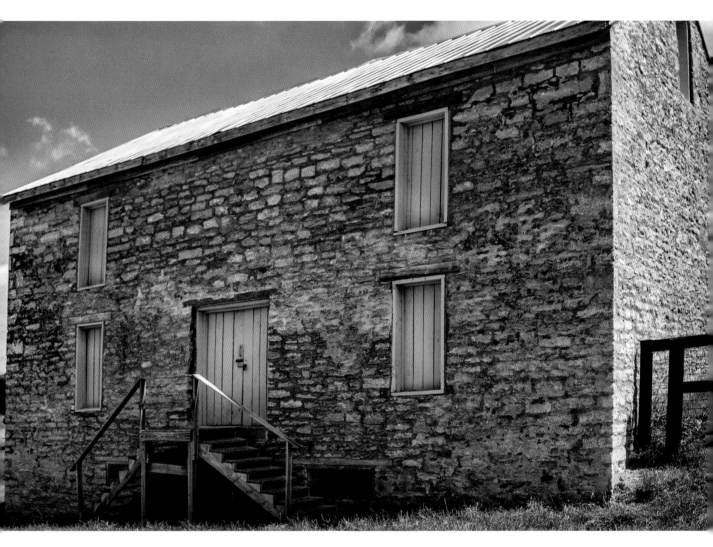

Eighteenth-century warehouse, Jacob Spears Distillery,
Bourbon County. The warehouse has been restored by the
current owners, using the original stonework on the exterior
and re-creating interior details such as the ladders and
floorboards much as they probably once appeared. Original
supporting beams and timbers are evident throughout.

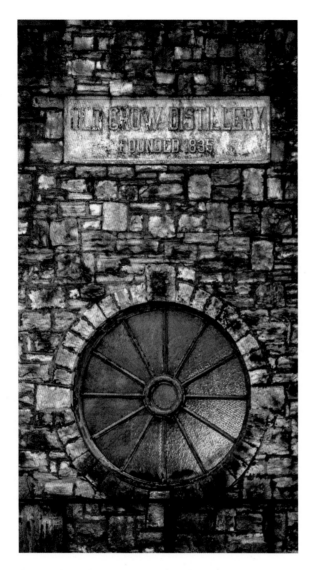

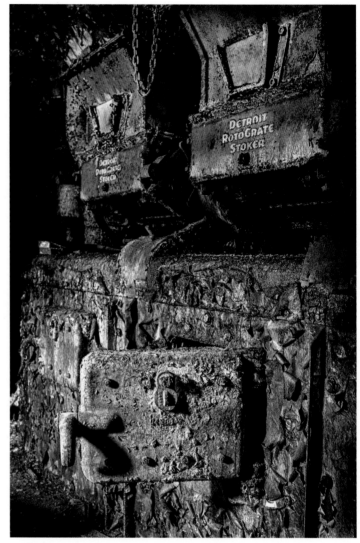

Sign and window, Old Crow Distillery, Woodford
County. This version of the distillery, located
along Glenn's Creek, was built in 1835 on a site
that had been used previously for a distillery
(another source says 1872). It was enlarged
again after Prohibition, and again in the
mid-twentieth century.

Detroit stoker, Old Crow Distillery, Woodford
County. In the boiler room coal ovens generated
steam-driven power to the rest of the plant. These
boiler stokers were later ovens (1930s), and they
worked along with three others from an earlier
date. The keyhole-shaped vent on this stoker was
known as the Eye of the Dragon.

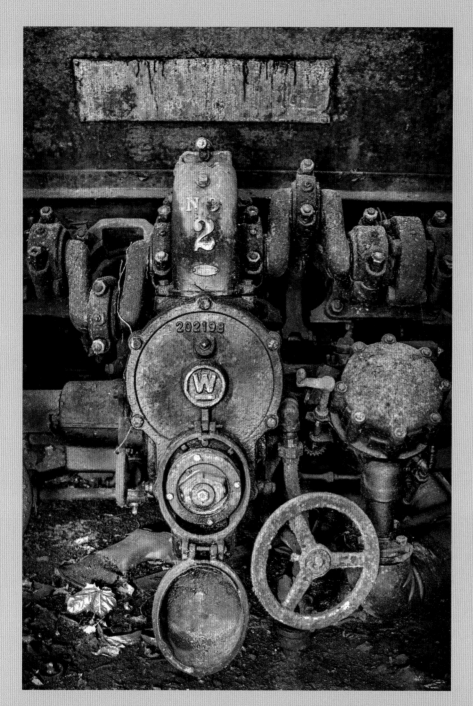

Engine no. 2, Old Crow Distillery, Woodford County. This boiler stoker, as well as two others, is from the early twentieth century, probably around 1912. During the post-Prohibition update, Detroit stokers were added to work along with these.

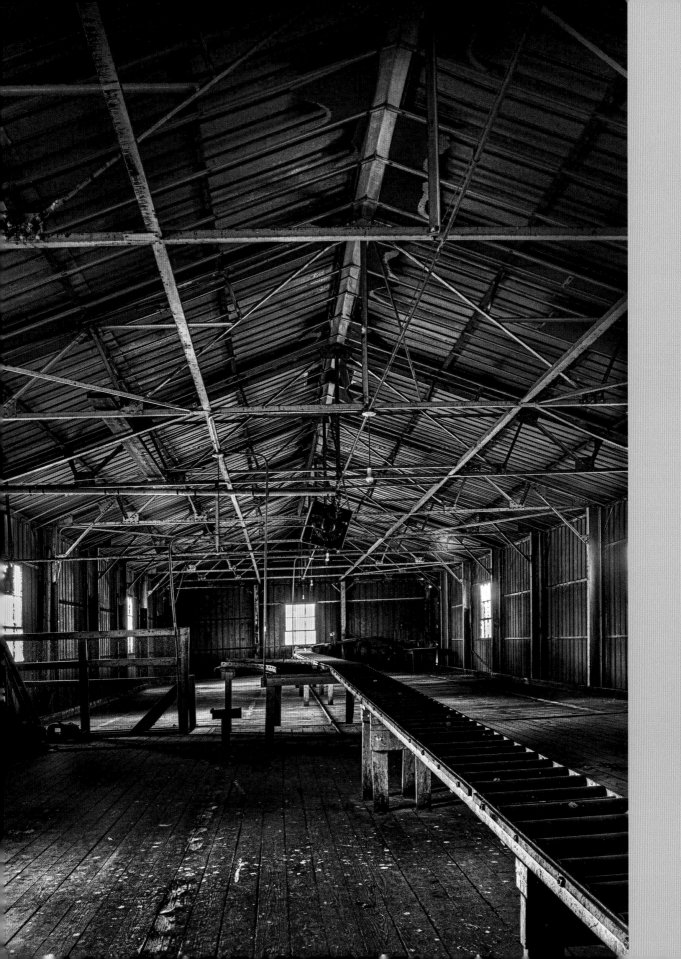

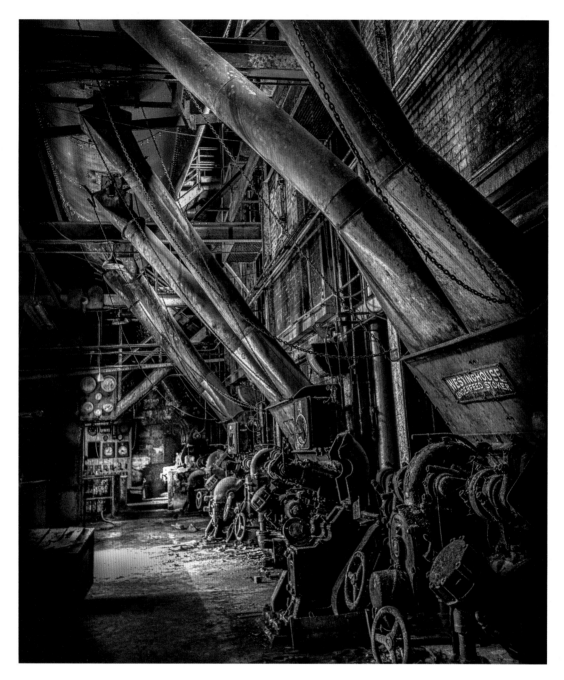

Boiler room, Old Crow Distillery, Woodford County. This long view of the first-floor boiler room shows both early and later stokers, a huge pipe suspended from the ceiling that delivered coal to the stokers, dials and meters, and the yellow brick that surrounded the steam pipes, much like those at the J. E. Pepper Distillery.

OPPOSITE: Upstairs bottling house interior, T. W. Samuels Distillery, Deatsville. This view shows the steel scaffolding that was considered cutting-edge technology at the time the distillery plant was constructed.

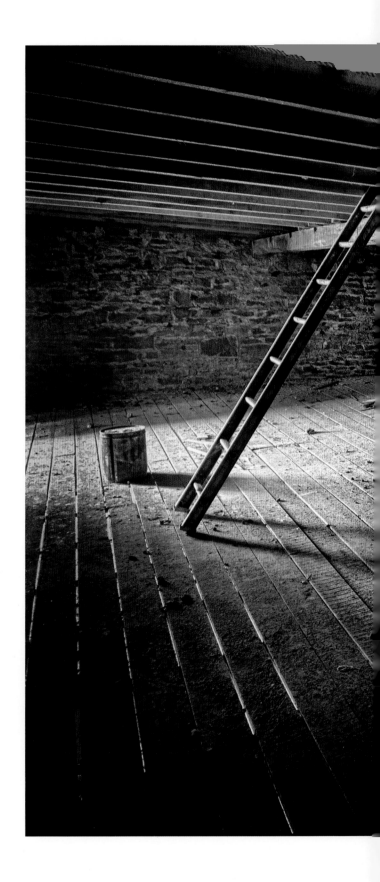

Second floor, long view,
Jacob Spears Distillery, Bourbon
County. Though the Spears
warehouse dates to the late
eighteenth century, some of the
items stored on the second floor
are from the mid-twentieth century
and would be considered historical
agricultural relics today.

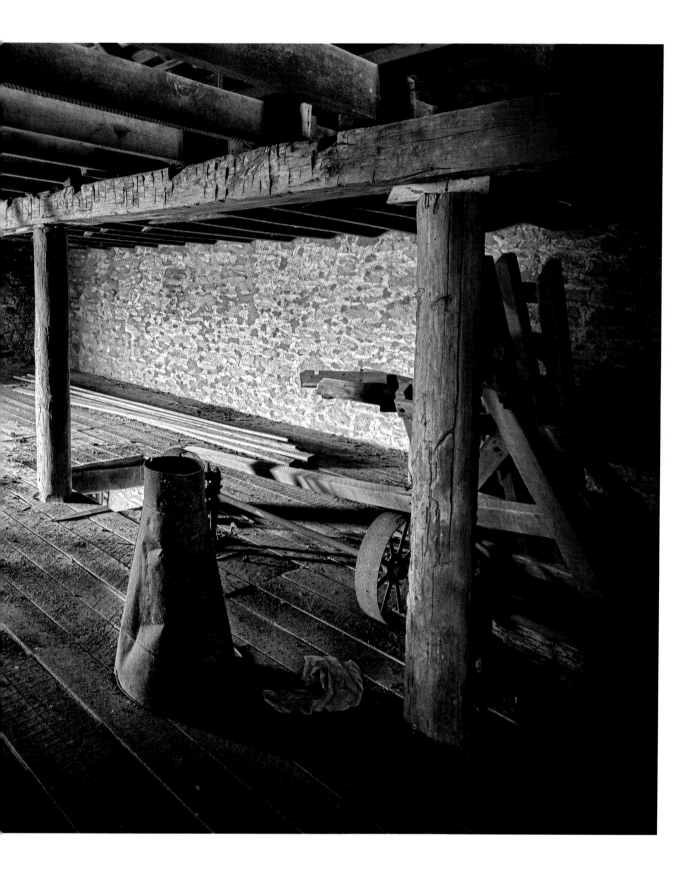

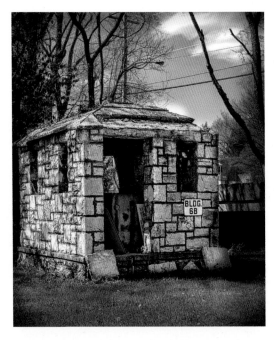

Building 6B, Buffalo Springs Distillery, Stamping Ground. Situated near the creek, this outbuilding probably held a pump. Now it sits, isolated and out of place, in the front lawn of a retail store.

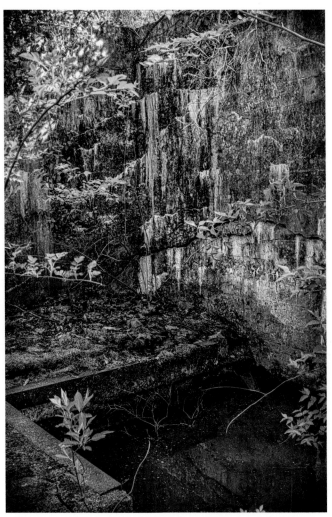

Warehouse spring, Buffalo Springs Distillery, Stamping Ground. The original warehouse that stood here used the wooden rick system on a concrete foundation. A natural spring has found its way into the foundation remains, creating a reflecting pool.

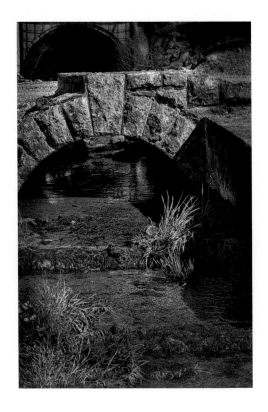

Creek-crossing arch, Buffalo Springs Distillery, Stamping Ground. Buffalo Springs was a distillery that displayed architectural embellishment on functional structures. This hand-cut stone arch still adorns a small creek crossing.

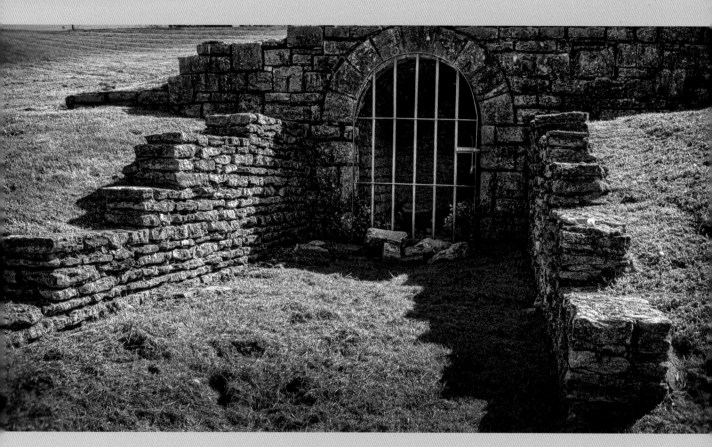

Gate surrounding spring, Buffalo Springs Distillery,
Stamping Ground. After the distillery was torn down
in 2007, a park was built on part of the old distillery
site. In this view the gate protecting an original
spring is surrounded by park land.

Heat-controller meter, J. E. Pepper Distillery, Lexington. Within panels of scales and dials, this instrument registered the functioning of one of the stills, engines, or turbines in the distillery.

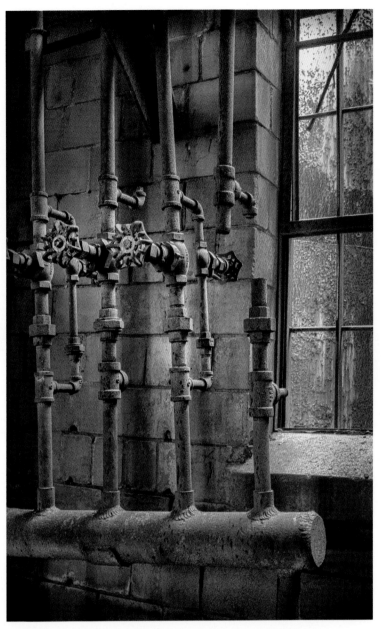

Pink pipes, J. E. Pepper Distillery, Lexington. Light deflected off an outside slop tank casts a pink hue on these iron pipes in the boiler room. The abundance of color, owing to the effects of heat, as well as the filtered light coming through mold-coated windows make the abandoned distilleries beautiful at certain times of the day.

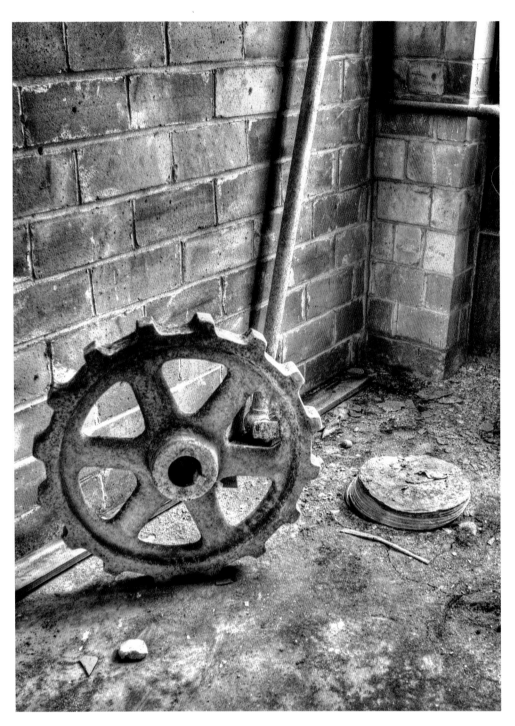

Large wheel, J. E. Pepper Distillery, Lexington. This large wheel
was freestanding in the mechanical tool room. It was about two feet
tall and six inches thick, and it seemed to be suspended in time,
removed from its original purpose.

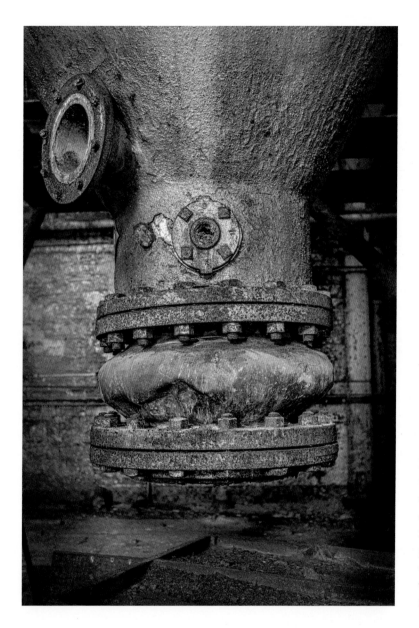

Heat exchanger, up close,
Old Crow Distillery, Woodford
County. The heat exchanger
cooled the vapor from the
first distilling. This one was
positioned in the stillroom at
the Old Crow Distillery, and it
would have been connected
to column stills.

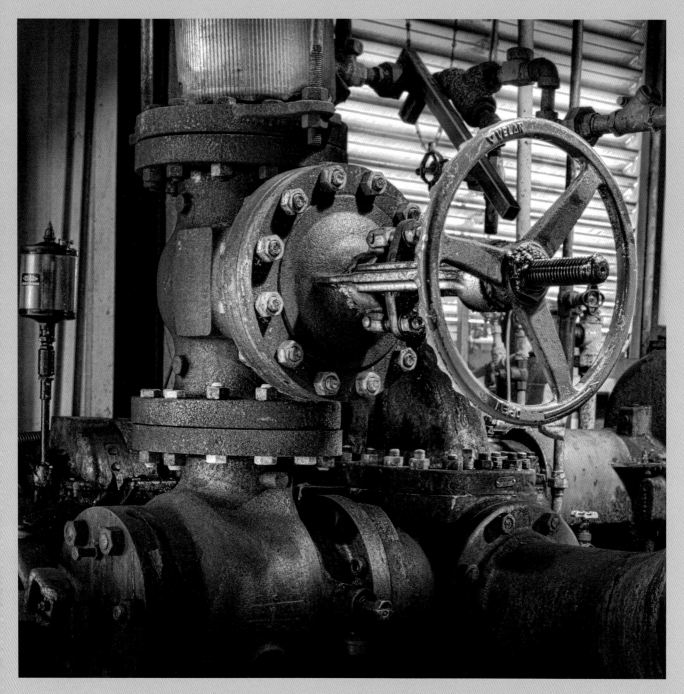

Blue wheel, George T. Stagg Distillery, Frankfort. Wheel-controlling
machinery in the Stagg-era boiler house dates from the post-Prohibition
upgrade in the 1930s.

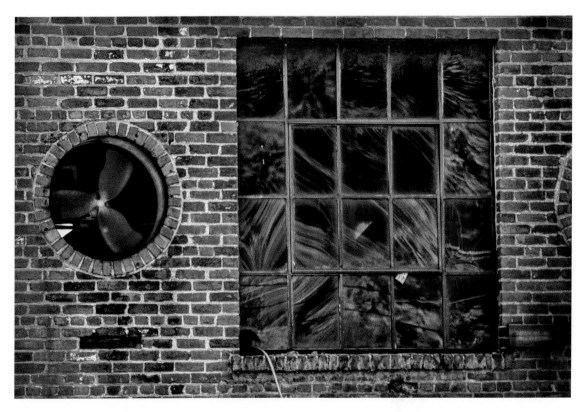

Window and fan, Atherton Distillery, Athertonville.
Decorative brickwork can be seen in the oldest sections of
the distillery. The windows, reflecting summer trees around
the site, were installed in a later century.

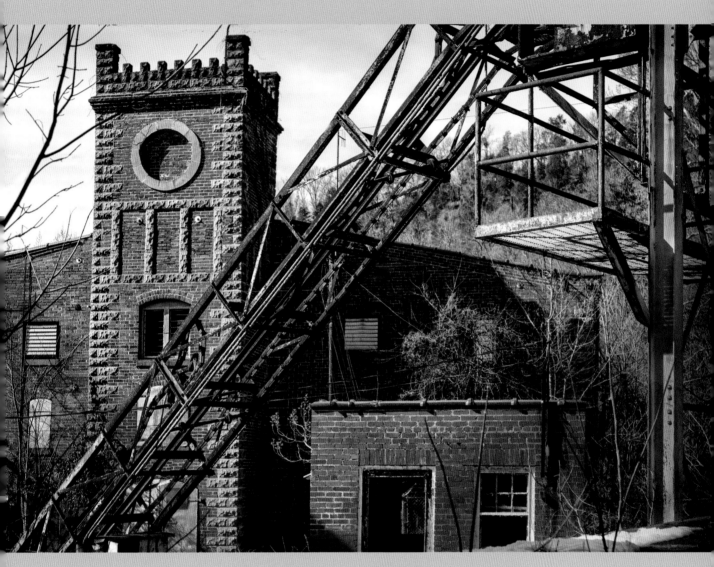

Warehouse and lift, Old Taylor Distillery, Woodford County. The elaborateness of Taylor barrel runs is evident here. They were constructed at a two-story elevation and engineered with pulleys and gears to move the barrels from warehouses across the road into warehouses, storage areas, and the government building.

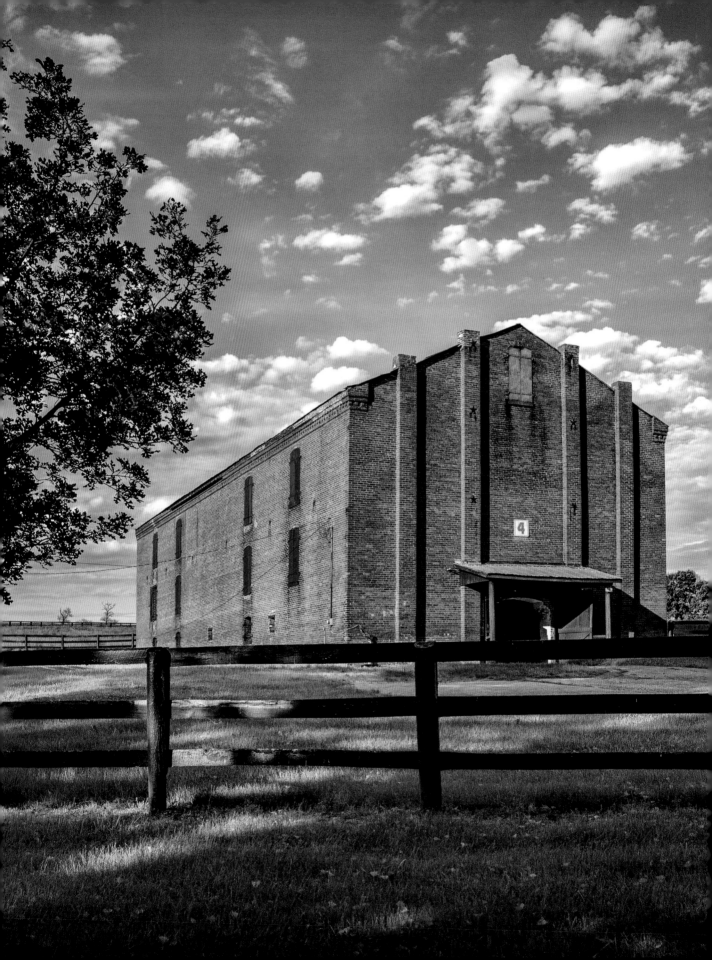

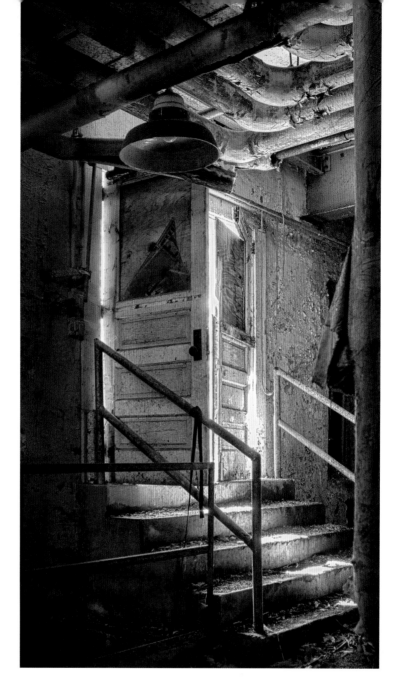

Engine room door, Old Taylor Distillery, Woodford County.
Leading directly from outside, these steps go down into one of
the rooms housing engines and turbines.

OPPOSITE: Brick warehouse at South Elkhorn, Scott County.
One of the oldest brick bourbon warehouses in Kentucky is on
private land, but it can be seen from Interstate 64 northbound
as the South Elkhorn Creek is approached.

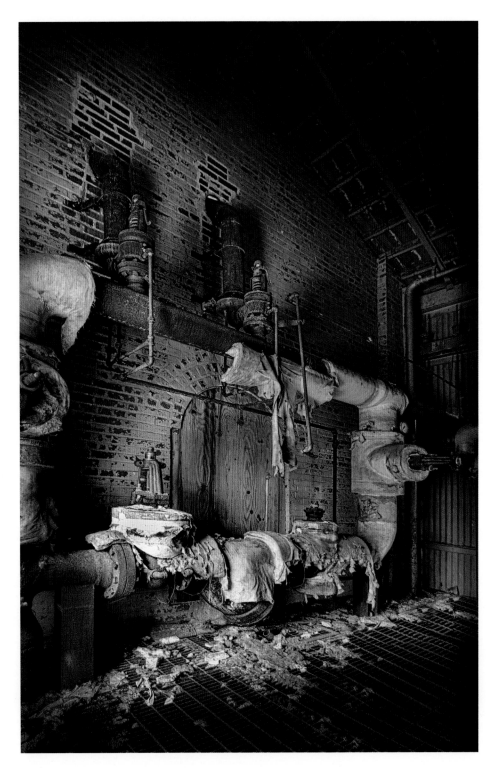

Still house attic, Old Taylor Distillery, Woodford County.
High in the still house is evidence of earlier architecture, bricked
and boarded up to accommodate later engineering.

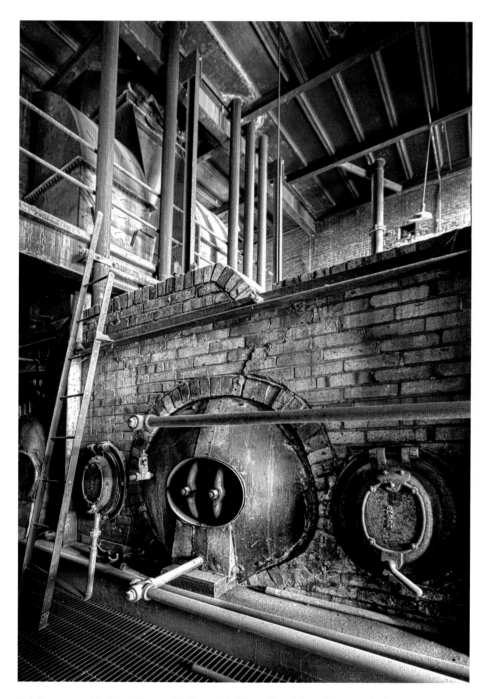

Brick oven and ladder, George T. Stagg Distillery, Frankfort. It was typical
for the post-Prohibition bourbon plant, although primarily designed to be
efficient, to include some architectural decoration, such as the curved brickwork
of this oven. The curvature of this brickwork suggests that Colonel Taylor's
influence was left somewhat intact when the distillery was later updated by
Blanton and Schenley. The front of the original distillery building was removed
to modernize the plant and create a new powerhouse.

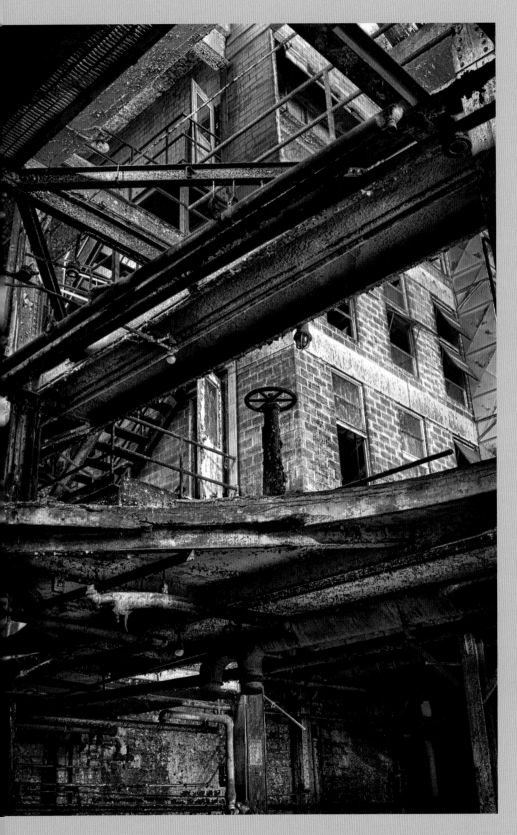

Interior view, looking
up, Old Crow Distillery,
Woodford County. In
this view of the still
house, looking up from
the basement through
an opening that once
surrounded a large tub,
one can see the interior
evolution of the distilleries
on this site. Beginning with
hand-cut stone, then brick,
and finally blond tiles in the
1970s, and moving from
wooden beams to metal
scaffolding, the expansions
span 150 years.

Dancing valves, J. E. Pepper Distillery, Lexington. Over the decades since the distillery shut down, much of the internal works has been salvaged, so that pipes, hanging chutes, and other unengaged elements have been left disconnected. These items sometimes create interesting sculptures in their new incarnation.

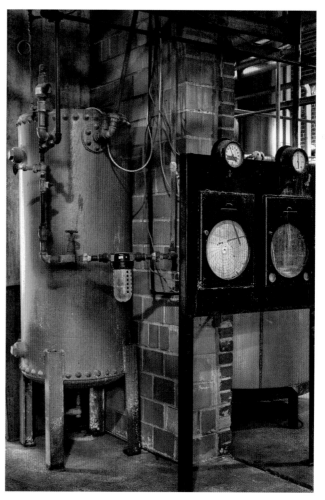

Orange tank and black dial, George T. Stagg Distillery, Frankfort. Although replaced by newer, digital equipment in the currently operating Buffalo Trace plant, these elements of the Stagg distillery remain witnesses to cutting-edge technology of the early twentieth century, when they were installed by Schenley Distillers.

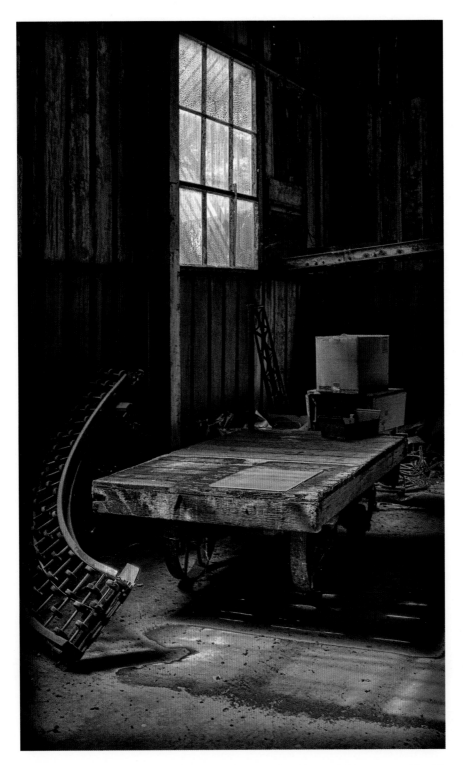

Bottling house cart, T. W. Samuels Distillery, Deatsville. This still life presented itself at the end of the bottling house where boxes were transported outside. The barred windows can be clearly seen, as well as a section of the bottling conveyer run.

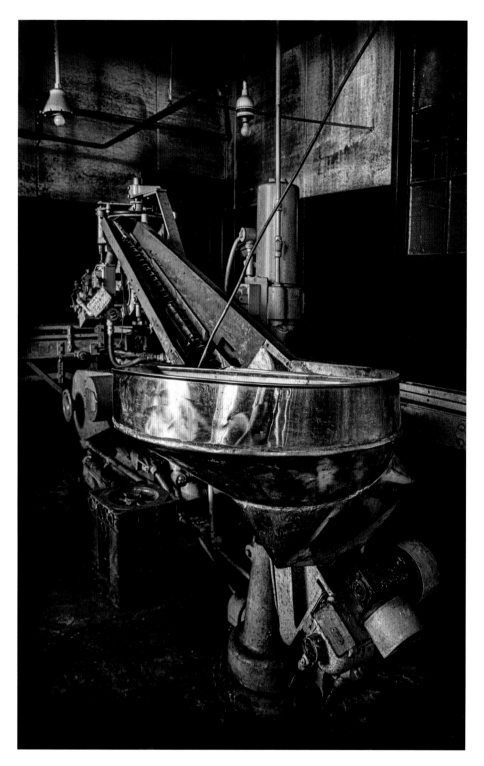

Silver basin, T. W. Samuels Distillery, Deatsville. Part of the original post-Prohibition remodel, this bottling room basin was repurposed for bottling water in the late twentieth century.

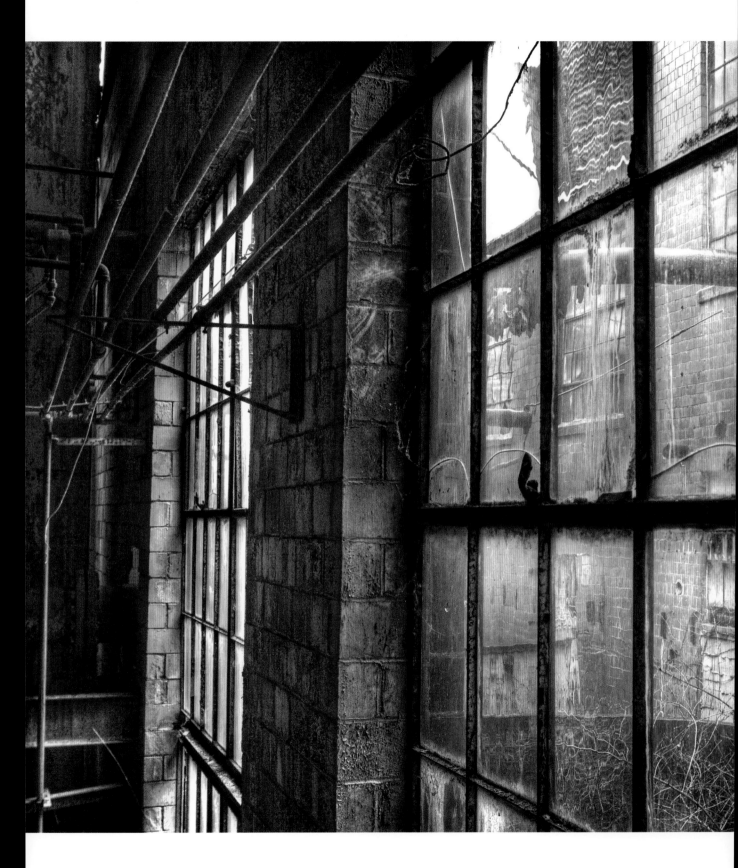

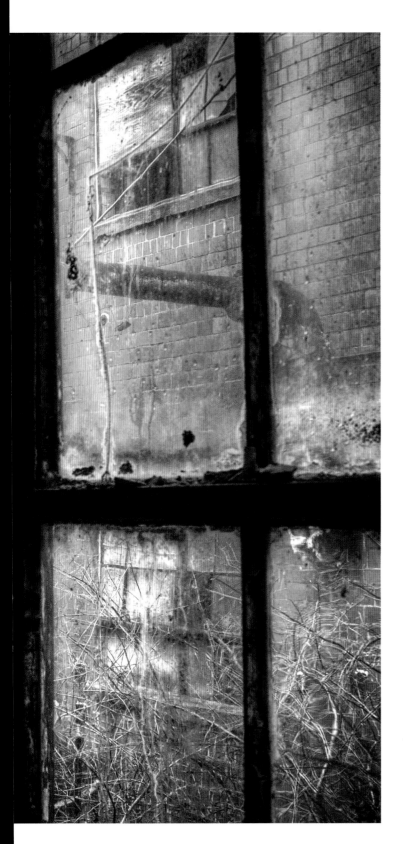

Engine room window,
J. E. Pepper Distillery, Lexington.
This is a view from the second
level of the engine room, looking
across outside slop tubs to the
fermenting, still, and processing
section of the plant.

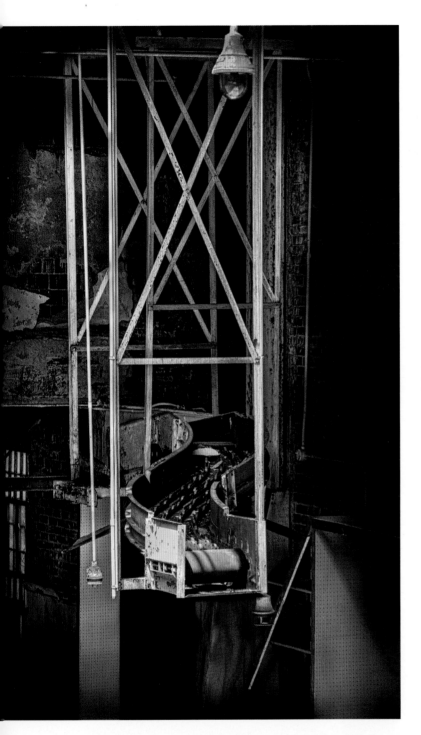

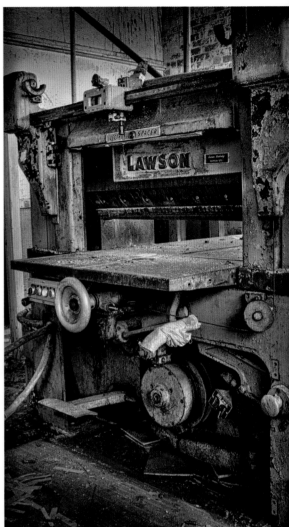

Lawson labeler, Old Taylor Distillery, Woodford County. After Prohibition was repealed, labels for products distilled on-site were printed in the government building. This labeling machine printed labels for a variety of products to be sold in many states, not just bourbon in Kentucky.

Bottling chute, Old Taylor Distillery, Woodford County. Historical photos of the bottling house show the bottling conveyers somewhat differently in the late 1800s. This updated post-Prohibition rack chute resembles those at T. W. Samuels.

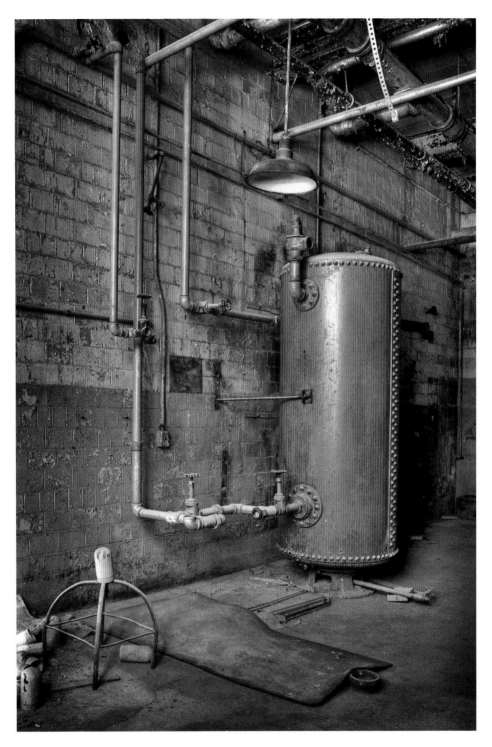

Orange boiler, J. E. Pepper Distillery, Lexington. Color-coded pipes indicated various things in the distillery. Located in the room with engines and dials next to the boilers in the powerhouse, this orange tank indicates it and the pipes connected to it are hot.

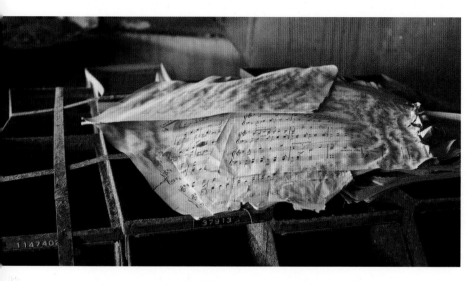

Music on racks, J. E. Pepper Distillery, Lexington.
In the office area of the plant were some old papers, including
this sheet music. I felt a certain mysterious feeling when
I encountered human elements like this within the huge,
abandoned spaces of the ruins.

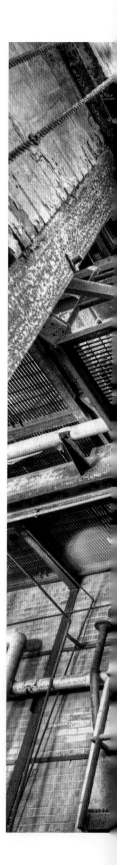

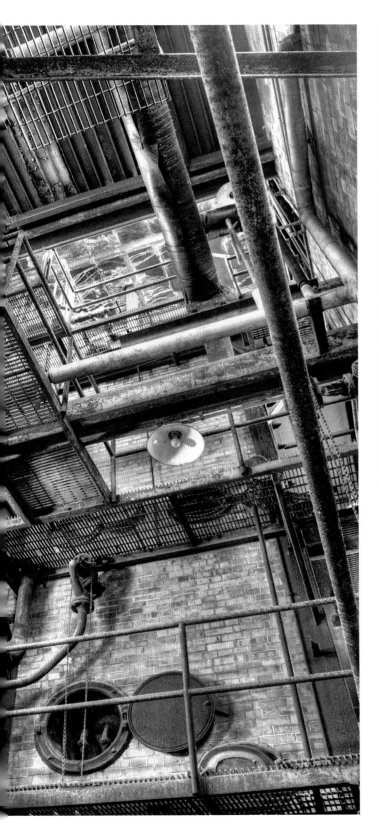

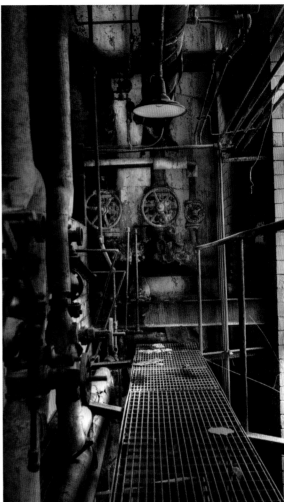

Second-floor catwalk, J. E. Pepper Distillery, Lexington. Catwalks, going up four stories, surrounded the steam ovens and boiler engines in the powerhouse. The updated industrial plant replaced wooden walkways with fireproof metal ones.

Catwalk, J. E. Pepper Distillery, Lexington. Looking up three stories in the powerhouse, one could see the walls of the steam boilers, metal catwalks, oven doors, light fixtures, and all manner of pipes.

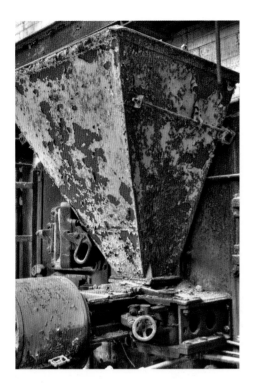

Red hopper, J. E. Pepper Distillery, Lexington. Located in the powerhouse, this hopper delivered coal into the stoker below.

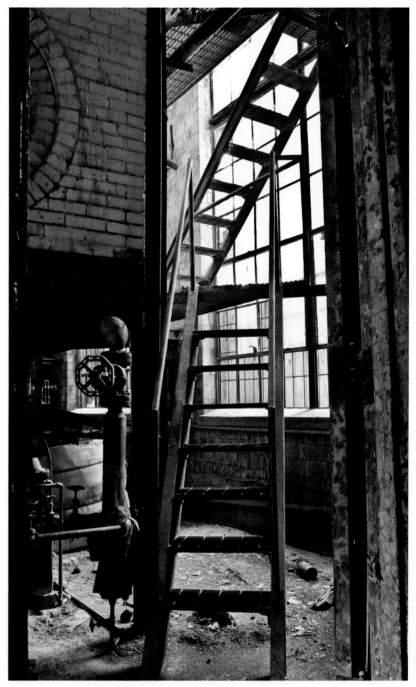

Engine room climb, J. E. Pepper Distillery, Lexington. Metal ladders, catwalks, and green brick ovens were lighted with the help of large industrial windows.

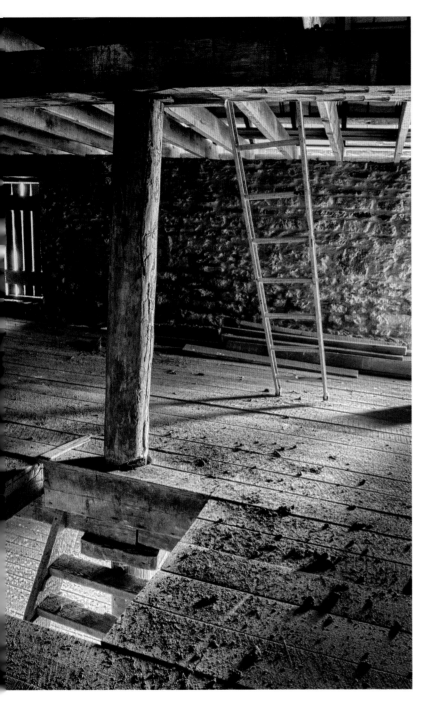

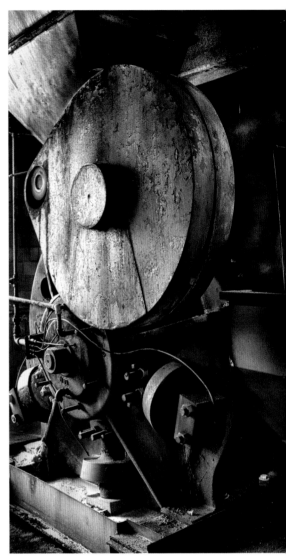

Dry house press mill, George T. Stagg Distillery, Frankfort. The dry house is where the spent grain is processed for recycling as livestock feed. This press mill from the 1930s continues to be used today to squeeze the moisture out of spent mash.

Warehouse, second floor, Jacob Spears Distillery, Bourbon County. The Spears Distillery warehouse is part of one of the oldest bourbon distillery complexes still standing. This view of the internal area of the second story shows original beams and stonework.

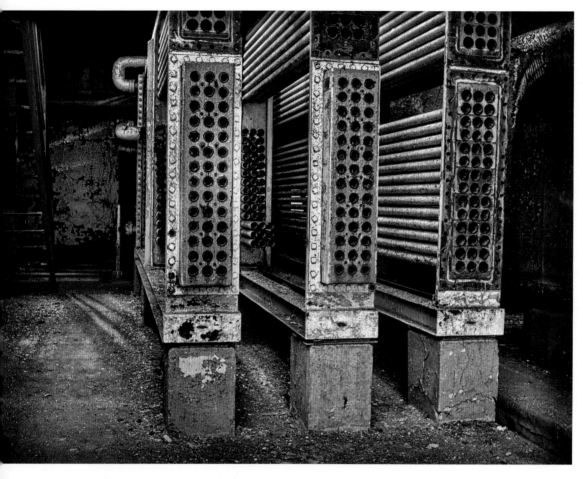

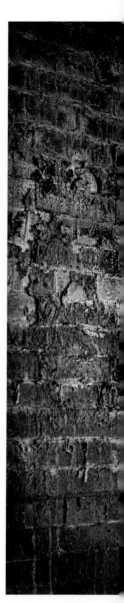

Chilling radiators, Old Taylor Distillery, Woodford County. Chilling coils cooled the temperature of the mash in these cold radiators. Identical radiators are present in the basement area of the Stagg fermenting room. These, below Taylor's fermenting room, have retained more detail.

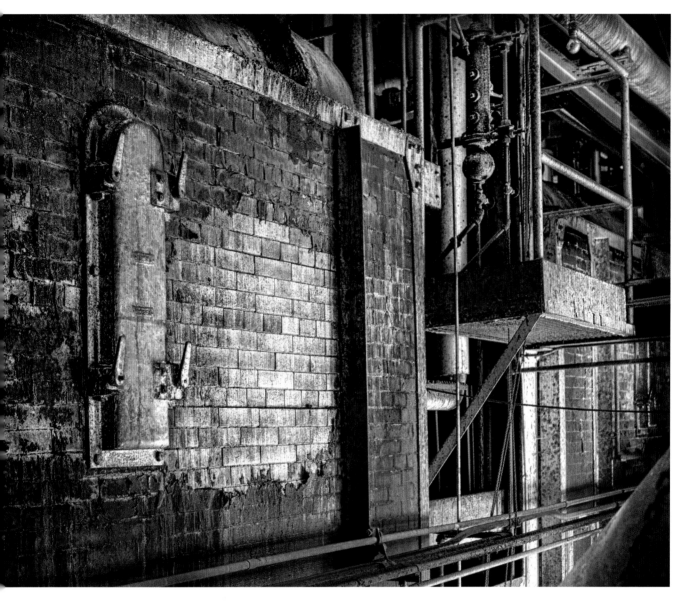

High oven door, Old Crow Distillery, Woodford
County. Up on the second level of the steam boilers
are the vents for controlling heat. At Old Crow the
doors were straightforward iron oven doors. At other
distilleries there were various brick embellishments.

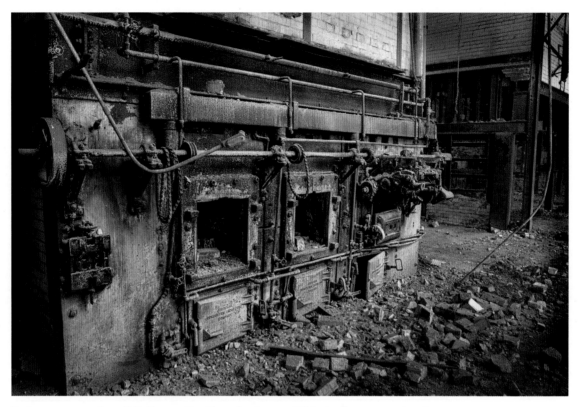

Boiler oven openings, J. E. Pepper Distillery, Lexington. With the hoppers and stokers stripped away, the openings of the ovens that heated steam in massive coils can be seen. A green color from the heat and industrial process stains the area surrounding the ovens; another green, intentionally painted on the brick, is seen above the ovens.

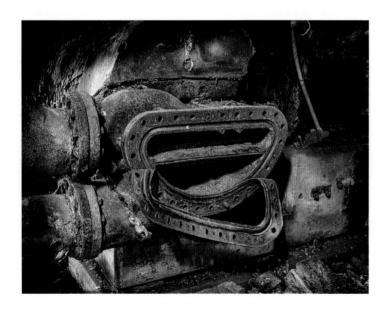

Gasket lips, Old Taylor Distillery, Woodford County. A detail from the engine room shows the rubber seal used when two pipes were connected.

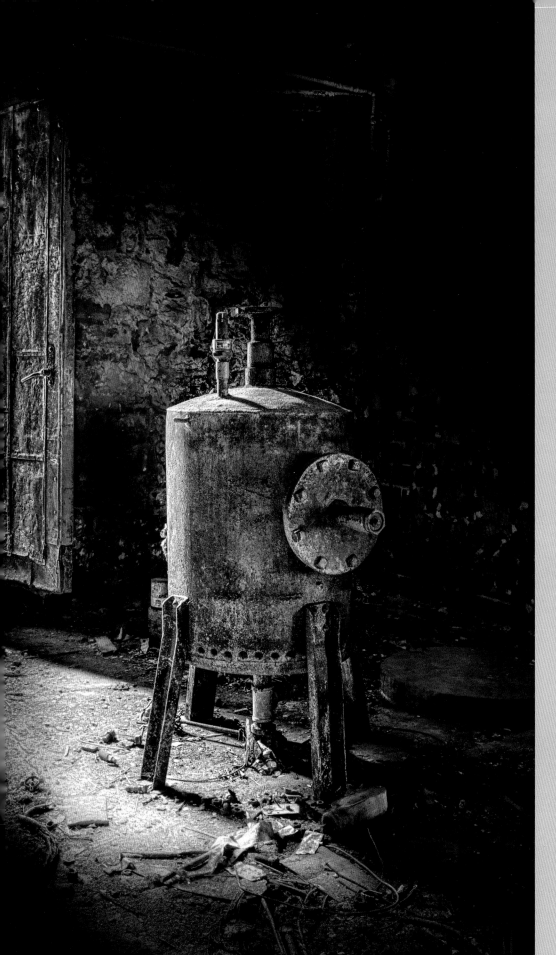

Orange heater, Old Crow Distillery, Woodford County. An isolated heating tank sits in the engine room. Note the steel-coated fire door in the background.

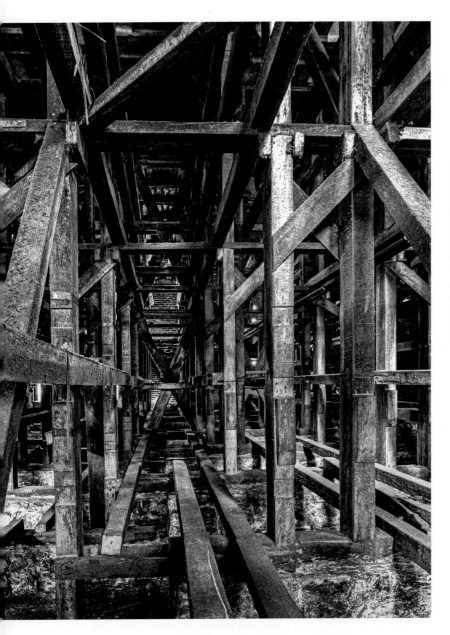

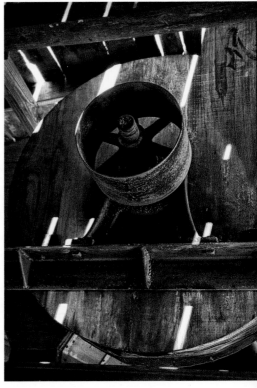

Monitor wheel, Dowling Distillery, Burgin. A close-up of the meal cleaner shows the wheel that was part of the belt-driven system.

Warehouse rafters, Old Crow Distillery, Woodford County. The interior rows of this rick-system warehouse rest on hand-cut stone foundations.

Peeling warehouse siding, Dowling Distillery, Burgin. The Dowling Distilling Company operated just outside Shakertown, near Burgin, along the railroad tracks. This typical rick warehouse was in the process of being torn down as I photographed it in 2013. Here the metal siding that covered the wooden cypress siding boards has been peeled away. Metal siding was used as one measure to contain fire, an all-too-common occurrence for distillery warehouses.

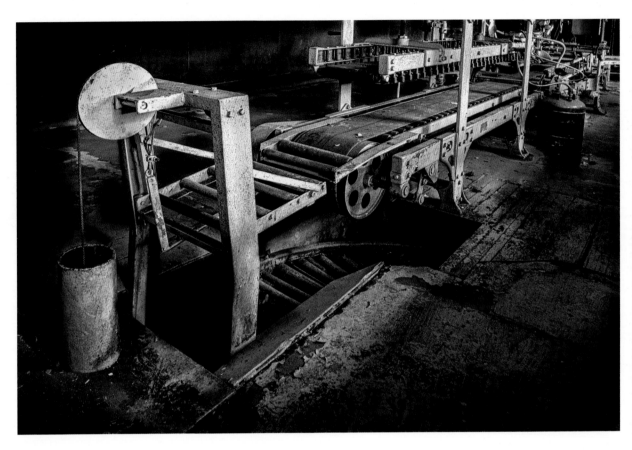

Bottling run drop, T. W. Samuels Distillery, Deatsville. Original bottling lines transport boxes of bottles beneath the room; they reappear in another part of the bottling house. The bottling room was one of the most intact rooms in the distillery because of the repurposing of the complex for water bottling in the 1990s.

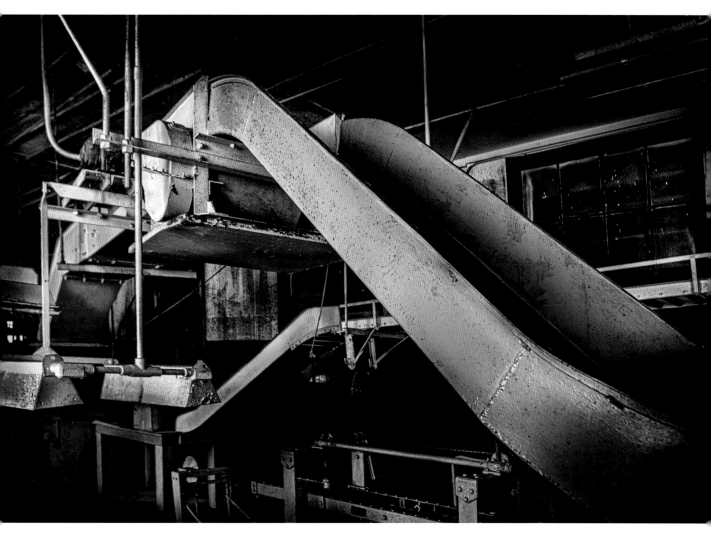

Bottling room slide, T. W. Samuels Distillery, Deatsville.
Bottling conveyers transported boxes of bottles both under
and over the bottling room.

Hose abstract, Old Taylor Distillery,
Woodford County. Color, line, and
texture throughout the distilleries often
come together through juxtaposition
of dormant functional objects. Here
a measuring stick and old fire hose
become found objects full of color
and design.

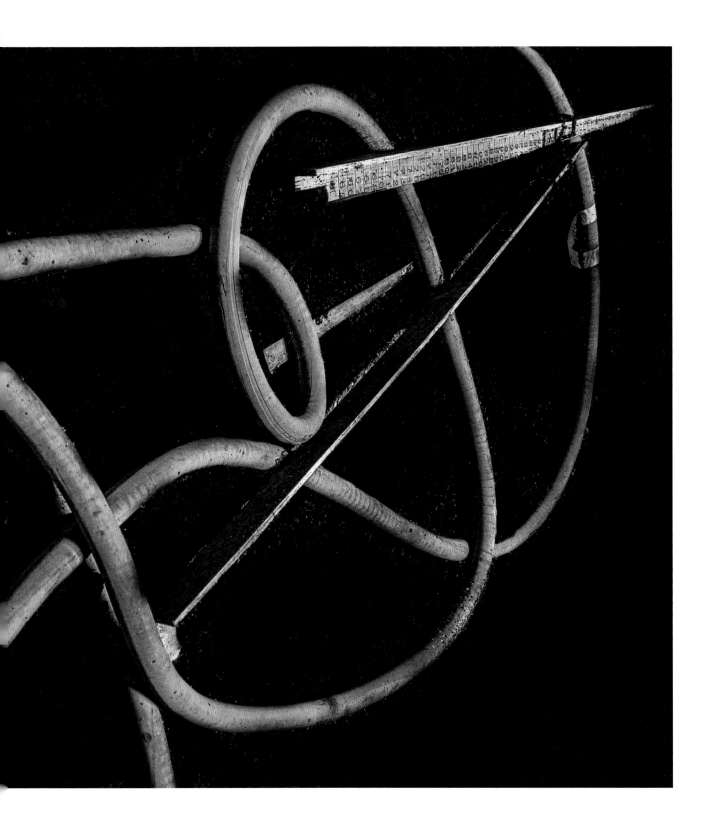

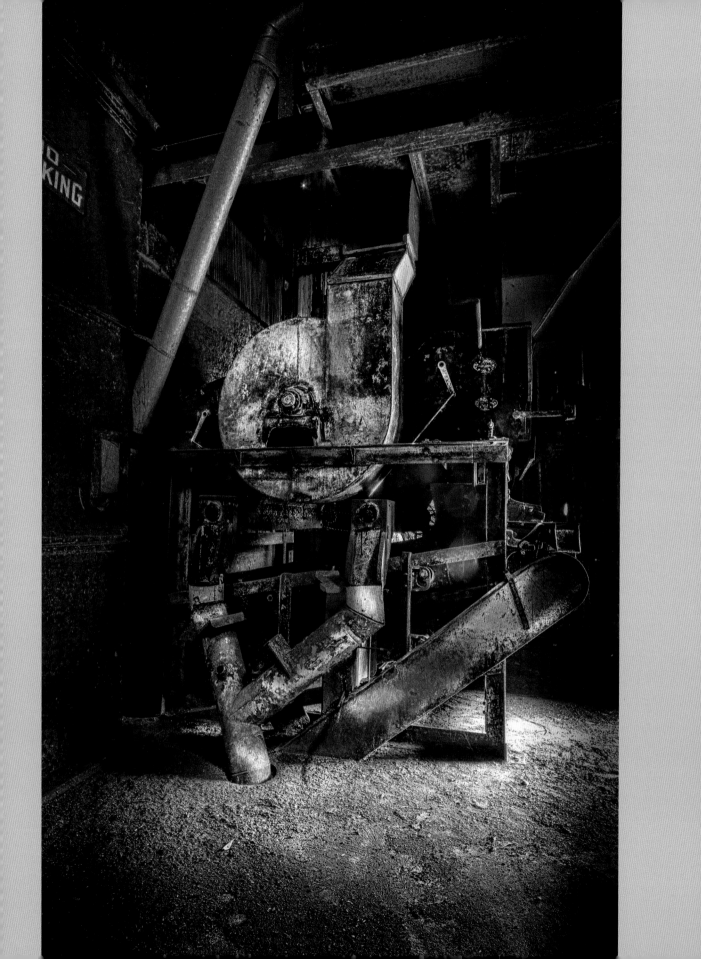

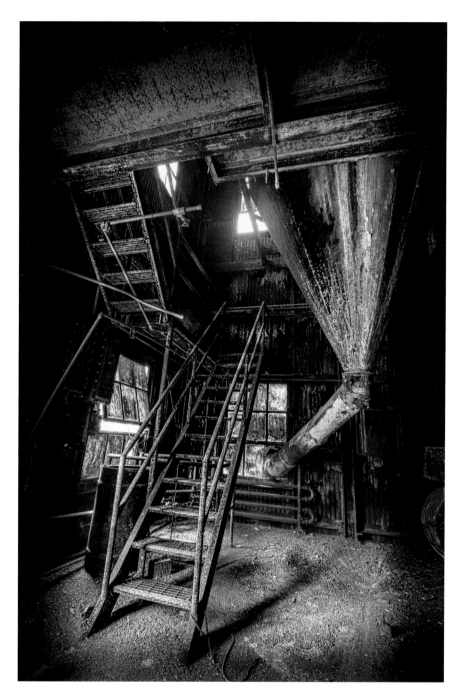

Granary steps, Old Crow Distillery, Woodford County. The granary building was separate from the still and fermenting house at Old Crow. Within the granary building were designated places for grinding, cleaning, and storing the various grains used in the production of the mash bill.

OPPOSITE: Granary meal cleaner, Old Crow Distillery, Woodford County. Identical models of this grain cleaner were found at Dowling Distillery and J. E. Pepper Distillery.

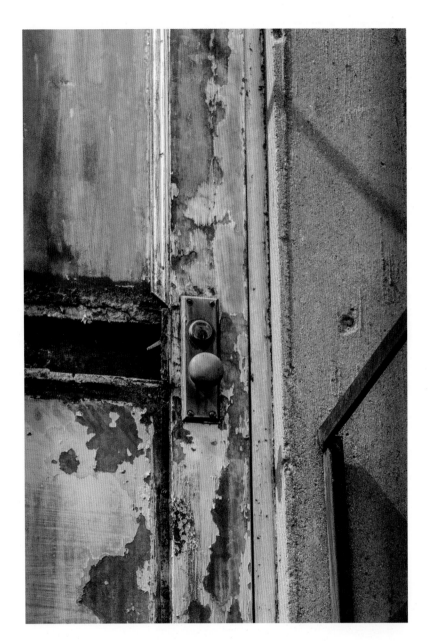

Warehouse doorknob, Old Taylor Distillery, Woodford County. On the roof of the post-Prohibition warehouse is a small utility shed; its doorknob has somehow managed to stay intact. One can compare this doorknob to the early-twentieth-century embellished handle inside the distillery (see page 98) to see the difference in pre- and post-Prohibition embellishments.

OPPOSITE: Blue and orange oven rust, George T. Stagg Distillery, Frankfort. In the boiler house an old oven, no longer in use, displays the amazing design and engineering of historical ovens. Heat has oxidized the metal to this orange color, though some of the original blue has been retained. This oven is another example of the functional being transformed into art.

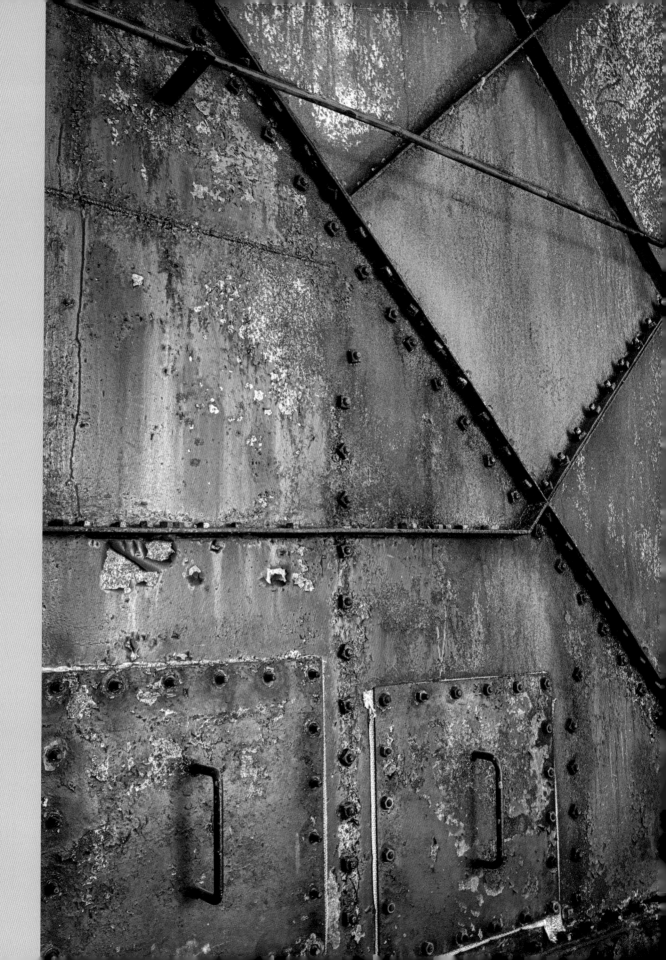

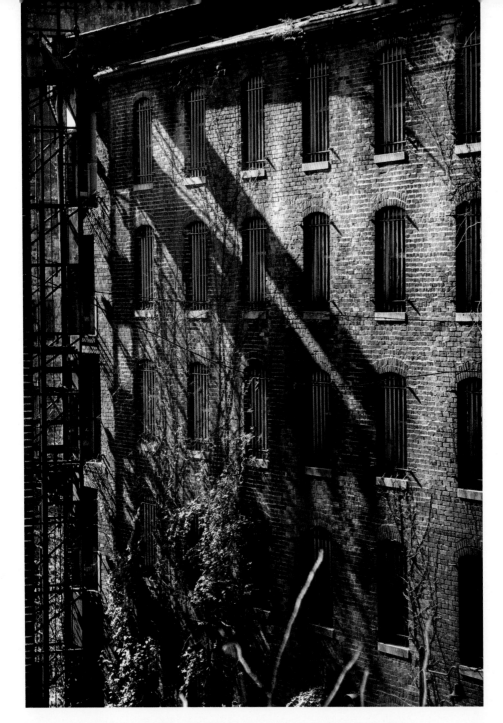

Warehouse, Old Crow Distillery, Woodford County. Only three of the earliest rick-style warehouses still remained when I was photographing. Torn down for salvage much earlier were at least three other nineteenth-century warehouses. Adjacent to the ruins on what was once Old Crow property are several of the newer-style pillar and concrete warehouses now housing product from Jim Beam Distillery.

OPPOSITE: Warehouse scaffolding, Dowling Distillery, Burgin. Once the siding was removed from the warehouse, the rick barrel-aging system could be seen from the ground floor up to the roof.

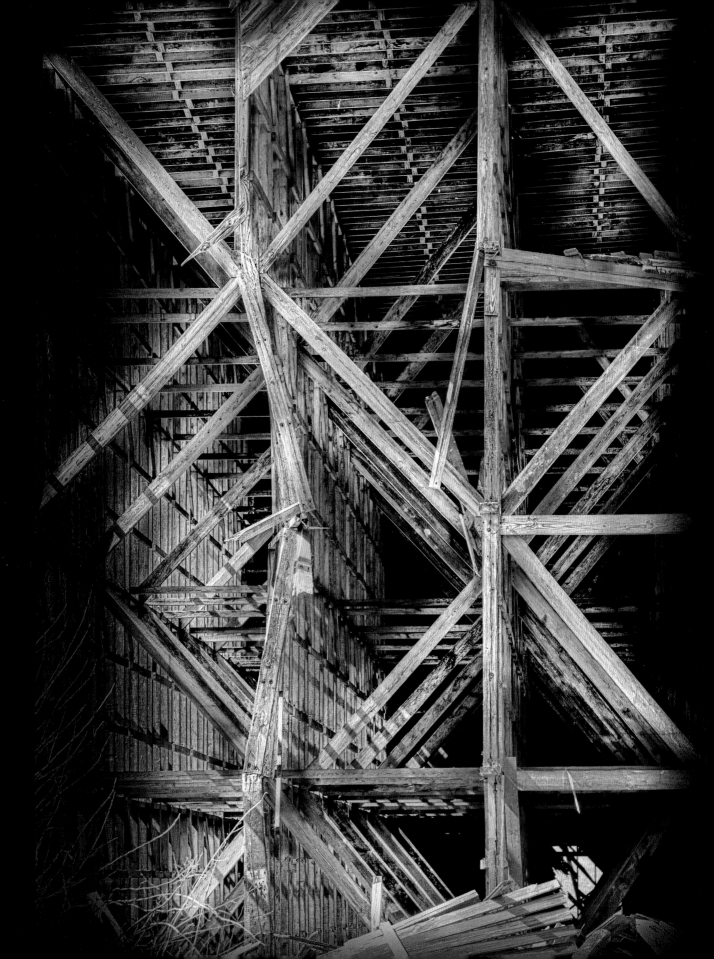

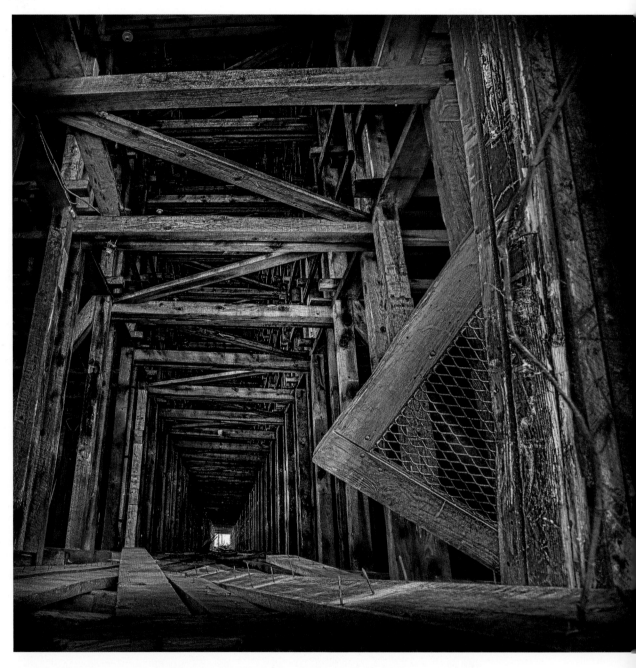

Green screen, Dowling Distillery, Burgin. As you look down the main aisle of the Dowling warehouse, the rick system's interior can be seen. Off to each side of this aisle would have been ricks that held barrels three high for aging.

OPPOSITE: Warehouse nave, George T. Stagg Distillery, Frankfort. Warehouse B is the oldest warehouse on the Stagg site, going back to the 1800s. It was restored after tornado damage decades ago and now sits empty. This view looks down a barrel rick.

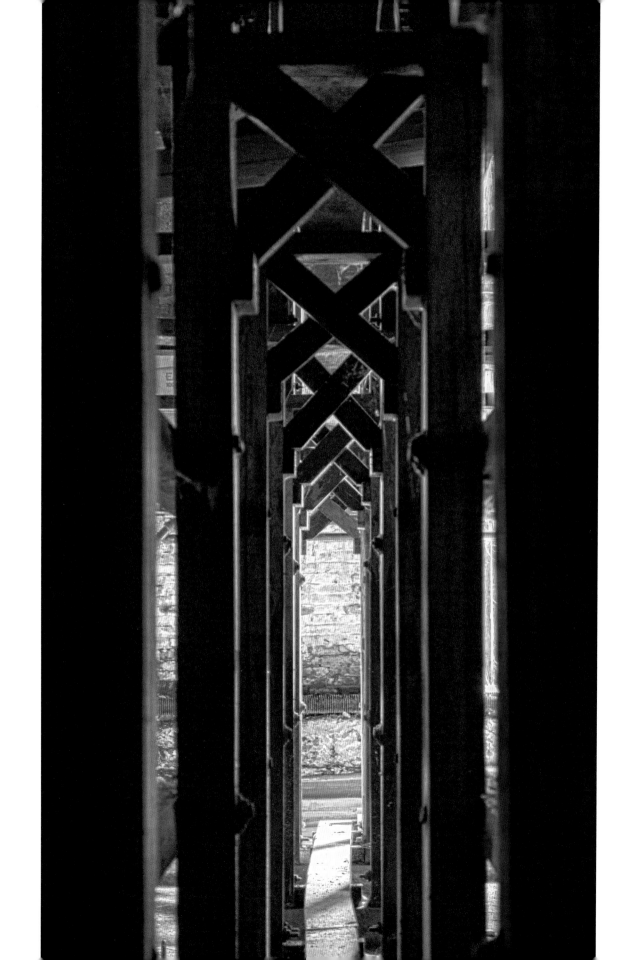

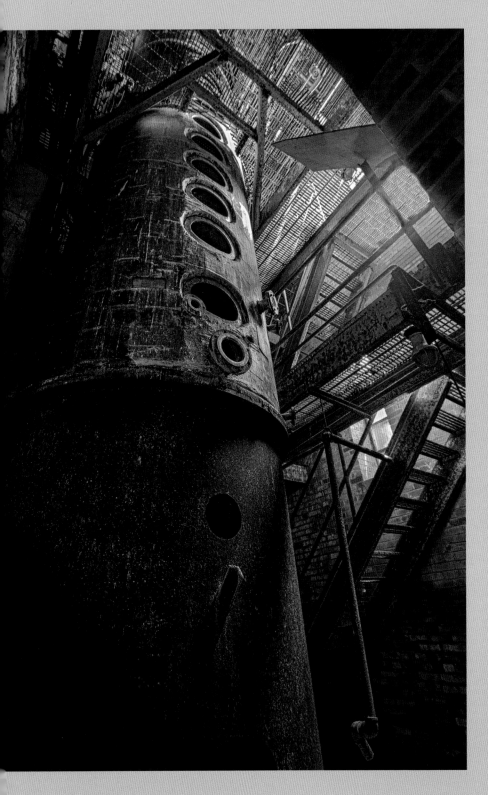

Column still, Old Taylor Distillery, Woodford County. The column still was originally created by an Irishman, Aeneas Coffey, in 1830. Its design allowed a higher concentration of alcohol—about 65 percent at that time (compared to 95 percent now). The column still goes by several names, including continuous still, patent still, and Coffey still. Rising five stories high, the Taylor still's rectifying column remains as it was when it was abandoned in the late 1980s.

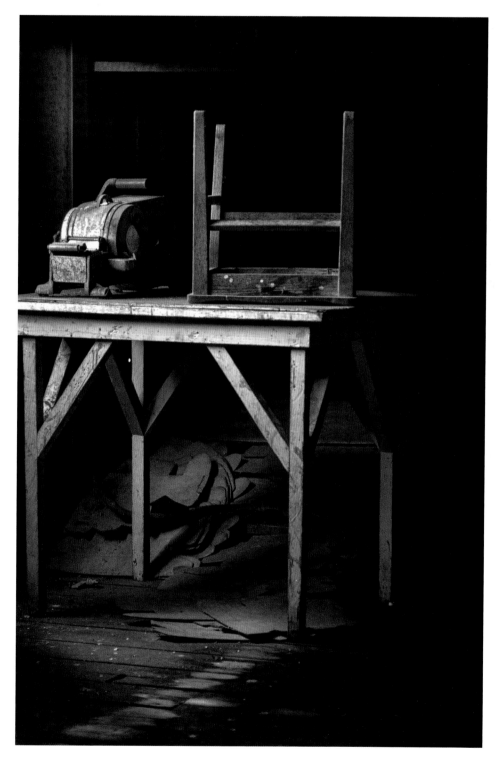

Table and labeler, T. W. Samuels Distillery, Deatsville. Within the Samuels distillery were not only stills, tubs, engines, and heavy machinery. The smaller equipment needed for the business of bourbon, such as this hand-labeling machine, was also found.

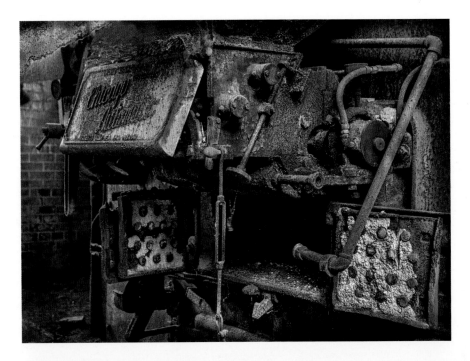

Chicago Automatic stoker, T. W. Samuels Distillery, Deatsville. Here are the remains of a coal-fed oven that heated a steam boiler for power in the boiler room.

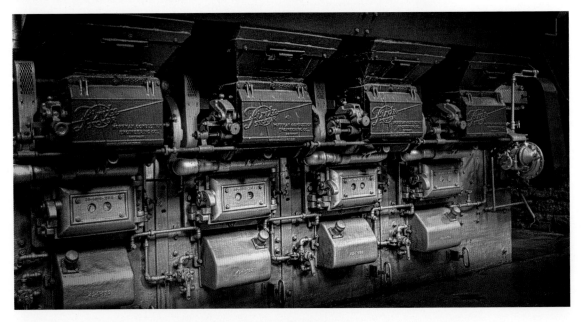

Green ovens, George T. Stagg Distillery, Frankfort. Although no longer in use and replaced by modern power sources, the old boiler house ovens were functional from the early 1930s until recently and so are in good condition. The front of the old O.F.C. Distillery was removed in order to install these stokers.

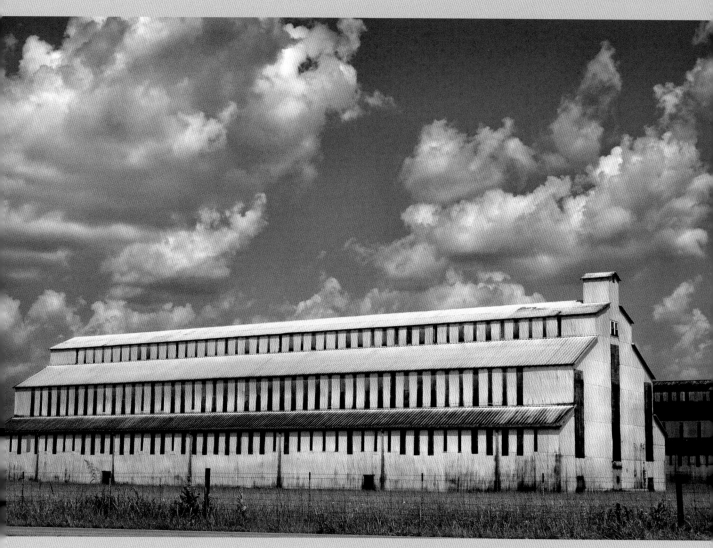

Warehouse, T. W. Samuels Distillery, Deatsville. The unique taste of bourbon is the result of not only the mash bill but also chemical processes that occur within the charred barrels while they age in the warehouse. There is a temperature-time relationship in this aging process. For centuries building designers have tried to figure out how to get the best results combining variations in humidity, temperature, and time. Although there is a science to it, this is the art of bourbon making. Bill Samuels Sr. designed this warehouse hoping to create better air circulation inside and more exposure to the sun outside for better aging.

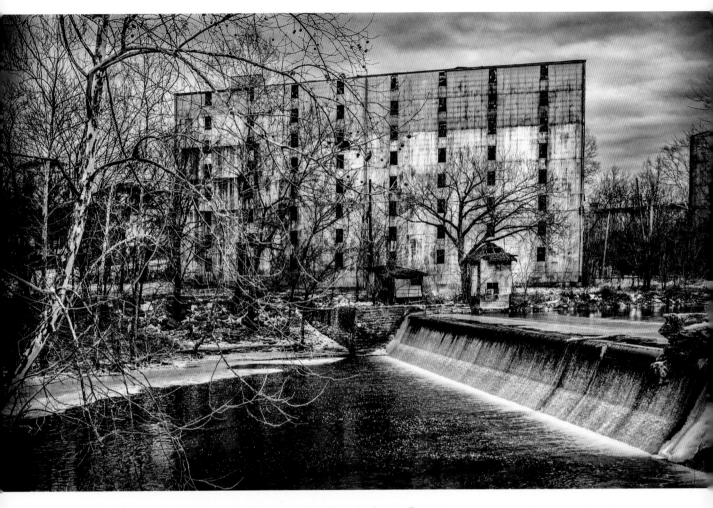

Warehouse and pump house, Old Prentice Distillery, Anderson County.
A waterwheel once powered an adjoining distillery at this site. It also is the
site of the old pump house used by Old Prentice.

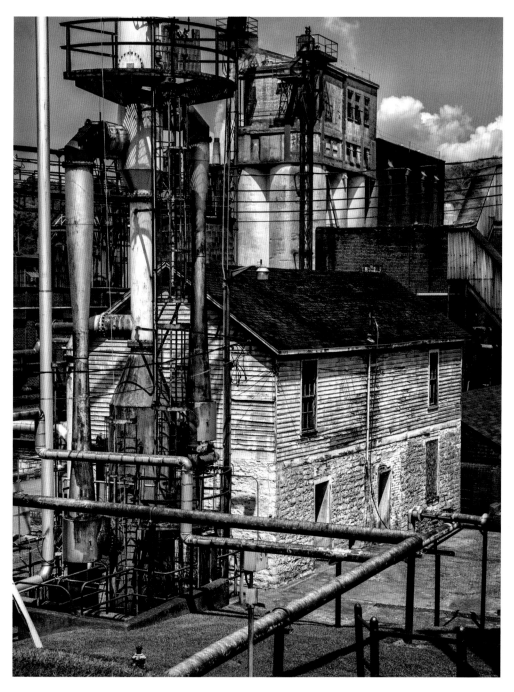

Commander Richard Taylor's house, George T. Staggs Distillery, Frankfort. Built in
the late 1700s and expanded in the 1800s, this historical house is believed to be one
of the original residential structures built during the formation of Leestown along the
Kentucky River in the 1700s. Distilleries grew up around it over the years. Later used as
a laboratory and a medical facility, as well as an office at various times, the house is now
known as the Taylor Building after Commander Richard Taylor, who was commissioned
to build the Kentucky River locks. It is being restored to its original state.

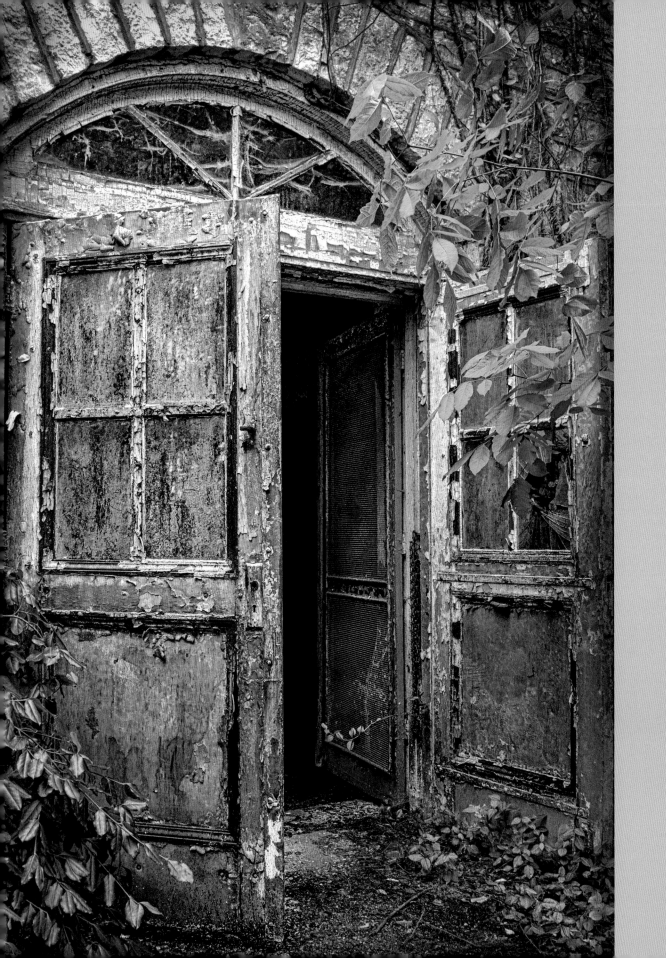

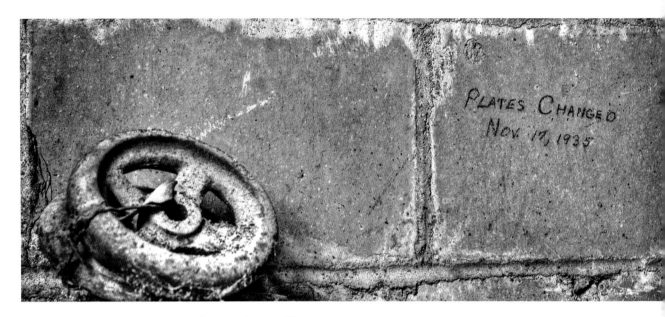

"Plates changed," J. E. Pepper Distillery, Lexington. Next to several spare plates, "Plates changed Nov. 17, 1935" is written on the wall. The plant was brand-new at that time.

OPPOSITE: Backdoor of the fermenting room, Old Taylor Distillery, Woodford County. The arched doorway leads from the fermenting room to an outdoor courtyard that is connected to the stillrooms and engine rooms.

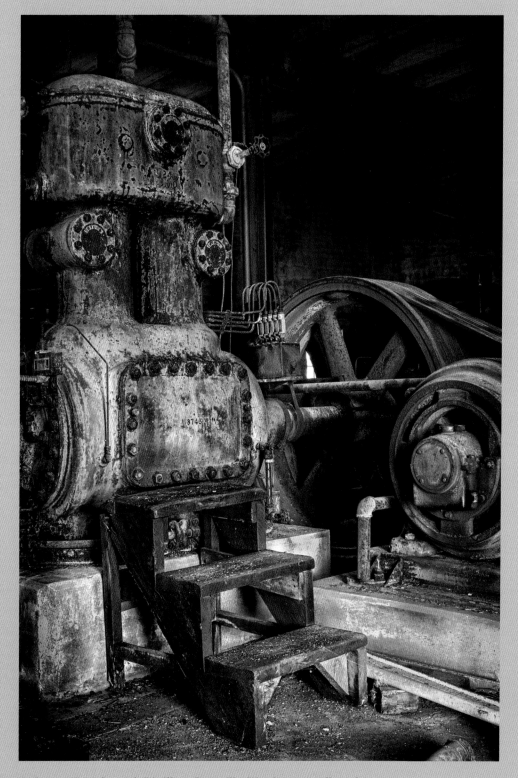

Red steps, T. W. Samuels Distillery, Deatsville. Wooden steps allowed
workers access to one of two turbines in the engine room.

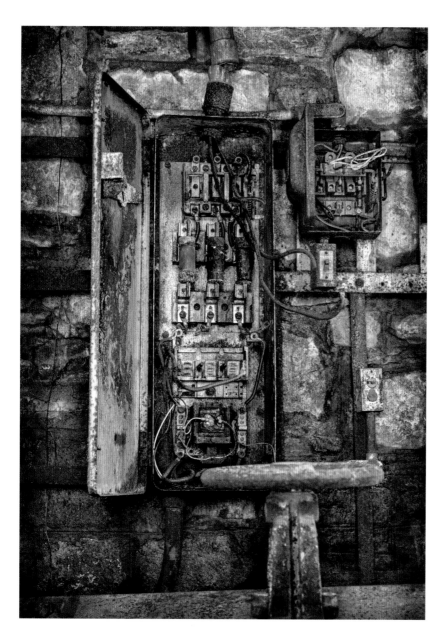

Electric box, Old Crow Distillery, Woodford County. An old twentieth-century fuse and electrical wire box is mounted on a nineteenth-century wall. This box probably controlled water flow from the springhouse nearby.

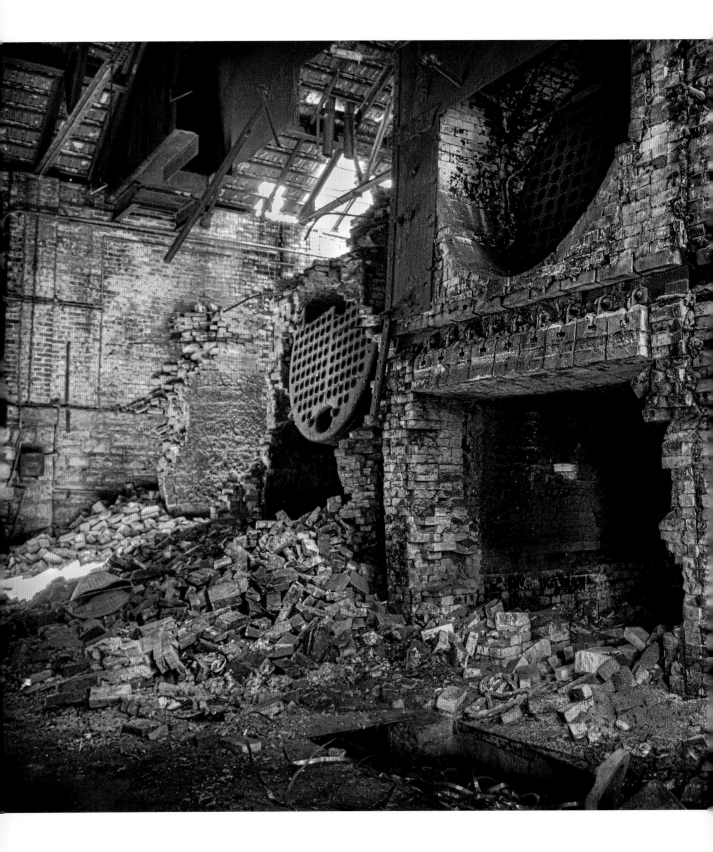

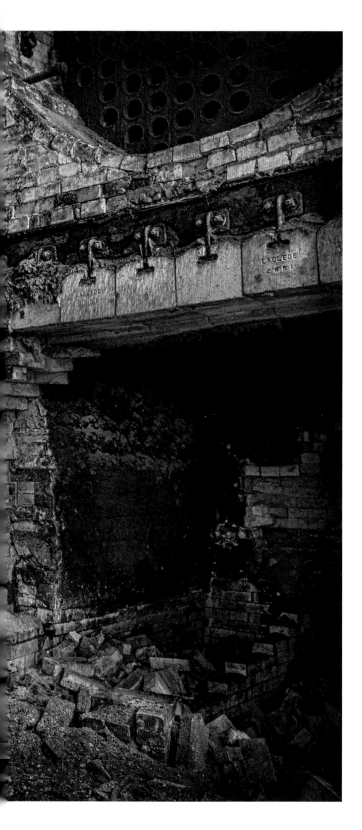

Boiler oven structure, Old Taylor Distillery, Woodford County. This long view of the ovens that powered the distillery with coal and steam shows both the intact brick supports and the iron steam cylinders.

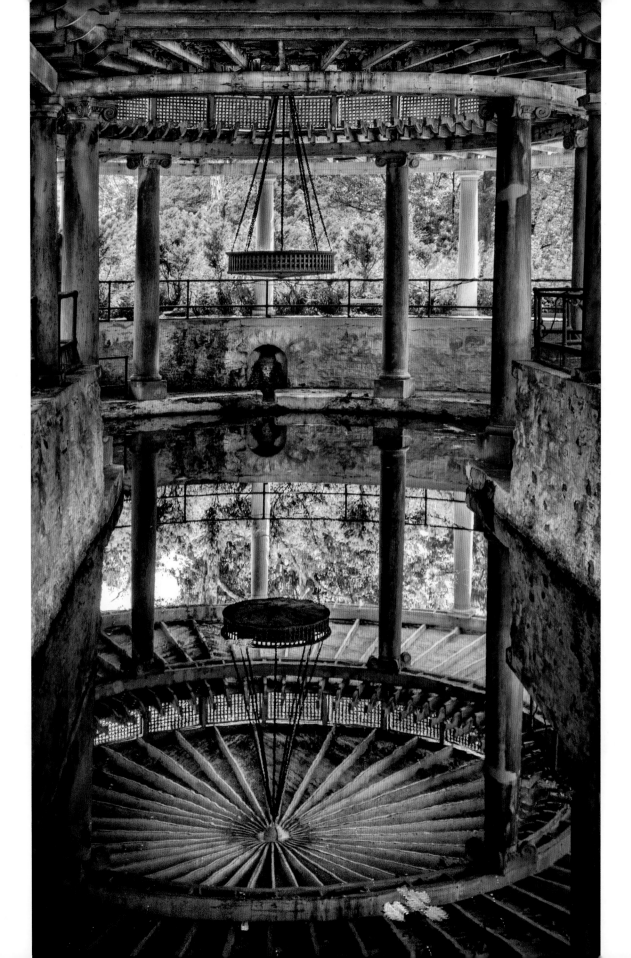

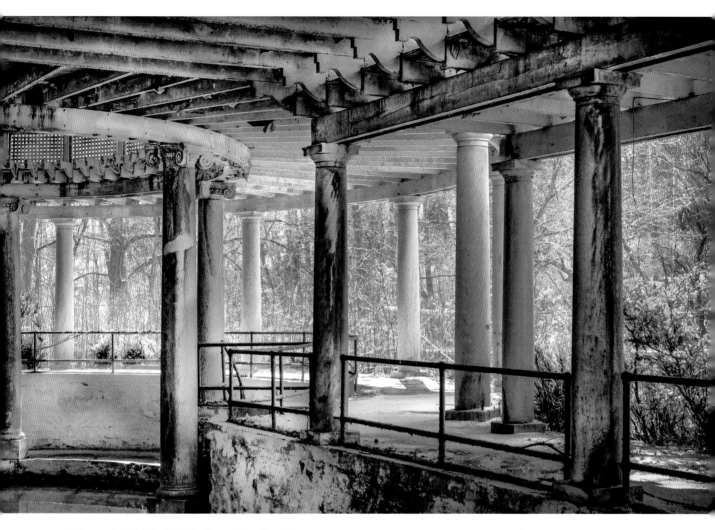

Colonnade, Old Taylor Distillery, Woodford County.
This view of the famous art nouveau pergola faces away
from the distillery, toward the peristyle spring pool.

OPPOSITE: Peristyle reflection, Old Taylor Distillery,
Woodford County. As can be seen in the reflection of the
peristyle ceiling, art nouveau features abound.

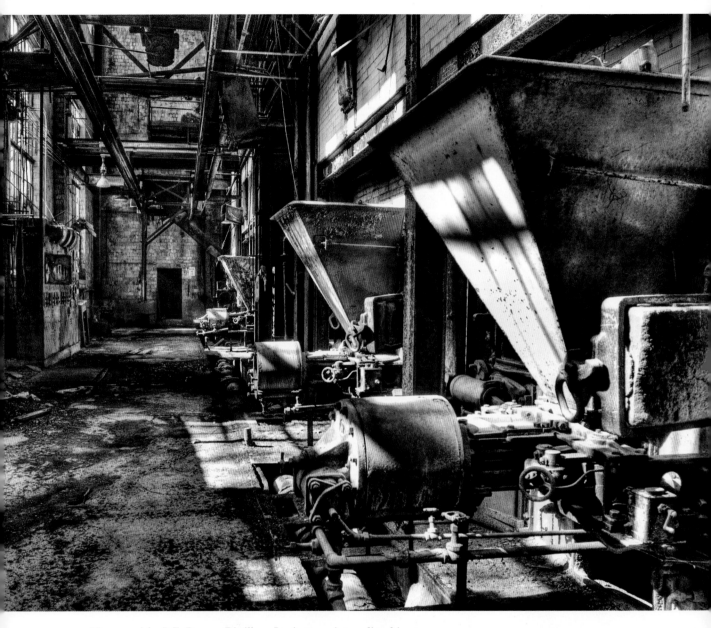

Hopper aisle, J. E. Pepper Distillery, Lexington. A traveling bin
suspended from the ceiling would move the length of the powerhouse,
delivering coal to the oven's bins. This newer system was more
efficient than the long pipe used in the Old Crow Distillery.

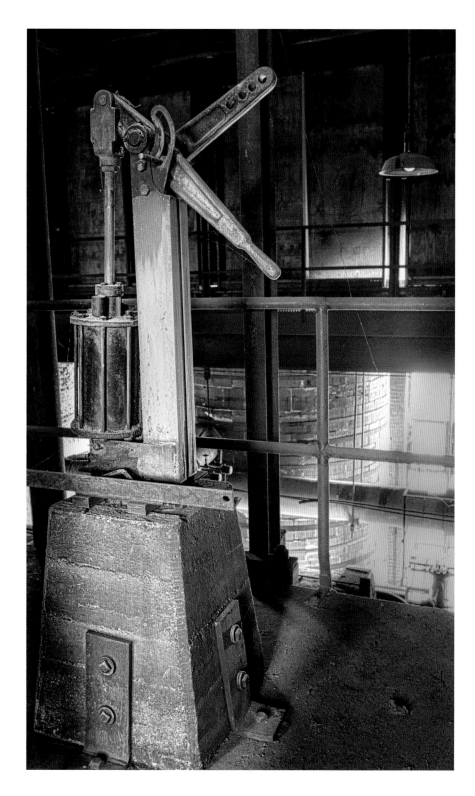

Green pump,
George T. Stagg
Distillery, Frankfort.
This bright primer
is located in the old
section of the boiler
house.

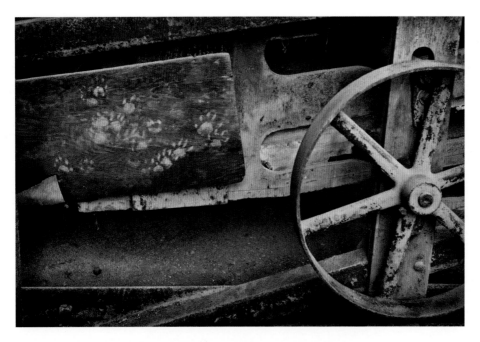

Footprints on grain cleaner, J. E. Pepper Distillery, Lexington. Because of the amount of grain residue, old distilleries frequently have evidence of animal visitors. Here, against the grain cleaner, are raccoon prints.

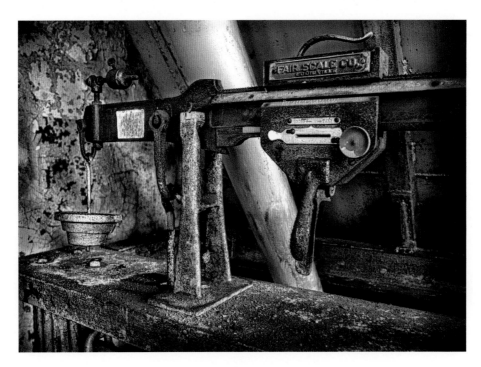

Fair Scale detail, Old Crow Distillery, Woodford County. This is a detail of the scales used for the traveling scale hoppers. Fairbanks Premier Scale Company made the Fair Scales used in distilleries from the earliest times.

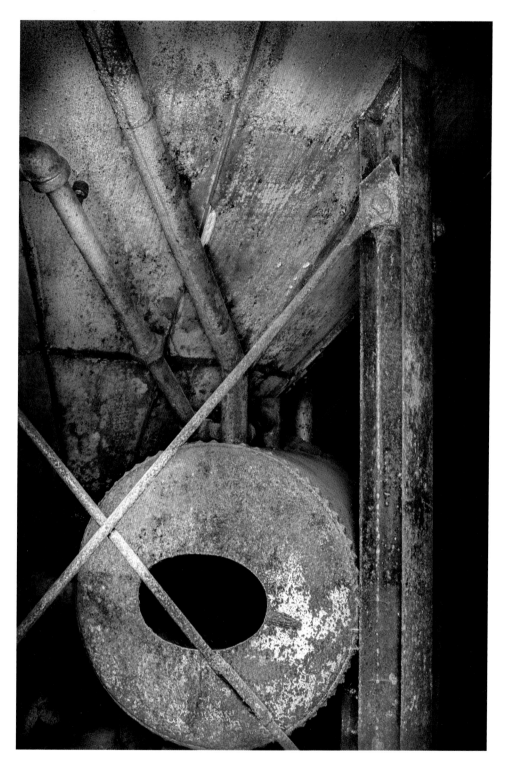

Boiler and pipe X, Old Crow Distillery, Woodford County. Old tanks
probably once part of a boiler and hopper ensemble now create an
abstract design when photographed through an open door.

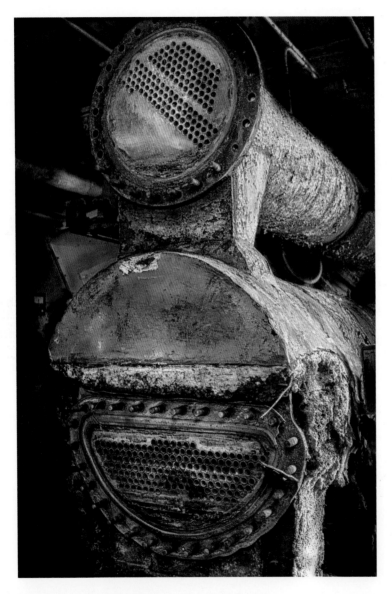

Piggyback, Old Taylor Distillery, Woodford County.
These exposed turbine cylinders are from a section of
the engine room.

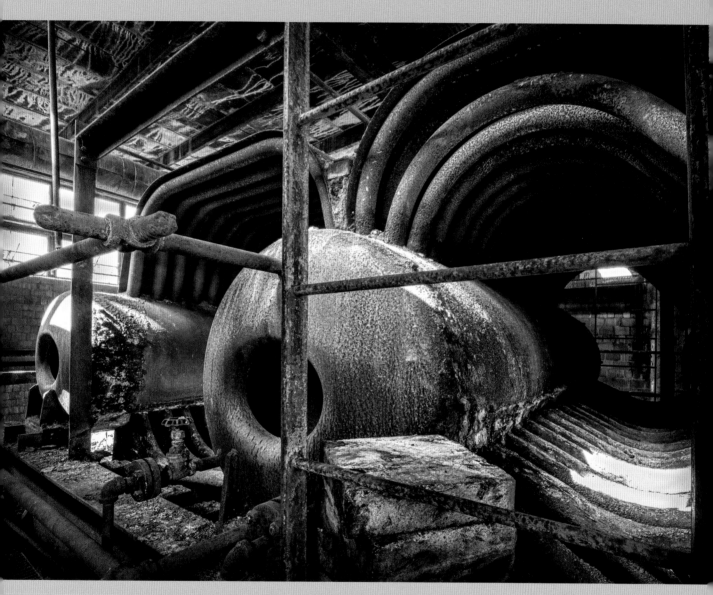

Second-floor boiler pipes, J. E. Pepper Distillery, Lexington.
Beneath the green bricks of the ovens in the boiler room are the
boilers' pipes, massive and two stories high.

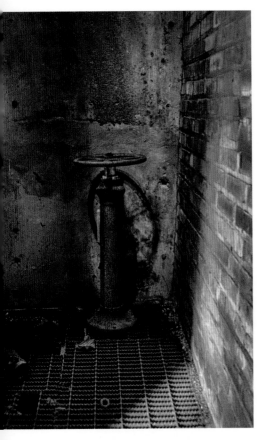

Corner valve, Old Taylor
Distillery, Woodford County.
Occasionally a beautiful
light illuminates a relic,
transforming the once-
functional to art.

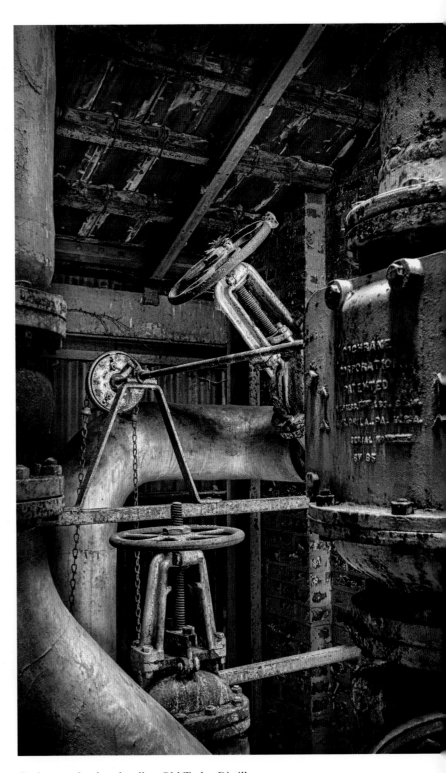

Cochrane wheel and pulley, Old Taylor Distillery,
Woodford County. Reminiscent of machinery seen at the
Stagg Distillery, this resides in the still house attic.

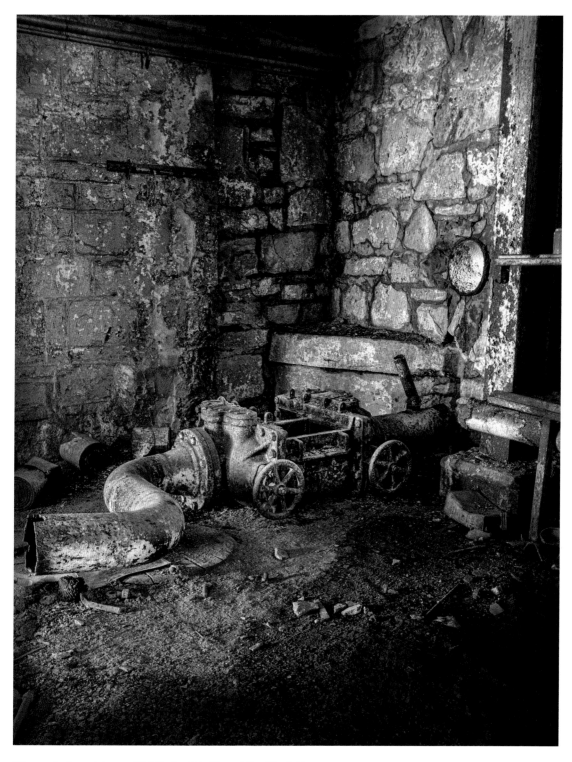

Dismantled machinery, Old Taylor Distillery, Woodford County.
Sometimes dismantled machinery can take on curious forms.

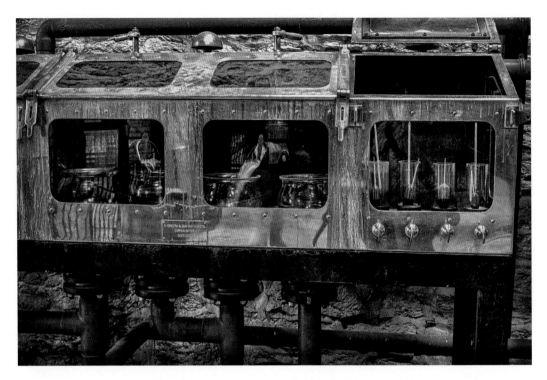

Multichamber tail box, Old Oscar Pepper Distillery/Labrot and Graham Distillery, Woodford County. Labrot and Graham updated the distilling technology, using state-of-the-art equipment for monitoring quality. Typical tail boxes consisted of a single chamber. This tail box, where the proof of the distilled bourbon is tested, includes hydrometers for both the first and second distillations.

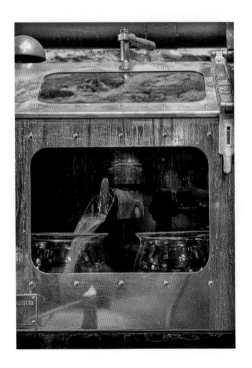

Tail box detail, Old Oscar Pepper Distillery/Labrot and Graham Distillery, Woodford County. One of a three-part section of Labrot and Graham's "modern" tail boxes.

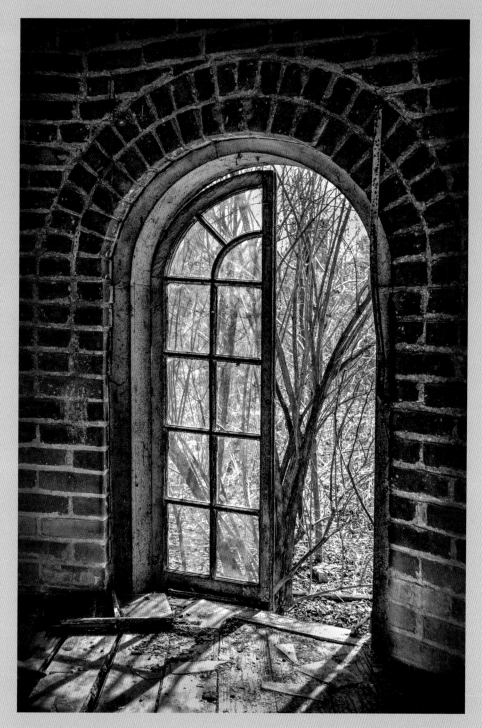

Garden gazebo arch, Old Taylor Distillery, Woodford County. Taylor entertained bankers and statesmen on the grounds of his distillery. Outside the distillery building is a sunken garden, overgrown at the time of this photograph, that stretched from the castle to this gazebo outside the bottling house. Renovations under way at the distillery have restored the garden's splendor.

Millstone, Old Oscar Pepper Distillery/Labrot and Graham Distillery, Woodford County. This old millstone preserves some of the Old Oscar Pepper stonework style and commemorates the beginning dates of the two distilleries.

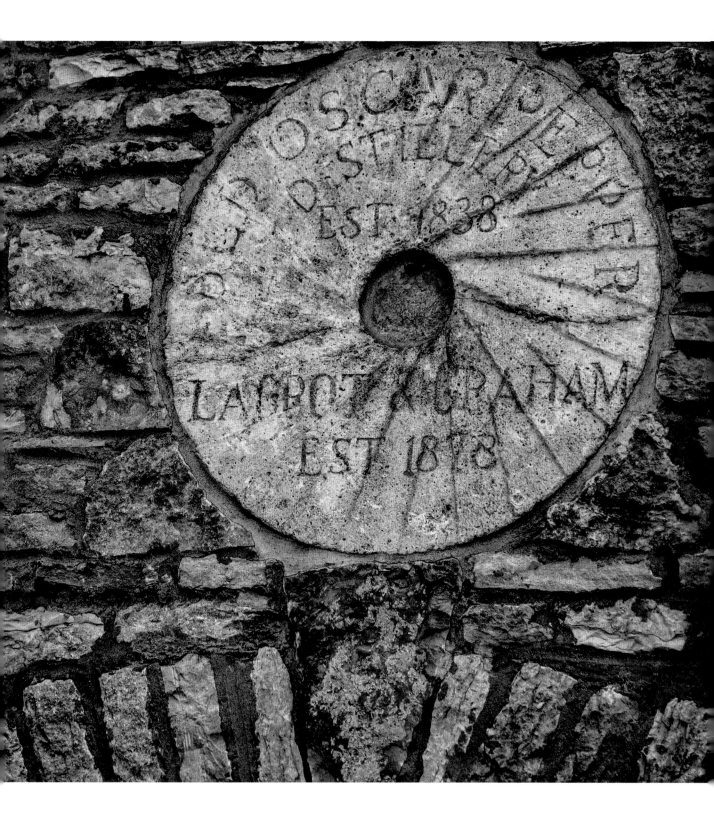

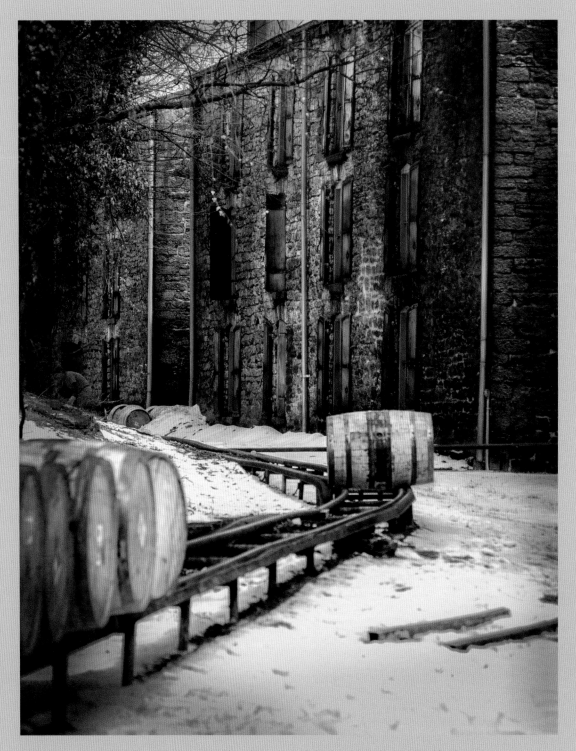

Barrels on a run, Old Oscar Pepper Distillery/Labrot and Graham Distillery, Woodford County. The historical warehouses of Old Oscar Pepper Distillery are the backdrop for the well-known 1934 Labrot and Graham elevated barrel runs, constructed after Prohibition and still used today. They are famous for being completely gravity driven.

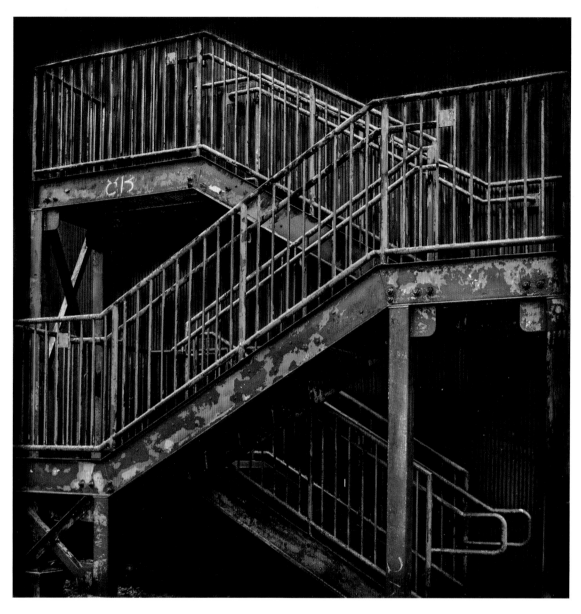

Steps, Burks' Spring Distillery, Loretto. Steps outside
a warehouse in the rural area of Loretto give an urban
atmosphere to this post-Prohibition building.

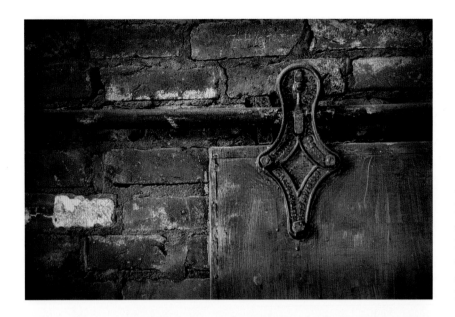

Green door detail, Atherton Distillery, Athertonville. In the cistern room of the Atherton Distillery, an old fire door, typical of post-Prohibition industries, still hangs with its original hardware.

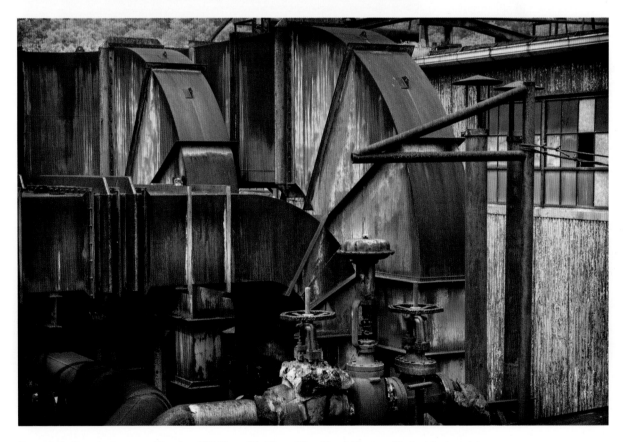

Rusted shafts, windows, and knobs, Old Crow Distillery, Woodford County. Typical industrial metalwork can be seen on the roof of the distillery alongside colorful glass-paned windows.

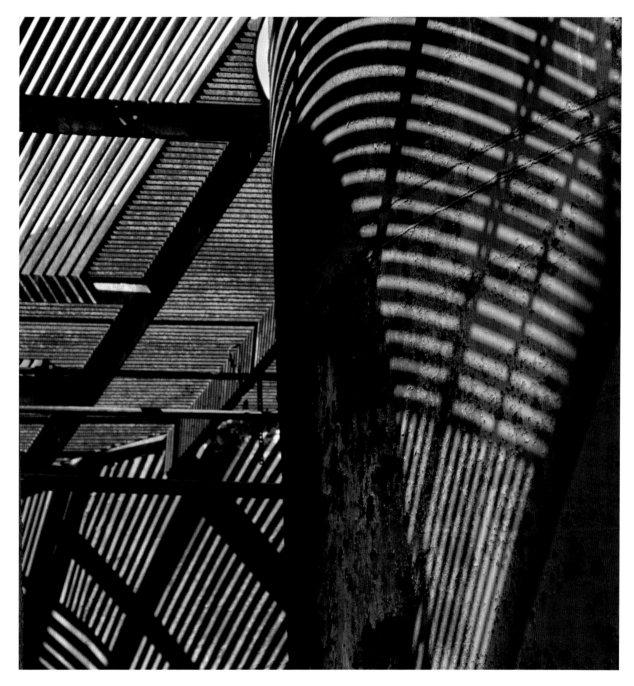

Tank lines I, T. W. Samuels Distillery, Deatsville. This abstraction comes
from catwalk shadows on distillery tanks along the railroad.

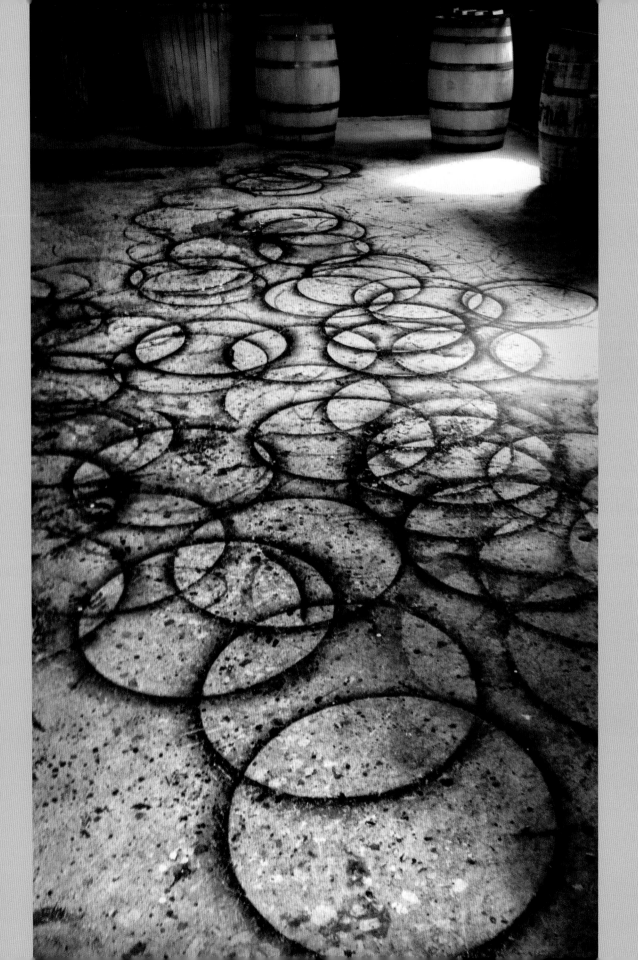

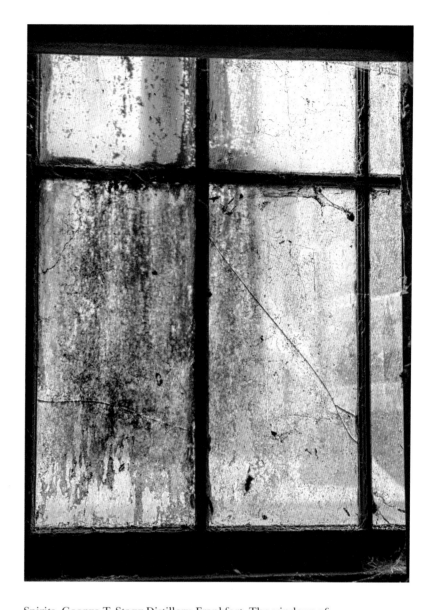

Spirits, George T. Stagg Distillery, Frankfort. The windows of
Warehouse B, the oldest warehouse at the Stagg site, are covered
with residue from the barrels of bourbon that once aged here.
Weeping clay from the old brick, mold, and the vapors that
evaporate during aging (called the angels' share) contribute to
the beautiful colors of this window.

OPPOSITE: Circles, George T. Stagg Distillery, Frankfort.
In Bonded Warehouse J, where barrel rings are repaired and
painted, years of effort leave an abstract design.

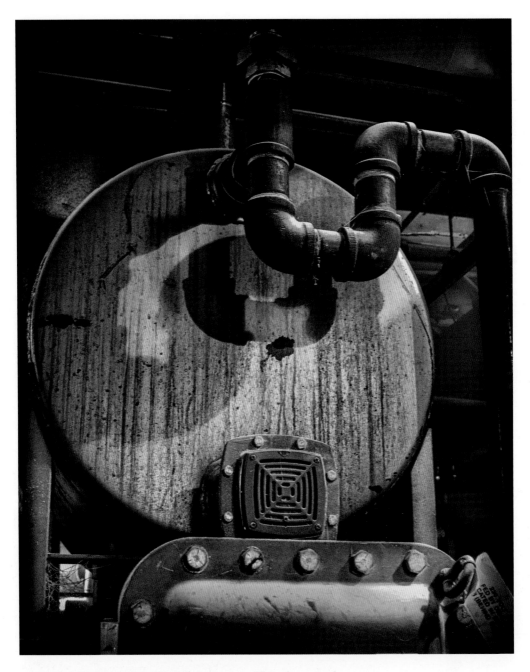

Maker's pipe, Burks' Spring Distillery, Loretto. This photograph
was taken in the basement of the still house.

OPPOSITE: Still II, Burks' Spring Distillery, Loretto.
This is one of two stills in the basement of the still house that
formed the original foundation of Burks' Mill of 1805.

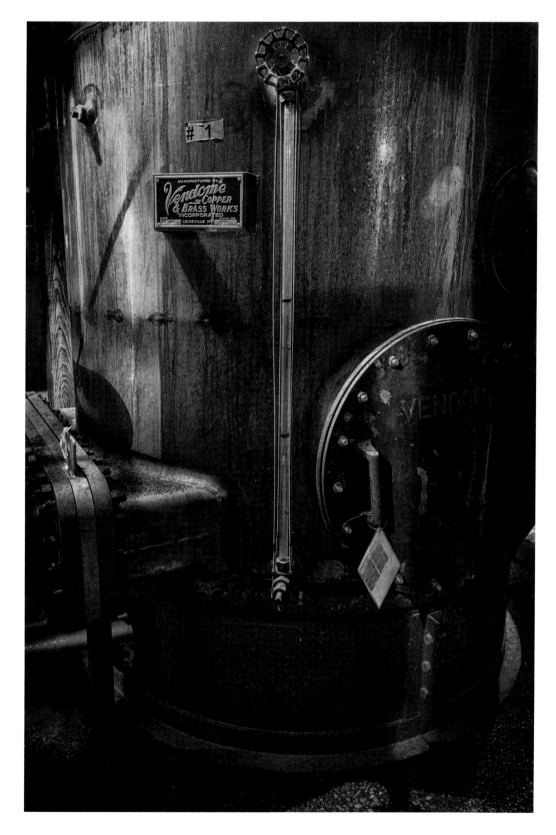

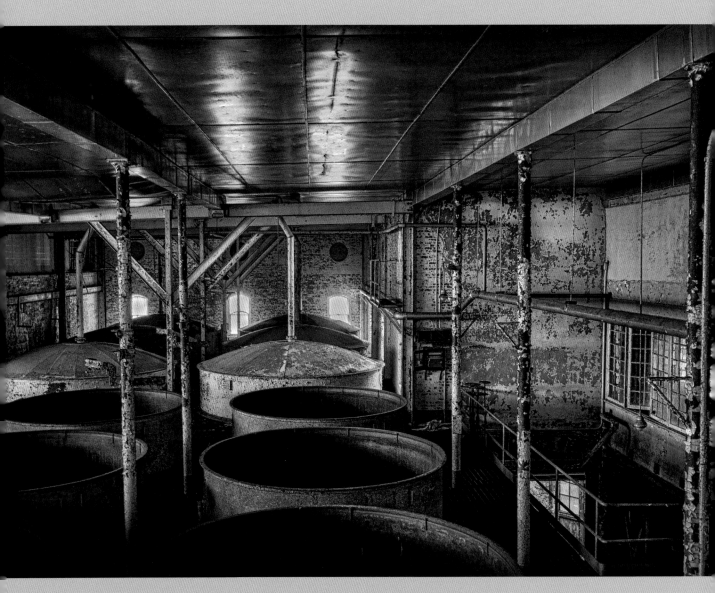

Fermenting room, Old Taylor Distillery, Woodford County. Seen from a wooden landing adjoining the electrical and dial control room, the fermenting room stretches out, its tanks both covered and uncovered. The fermenting tubs here are made of copper and steel, known as "banged" copper. To the right is the window-encased room for visitors' viewing.

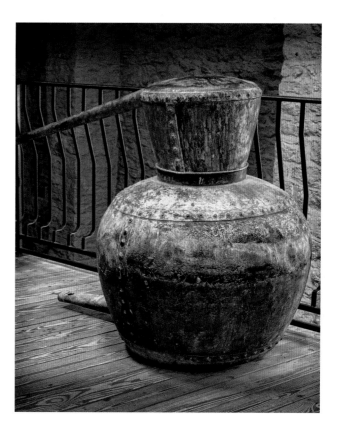

Old pot still, Old Oscar Pepper Distillery/Labrot
and Graham Distillery, Woodford County. This is an
example of one of the earliest copper pot stills used,
a relic now on display, and the sort Elijah Pepper
might have used in 1797, when he began distilling
on his farm. It sits waist-high next to modern stills
installed by Brown-Forman that are almost two
stories high.

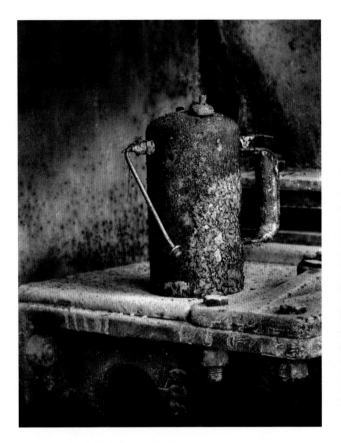

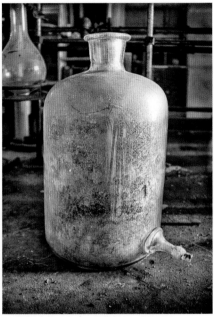

Oilcan study, J. E. Pepper Distillery, Lexington. This oilcan invokes the spirits of workers long gone, resting as if just put down; only the rust suggests how long it has remained untouched.

Glass jug, T. W. Samuels Distillery, Deatsville. Each distillery had a lab where the yeast used in fermenting was kept and cooled. Other mash bill (recipe) determinations were also done in the lab. This jug is in the Samuels distillery lab, probably used during the repurposed water-bottling phase of the 1990s rather than for bourbon production.

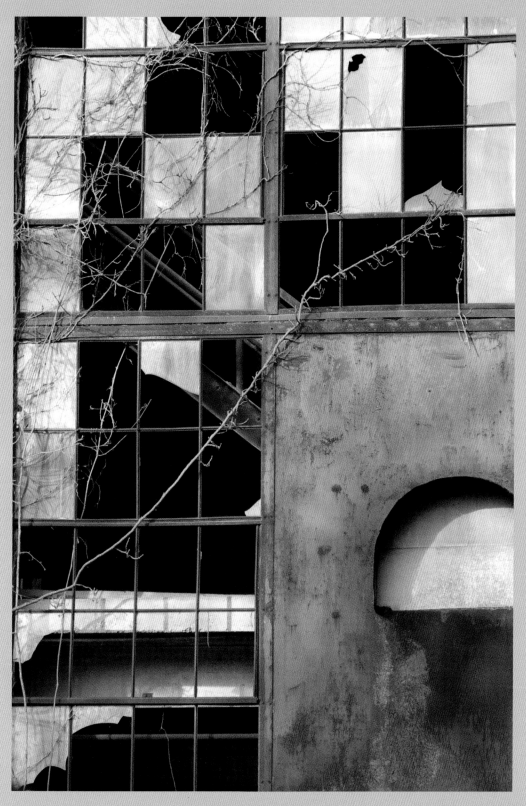

Checkered window, J. E. Pepper Distillery, Lexington. Blown-out windows alternate with intact panes in back of the distillery.

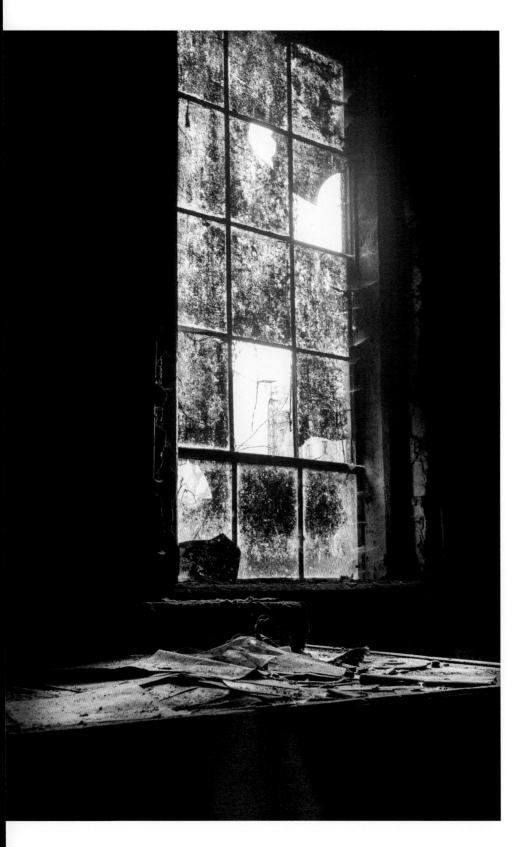

Window and papers,
Old Crow Distillery,
Woodford County.
Papers left behind in
the boiler house lie
on a table along with
miscellaneous artifacts.

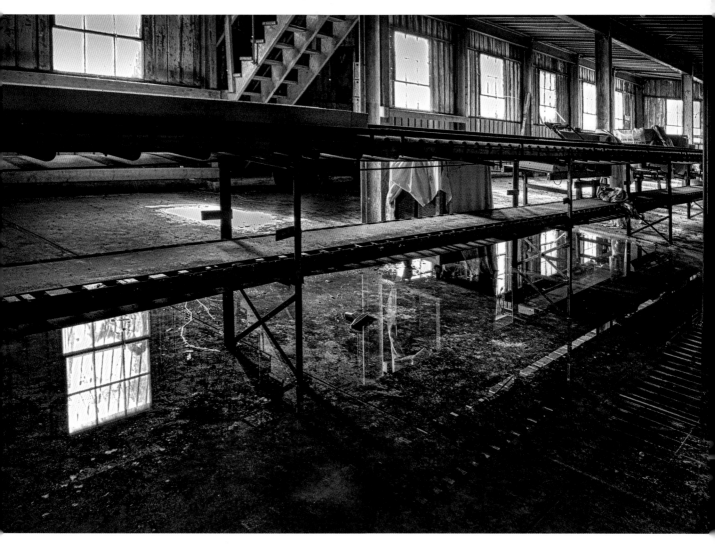

Bottling run flood, T. W. Samuels Distillery, Deatsville. Bottling
lines traveled the length of the bottling building to where the boxes
were loaded onto trains and other transportation for delivery throughout
the United States. The first floor had flooded when I was there.

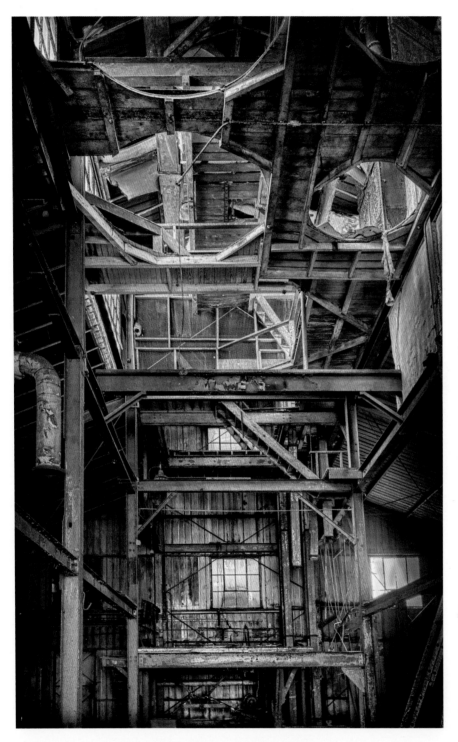

Stillroom, T. W. Samuels Distillery, Deatsville. Although the
column stills are no longer here, the openings for their tall stacks
still outline their vertical paths.

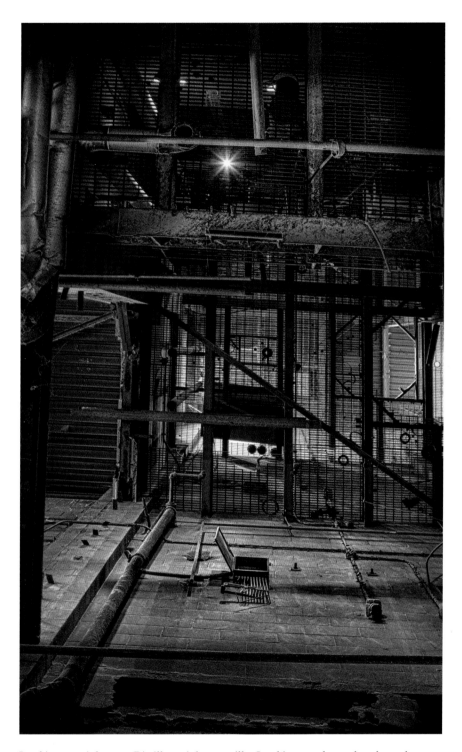

Looking up, Atherton Distillery, Athertonville. Looking up through at least three stories shows the metal catwalk system used in the main distillery. Metal helped fight the constant threat of fires. The Atherton Distillery has been stripped of all equipment; this interesting infrastructure is what remains.

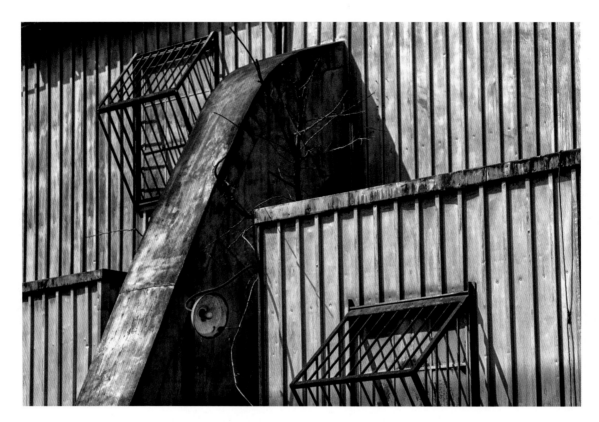

Samuels cage, T. W. Samuels Distillery, Deatsville.
A chute from the bottling section of the distillery
delivered filled cases to a platform next to the railroad
for transport. The cages around the windows allowed
them to be opened while keeping the building's
contents safe from theft.

Home of the Wildcats, J. E. Pepper Distillery, Lexington.
This sign for the University of Kentucky Wildcats was stored behind
the distillery in 2010, but it disappeared around 2012.

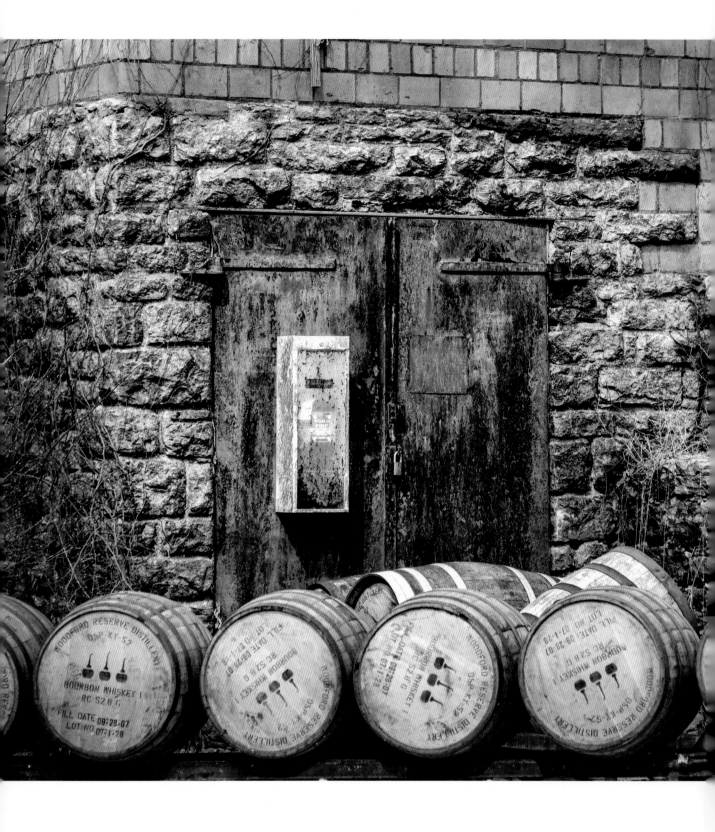

Barrels and door, Old Oscar Pepper
Distillery/Labrot and Graham Distillery,
Woodford County. A view of one of the
glazed-tile warehouses built in the 1930s on
top of older stone warehouse foundations
shows how distillery materials have evolved.

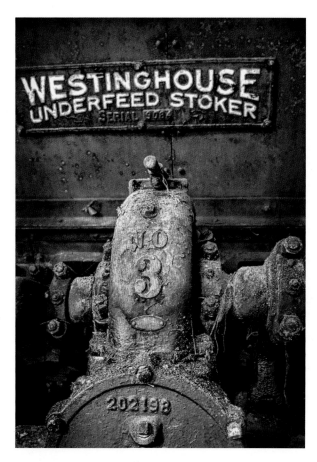

Underfeeder no. 3, Old Crow Distillery,
Woodford County. This is one of three stokers
from the early twentieth century used to keep
the boiler ovens active, powering the distillery
complex.

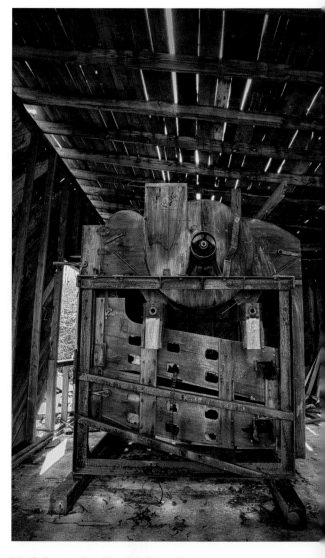

Meal cleaner, Dowling Distillery, Burgin.
Identical meal cleaners can be seen at
J. E. Pepper and Old Crow distilleries.

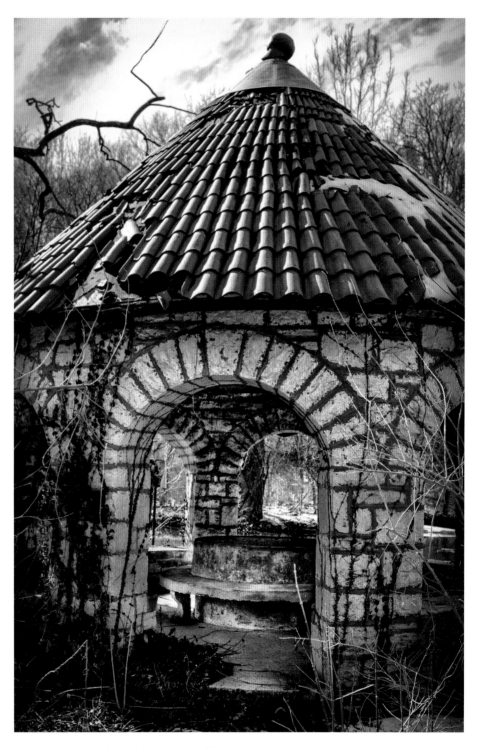

Spring pump gazebo, Old Taylor Distillery, Woodford County. Like the garden gazebo, the spring pump gazebo beside the colonnaded springhouse pergola is topped with barrel tile and a copper cupola. This structure is of limestone rather than brick, and it has an open spring wheel inside.

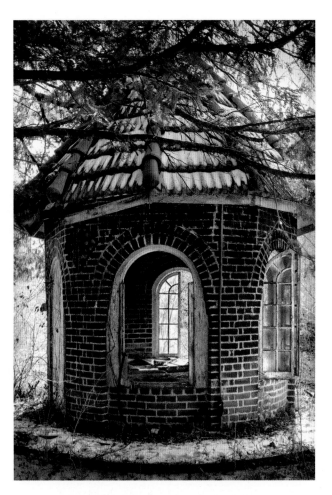

Garden gazebo, Old Taylor Distillery, Woodford County. This gazebo anchors the sunken garden at the bottling house end and looks out toward the other anchor, the castle-inspired distillery. The original spring still flows into a pool in the center of the garden.

Government building wall, Old Taylor Distillery, Woodford County. Near a loading dock, this wall in the government building reveals various building materials of the post-repeal era.

Iced fountain, Old Prentice Distillery, Anderson County.
The fountain beneath this ice sculpture is original to the
Old Prentice Distillery.

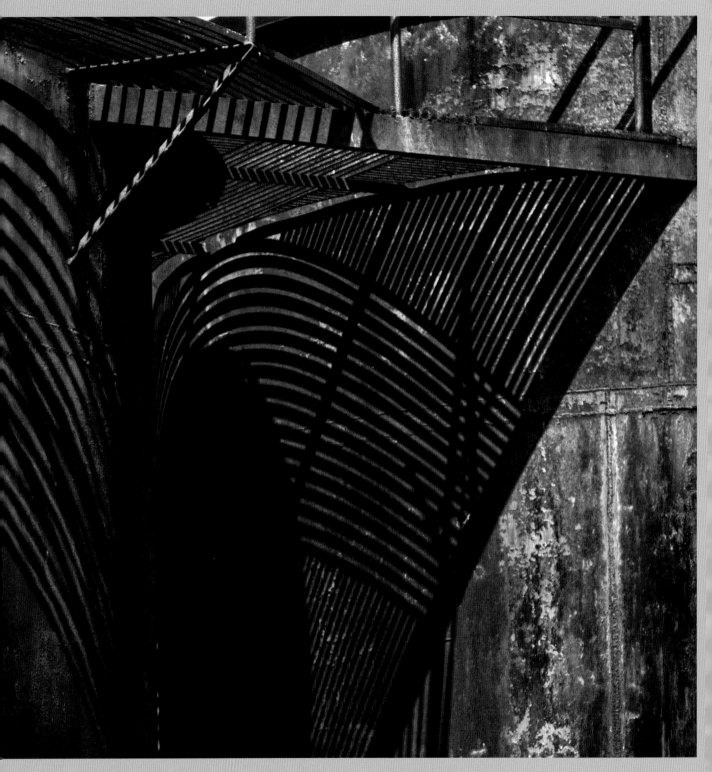

Tank lines II, T. W. Samuels Distillery, Deatsville.
On a bright summer day the sun casts shadows of the
catwalks on the tubs along the railway.

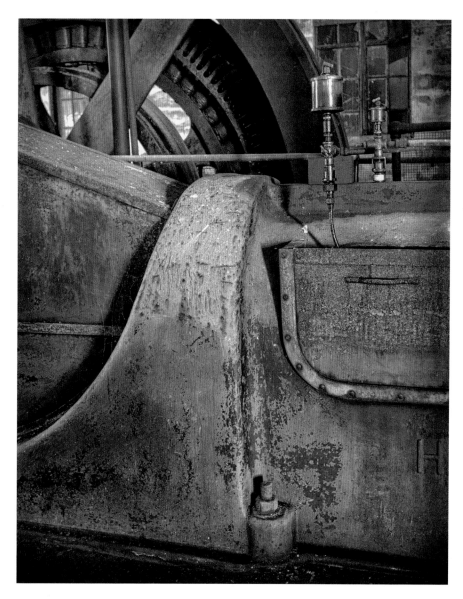

Belt cover curve, T. W. Samuels Distillery, Deatsville. This is a detail
of a belt-driven steam engine in the engine room.

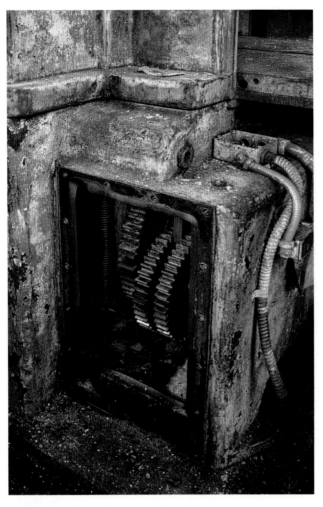

Labeler gears, Old Taylor Distillery, Woodford County. Gears and wires are visible in this detail of the Lawson label machine. The labeler is in the government building, where bottles were inspected and labeled after bottling, and then crated and shipped.

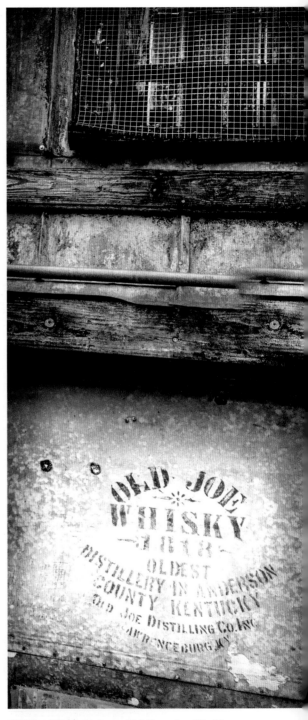

Old Joe Whiskey door, Old Prentice Distillery, Anderson County. The Old Prentice warehouse once housed aging Old Joe Whiskey before the distillery name was changed. The warehouse is now owned by Wild Turkey Distillery.

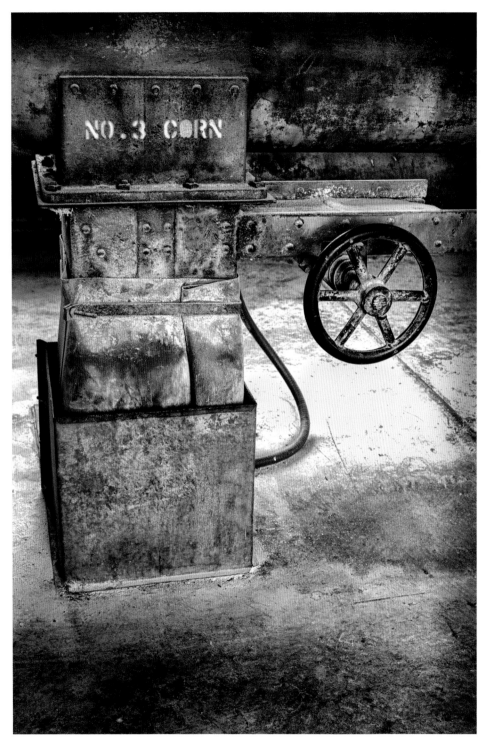

No. 3 corn, George T. Stagg Distillery, Frankfort. There were five grades of corn available, grade 5 being the highest. Only the top three grades were used for bourbon. Grade 3 corn went through this chute on the upper floor to bins below.

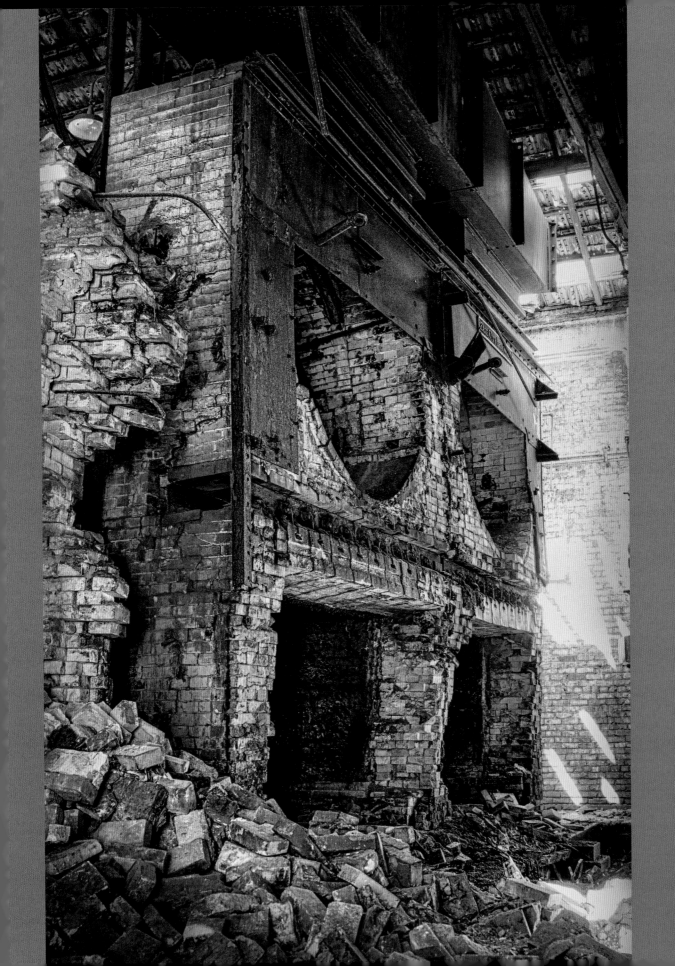

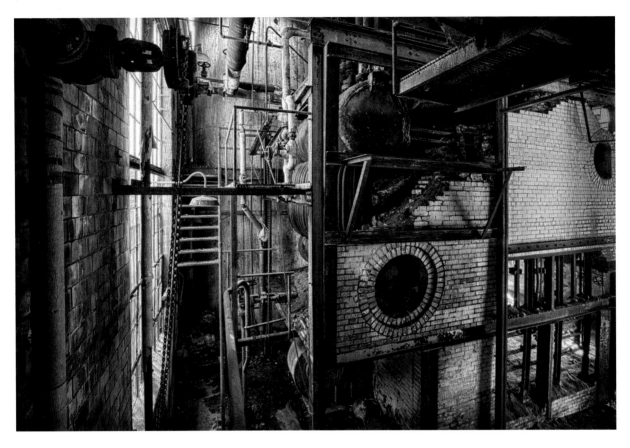

Exposed boiler ovens, J. E. Pepper Distillery, Lexington.
In this view one can see the green brick and the exposed boiler
pipes of the boiler room ovens.

OPPOSITE: Boiler oven backs, Old Taylor Distillery, Woodford County.
Intact brick surrounds held two of the massive iron steam cylinders
and the ovens used to heat them. The cylinders have been removed,
as have the ovens, stokers, and hoppers, leaving behind this massive
infrastructure, which is to be preserved in a craft distillery that
will occupy this building after the new owners renovate the site.

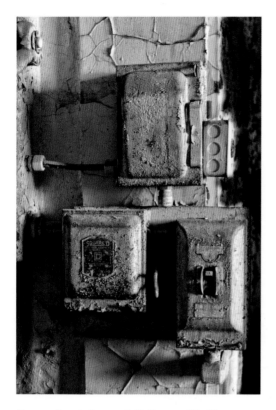

Green electric boxes, J. E. Pepper Distillery, Lexington. This assortment of electric boxes was located in the mash room.

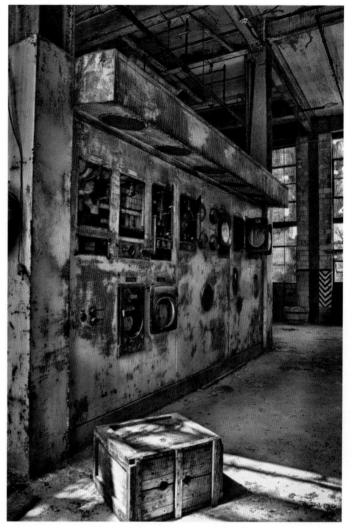

Control room, J. E. Pepper Distillery, Lexington. Brand-new in the 1930s, these dials monitored all sorts of functions throughout the plant. The University of Kentucky's archives hold a photograph showing this room with the panel when it was new, complete with indoor plants by the window.

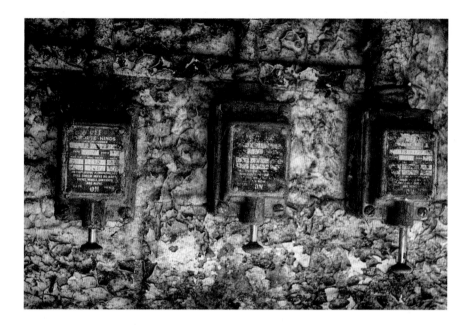

Orange plungers, Old Crow Distillery, Woodford County. Located in an outbuilding where spent grain was probably bagged, these electric switches were common in early industrial plants.

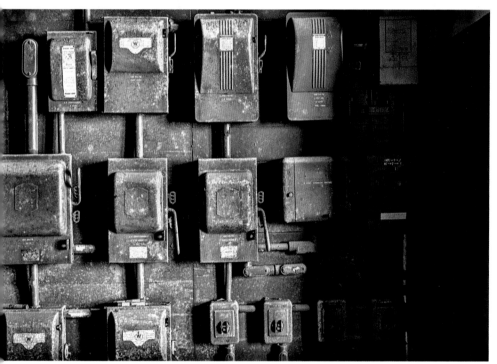

Breaker boxes, T. W. Samuels Distillery, Deatsville. This array of breaker boxes shows change and variety over the years.

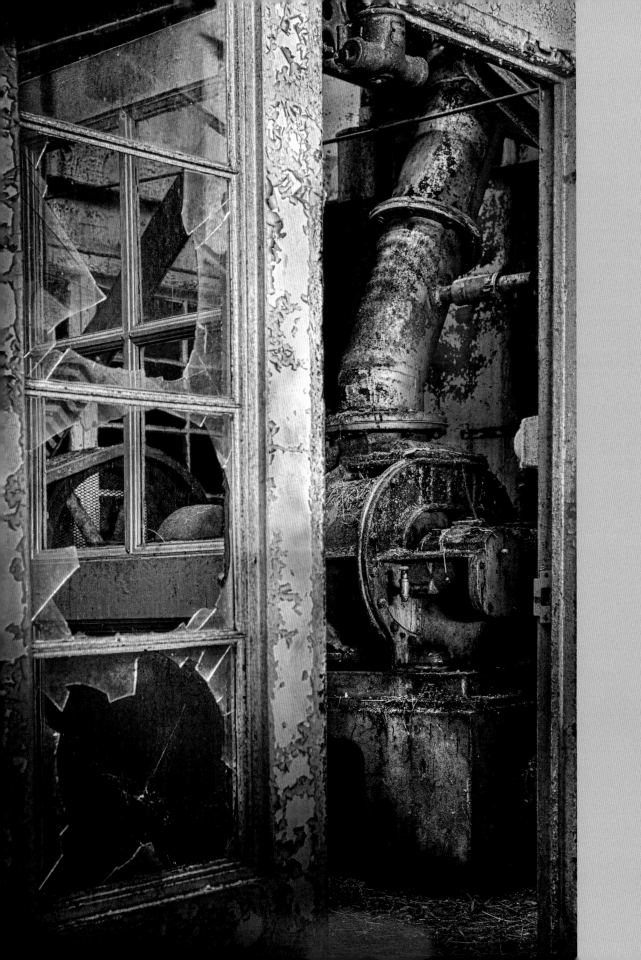

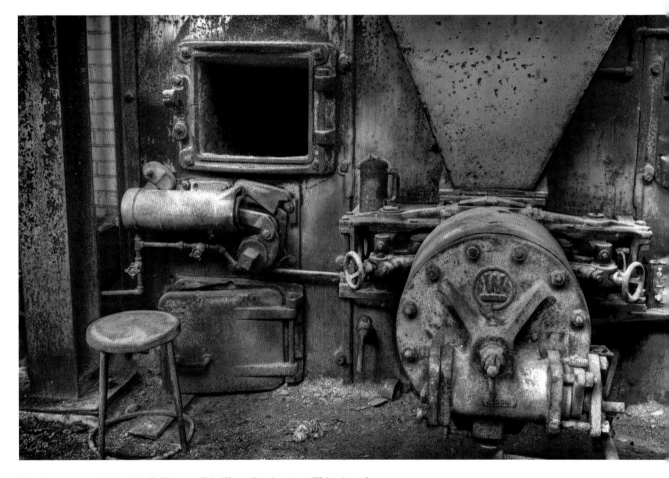

Blue hopper and stool, J. E. Pepper Distillery, Lexington. This view shows
the oven, stoker, and hopper used to create steam power in the boiler room.
The stool invites the assumption that a worker would have been close by.

OPPOSITE: Machine and glass, Old Taylor Distillery, Woodford County. Next to the
fermenting room and surrounded by small-paned windows, the mechanical workings
of some of the distillery can be viewed. Colonel E. H. Taylor constructed his distillery
so that visitors would be both entertained and impressed by its grandeur.

ACKNOWLEDGMENTS

Many books, blogs, magazine articles, and newsletters have been written on the distilling process, the history of distilling, and the histories of the people involved in distilling. This work is meant to be different: a visual exploration of the distillery complex—a type of industrial archaeology through the lens of my camera. The captions I provide are comments, information, and little sprinklings of facts. They are not meant to be an authoritative explanation of bourbon distilling. There are far better resources available for that. Still, I offer an informal guided tour through the images. Any inaccuracies are strictly my own.

Photographing this book over the last four years has involved many skills I lacked at the onset. The result could never have happened without all the people who endured me, some intentionally assisting me and some doing so by accident, those who helped, those who thwarted, and those who purely by chance ended up helping, as well as those enthusiastic and those vaguely interested, those who thought I was a genius and those who thought I was nuts. Thank you, thank you, thank you.

First, I must thank Sarah Tate for all she did to bring this book into being. It was my conversations with Sarah that convinced me to bring my project into the public view. An avid preservationist and a passionate architect, Sarah encouraged me, researched for me, wrote for me, and was always enthusiastic and optimistic about the value and interest of the project. After Sarah, in chronological order through the time line of this project, I must thank the Kentucky Women's Photography Network and Susan King for dragging me around the Distillery District, looking for material that led to the discovery of the J. E. Pepper Distillery ruins. I am grateful to Sheila Ferrell and Jason Sloan of the Blue Grass Trust for Historic Preservation for providing a platform of support, connections, and good cheer I could push off from early on. As a result of their willingness to show my images at the Hunt Morgan House Gallery Hops as well as to promote my work from their gift shop and office, I was able

209

to put together the underground distillery trail that informs this book. Next I must thank Graham Pohl, Clive Pohl, and Krisia Rosa of Pohl, Rosa, Pohl Architects, and Barry McNees of the Lexington Distillery District Group for their encouragement, support, and unlimited access to the Pepper Distillery. Also in this early group of supporters are Pete Wright and Jeff Wiseman of the Barrel House Distilling craft distillery and Tony Davis of Studio 300/Kentucky Knows. Their enthusiasm and willingness to sell my photographs and self-published work, and to invite me to all their functions for networking, boosted my confidence in this project. Also, I am extremely grateful to Carolyn Brooks, a distillery historian, for her personal interest in and help with this book. Carolyn unselfishly shared her extensive knowledge and saved me untold hours of searching for existing sites. Without her help, I would still be trying to figure my way out of the maze of bourbon architectural history. I would also like to acknowledge my deep gratitude to Ashley Runyon, my editor at the University Press of Kentucky, for not only her belief in this project but also her enthusiastic hands-on involvement, talking me both up and down throughout the publishing process.

Special thanks are in order to the guides of the operating distilleries for their wisdom, stories, and tours of the NHL/NRHP areas I photographed. I'd like to thank Freddie Johnson from the bottom of my heart for his tour and guidance. Freddie is third-generation at the George T. Stagg Distillery site. Either his grandfather James B. Johnson Sr. or his father, Jimmie Johnson, or now Freddie has been present for every millionth barrel produced on the Frankfort distilleries' site. Freddie's information, personality, and insights were absolutely uplifting and invaluable. I'd also like to thank Al Young, my guide at Four Roses. Al is another great storyteller who helped form this book in more ways than he can imagine, including sharing many of his exploits and interviews of older distillers. Thanks to my guide extraordinaire, Carey Tichenor, at Woodford Reserve's Old Oscar Pepper Distillery, for his historical perspective on distilling, which helped refine my choice of images for this work. And much gratitude goes to Bill Samuels Jr., my guide at Maker's Mark's Burks' distillery. Thanks to Bill for escorting me across hill and dale to look for original stills, up to the old house to look at wainscot, and through the boardroom to introduce me to his storied family, and finally for unselfishly sharing his family's photos of both T. W. Samuels Distillery and Burks' Spring Distillery. I am deeply indebted to you all.

Last but not least is the gratitude I owe to family—my mother, Nancy Wagner Peachee, an artist and a historian who educated, shaped, and encouraged my artistic life, and to my father, Charles Andrew Peachee Jr., for his support of my adventurous curiosity, regardless of where it may take me. And to Monica, who thought I was both nuts and genius, but supported and endured me through it all. Without her, this book just wouldn't exist.